Nineteenth-Century American Art

Oxford History of Art

Barbara Groseclose is Professor of Art History at Ohio
State University. She has written extensively on
eighteenth- and nineteenth-century art and literature.
Her most recent book is *British Sculpture and the
Company Raj: Church Monuments and Public Statuary in
Madras, Calcutta, and Bombay to 1858* (1995). In 1994 she
was appointed a Fulbright Distinguished Chair in
American Studies at the University of Utrecht.

Oxford History of Art

Titles in the Oxford History of Art series are up-to-date, fully-illustrated introductions to a wide variety of subjects written by leading experts in their field. They will appear regularly, building into an interlocking and comprehensive series. In the list below published titles appear in bold.

Oxford History of Art

Nineteenth-Century American Art

Barbara Groseclose

OXFORD

UNIVERSITY PRESS

OXFORD
UNIVERSITY PRESS

Great Clarendon Street, Oxford OX2 6DP

Oxford New York
Athens Auckland Bangkok Bombay Calcutta
Cape Town Dar es Salaam Delhi Florence Hong Kong Istanbul
Karachi Kuala Lumpur Madras Madrid Melbourne Mexico City Mumbai
Nairobi Paris São Paulo Singapore Taipei Tokyo Toronto Warsaw
and associated companies in Berlin Ibadan

First published 2000 by Oxford University Press

0–19–284225–0 *(Pbk)*
0–19–284282–x *(Hbk)*

10 9 8 7 6 5 4 3 2 1

British Library Cataloguing in Publication Data
Data available

Library of Congress Cataloguing-in-Publication Data

Groseclose, Barbara S.
Nineteenth-century American art / Barbara Groseclose.
(Oxford history of art)
Includes bibliographical references and index.
1. Art, American 2. Art, Modern–19th century–United States. I. Title. II Series.
N6507 .G76 2000 709'.73'09034–dc21 00-036751
ISBN 0–19–284225–0 *(Pbk)*
ISBN 0–19–284282–x *(Hbk)*

Typeset by Paul Manning
Design by John Saunders
Picture research by Virginia Stroud-Lewis
Printed on acid-free paper by C&C Offset Printing Co. Ltd

*The web sites referred to in the list on pages 217–220 of this book are in the public domain and
the addresses are provided by Oxford University Press in good faith and for information
only. Oxford University Press disclaims any responsibility for their content.*

Contents

Acknowledgements

I am grateful to what seem to me the multitudes of friends and colleagues who have helped me in the preparation of this volume, especially those who read portions of the manuscript or advised me on its content: Steve Conn, Lisa Florman, Barbara Haeger, Ruth Melville, Steve Melville, Arline Meyer, Melissa Wolfe, Eva Heisler, Melissa Dabakis, Sarah Burns, Erika Doss, Vivien Fryd, Ann Abrams, Rebecca Zurier, Katherine Manthorne, William Gerdts, Sally Webster, Patricia Hills, Joy Kasson, graduate students in the seminar on war and memory that Steve Conn and I taught, and, above all, Simon Mason. I am indebted, as always, to Catherine Wolner.

Barbara Groseclose

Introduction

Mark Twain (1835–1910), ranting as usual at a trifle while taking aim at a much larger target, corrected a French writer who dared to assert knowledge of 'the American soul':

There isn't a single human characteristic that can be safely labeled 'American'. There isn't a single human ambition, or religious trend, or drift of thought, or peculiarity of education, or code of principles, or breed of folly, or style of conversation, or preference for a particular subject for discussion, or form of legs or trunk or head or face or expression or complexion, or gait, or dress, or manners, or disposition, or any other human detail, inside or outside, that can rationally be generalized as 'American'. [1]

I imagine Twain would have included art in his list if he'd thought about it. Now, I am not beginning this book by announcing that there is no American painting and sculpture, but I take his point: 'Whenever you have found what seems to be an "American" peculiarity, you have only to cross a frontier or two, or go down or up in the social scale, and you perceive that it has disappeared. And you can cross the Atlantic and find it again.'

Twain notwithstanding, a single concern preoccupied artists and audiences for the visual arts in the United States from the close of the War of Independence in 1783 right up until Twain wrote his harangue in 1895: is the work American? Avid viewers inspected paintings and sculptures, seeking 'American' qualities. Critics, historians, and journalists proclaimed the necessity of fostering an American style and subject matter. Yet there was little unanimity of thought. As Twain knew, what is 'American' cannot be pinned down to a list or limited to geography.

Nineteenth-Century American Art offers an account of painting and sculpture in terms that consider their aesthetics amid political, social and economic contexts. From this angle, whatever might be understood by the term 'American art' constantly shifts and re-forms, a temporal fluidity which, when added to regional variations, defies—or at least inflects—any over-arching definition of 'American'. I wish I could have been more true to Twain's insights about regionalism myself, but

in this book I have addressed the local only glancingly, though always aware of its power to pulverize the monolith 'American'.

Conversely, Twain's claim that one may 'cross the Atlantic and find [an American quality] again', resonates throughout. If I recognize the embeddedness of things American within their predominant European heritage, I also reconfigure the prevailing dichotomous reading of the European–American cultural interchange with one in which that interchange is understood to be a dialogue, continuous and salutary, rather than an intermittently valuable but inherently crippling obstacle to the formation of a national art. The reader should not infer from this statement an absence of other cultures in the shaping of American art. Asian, Mexican, African, and Native American arts influence what has been taken to be mainstream American art in diverse ways, though none held so pervasive a grip on its development nor was so thoroughly conceded as European art. As African–American and Native American arts in the United States have already been published as volumes in this series, they are not (with a few exceptions) addressed herein. The relevance of the art discussed in this book *vis-à-vis* African- and Native Americans as subjects, on the other hand, is integral to what it has meant for something to be 'American' art.

My narrative also spotlights the cultural and social work American art did in the United States during the nineteenth century. It is a burden on art to *matter*, and all the greater when one realizes this work is not all the same nor the same all the time. Like-with-like offers the best model for such an investigation, so the chapters are, generally, governed by subject category and developed chronologically. Take, for example, the dominance of portraiture after the United States gained independence: how did that art evolve stylistically, in content, and function, alongside the new country's own social and economic development? What things remained the same? What special requirements did an American situation impose? (These points are addressed in Chapter 2.) Other chapters pose similar questions. How were artists trained and what individuals, commercial developments, and institutions were significant, and significant in what way, and how did they change? (See Chapter 1.) How was genre painting, with its scenes of ordinary people in everyday life, informed by constantly modifying notions of political and social democracy, or vice versa (Chapters 3 and 4)? Why, how, under what conditions, and at what moments does landscape serve as the epitome of American art history and/or American art (Chapters 5 and 6)? How and why does art inscribe the myths of nationhood on memory in history painting and commemorative sculpture, and when do these things become important? (See Chapter 7.) This history, in other words, is not *the* history—it contains *histories*.

I am engaged throughout by critical and philosophical understandings of art that practise alertness to the ways in which social history

might be implicated—or not—in the making, meaning, and reception of art and art history. What may not be as readily apparent is the selection criteria for objects that raise the issues I address. Whatever one's theoretical or methodological orientation, it is evident that art history's current centre, the so-called new art histories, encompasses works of art from a repertoire larger (in regard to authorship) and looser (in regard to aesthetic strictures) than was previously the case. Although in some other fields it dominates the discussion, questions of canonicity—which usually means not only what the canon is or should be, but also why and how it exists—hover on the peripheries of American art history, an inspiration instead of a critical practice. This situation reinforces, but does not direct, the choice of paintings, sculptures, and popular graphic arts addressed in this book.[2]

I have included here discussion of both familiar and less well-known works of art. At risk of flattening the field when what I want to do is offer a different viewpoint, I have been selective in the range of artists and works of art brought into the text, which itself is constrained by the series' norm. Thorniest of all has been the question of American artists abroad. Expatriates whose works were intended exclusively for American markets, like Richard Caton Woodville (1825–55), or who spent considerable time in the States, like John Singer Sargent (1856–1925), are included. But painters like Mary Cassatt (1844–1926) and James McNeill Whistler (1834–1903), whose art was formed and produced entirely within a framework abroad and only partially or belatedly seen in America, belong to a different story.

Some background on the 'new art histories' may be helpful to readers. Feminist art history chiefly accounts for the recent turn away from the individual genius/masterwork case study and, following a much older tradition of social history, concomitant perspectives that emphasize societal (institutional) circumstances in the production of art. In 1971, Linda Nochlin asked, 'Why have there been no great women artists?' She exposed the disadvantages under which European women artists laboured in the academy when obliged by decorum and bias to forego study of the nude model. Her examination of an institutional 'detail' was not intended, she wrote, to produce a definitive answer to a question of staggering proportions, nor even to suggest a rationale for women's 'failure' but rather 'to provide a paradigm for the investigation of other areas in the field'.[3]

Given the sea change in art history since Nochlin wrote these words, one is forced to ask, the 'field' of what? Gender studies, among other things, track the discursive formation of gender for its institutional and ideological consequences in art. Anthropology shades into art history in studies of the construction of alterity, in which—particularly in American art—the racial 'other' is imagined, imaged, confronted, or accommodated. Art-historical practices exert pressure on

what is perceived by some to be the discipline's basis by questioning not only the canon's formation but the very possibility of a canon; and cultural studies challenge the binary formulation high–low, interrogating the whole of cultural production as 'signifying practice'.

Emerging at the same time that the critic Raymond Williams gained adherents in the United States, and sharing some of his and other Marxists' concerns with cultural constructions and hegemonies, feminist writers destabilized art history and helped give birth to its current state of polytheorization. (Indeed, I should make it clear that there is not one 'feminism' but many feminisms, and these in turn sometimes share interests of other cultural projects.) The ideological and institutional shape of art history, deconstructed, revealed what formerly constituted the *givens* of art and its history, such as the practice of collecting and display, or the interaction of the artist with the social controls as well as the economics of the marketplace. Such topics have moved into the art-historical spotlight, informing and contesting preconditioned notions of the art object and its makers.

One feature of 'new art histories' that I particularly welcome has to do with a willingness to avoid closure, which, though sometimes unsettling to the reader, emphasizes tensions and contradictions within both representation *and* interpretation. Complaints that easy-to-read texts convey the sense that the material under discussion is tidy or transparent are as responsive to the problems of 'new' art history in this regard as rejections of dense writing. Tidiness, I think, has to do not only with meaning but with 'voice' as well, and brings up another 'new' goal: to reduce the impression surveys frequently deliver of a single, omniscient, authoritative Text. For me, this cuts two ways: self-consciousness about my own construction of history, in this Introduction and throughout the text; and attention to the constructedness of the histories on which I draw, and to which I am beholden.

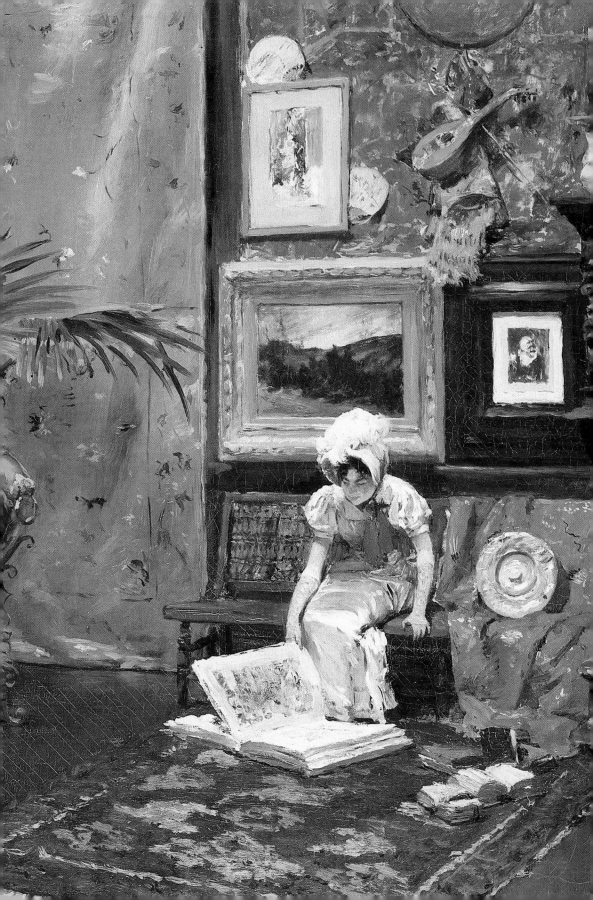

The Profession of the Artist

1

In the 1760s, Boston was the most cosmopolitan of North American cities, with one of the continent's busiest harbours. The wealthiest families luxuriated in the latest furnishings and fashions from Europe and the Far East, and intellectual life was cultivated and progressive. Despite these advantages, John Singleton Copley (1738–1815), Boston's greatest painter in those days, had cause to complain: 'In this Country … there are no examples of Art, except what is to [be] met with in a few prints indifferently executed, from which it is not possible to learn much.' Of his patrons, he was equally disparaging: 'people entirely destitute of all just Ideas of the Arts' he called them, and lamented the narrowness of taste which was so restrictive that 'was it not for preserving the resembla[n]ce of particular persons, painting would not be known in the plac[e]'. Most disheartening of all was the colonials' attitude toward the profession of art: 'The people generally regard it no more than any other useful trade, as they sometimes term it, like that of a carpenter[,] tailor or shoemaker',[1] wrote the mortified painter, whose 'trade' nonetheless had made him a good deal of money.

At the time Copley was writing, painting was only relatively scarce, and decorative arts and furniture making positively flourished. Yet colonists who bought fine art single-mindedly favoured portraiture, as much in emulation of prevailing taste in the mother country as anything else; and, because colonial art patrons believed that London and Rome constituted the established fonts of artistic production, they showed little concern about training artists locally. Then the Revolutionary War, though scarcely a threat to British dominance culturally, turned indifference about home-based art production on its head. Indeed, had he lived another century, Copley would have modified, or even dropped, his most serious grievances. Not long after the new country established itself, a few wealthy individuals formed collections of art, mostly European, though American works made a strong showing as the century wore on. Tastes broadened and, far from monopolizing the art market, on occasion portraiture barely held its own. Finally, artists banded together in academies, which not only afforded them instruction but raised their morale.

Two key features in the professional development of the American

Detail of 17

artist highlight salient conceptual, vocational, and economic conditions. The first involves the formation of academies and the adaptation of central academic tenets—the primacy of history in subject matter early in the century and, a later development, the significance of the live model to instruction—from European prototypes.[2] A second model of engagement with professionalism, self-invention, may be more expressly American (and heavily dosed with mercantilism), yet self-inventions were also adjusted to the European cultural frame in which American art has been enacted.

Academies

When art history began to be a staple subject of American higher education, a process that began in earnest more than a decade after World War II, the words 'academy' or 'academic' usually signalled the opposite of 'modern'. Academies of fine arts started in sixteenth-century Italy for the purpose of training artists (a function previously undertaken by guilds), and they later took on the task of encouraging and instructing patronage, usually through exhibitions. The system of thought by which academies taught the rudiments of art and ordered its aesthetic value did not change to any great degree over the centuries. Those artists around whom a modernist art history was built, basically nineteenth-century French artists from Gustave Courbet (1819–77) to the Independents, were considered avant-garde not least for their ostensible rejection of the academy's congealed authority and attendant conceptual sterility. Likewise, the American abstract expressionists, at their peak in the 1950s, also appeared to exist well outside of the kind of art-making, not to say art-thinking, academies previously sanctioned. Finally, Eisenhower-era intellectuals were eagerly trying to isolate themselves from the hierarchies and absolutism associated with academic structures. By the 1960s, the academy was an idea whose time had passed.

The pendulum of judgement on the academy's nature had commenced its return swing when Joshua Taylor and Lois Fink curated *Academy*, a 1975 exhibition that reiterated the American academy's history as an implement rather than an impediment of art. In the young republic, they wrote, the 'basis for [the academies'] organization' had been 'a matter of artistic solidarity and aesthetic principle' in which artists endeavoured to create 'a reassuring environment', and procure for themselves 'a wide and accepting public'—exactly what Copley thought the colonies lacked.[3]

Obstacles

The rise of American academies of fine art during the first decades of the nineteenth century, and especially their programmes of instruction and emphasis on history painting, testifies to the manner in which

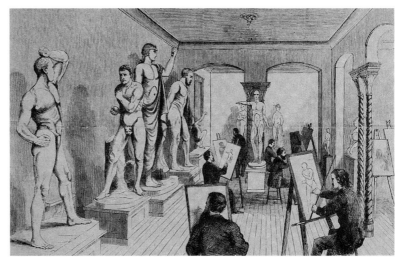

Europe supplied a prototypical professional context for the United States. Initially, there were obstacles. Academic theory holds that, in addition to the study of nature, art comes from art. Not just any art—rather, intimate knowledge of the Antique and of the techniques and subject matter of certain revered artists of the Renaissance and Baroque, known as Old Masters. Benjamin West (1738–1820), a colonial-born London painter who knew the deficiencies under which North American aspirants suffered, wrote to Copley saying: 'Nothing is wanting to Perfect you … but a Sight of what has been done by the great Masters.'

Plaster casts of Greek and Roman sculpture were already in use as exemplars for drawing classes in European academies and facsimiles were relatively easy to import [1], but in the early decades of the new republic, paintings worthy of emulation were scarcely to be found, though their general features were known through engraved reproductions. The first collection of substance in the United States, works of art acquired by Thomas Jefferson (1743–1826) during his tenure as American Minister to France (1785–89), was relatively inaccessible at Jefferson's rural home in Virginia. In the first quarter of the nineteenth century, a collector named Luman Reed purchased quasi-Old Master paintings (or copies thereof) and opened the gallery of his New York townhouse weekly so that the city's growing community of artists might derive educational benefit from them. Nonetheless, to see first hand the masterworks of a Raphael or a Michelangelo, Americans were (and indeed are) obliged to go to Europe.

There were other hurdles. In big cities and small, north and south, founding an academy laid open the insecurities of the artist's position in a society where patronage was emerging only alongside the production of art or even lagging behind it, and where uncertainties about democracy's capacity to sustain art were concealed under differences of

opinion as to whether lay persons or artists should provide the academic leadership that determined the course of training an artist should follow. As if all this were not enough, antipathies to art brewed from a mixture of prudery and religion also surfaced repeatedly. Depending on who was doing the forecasting, it was averred that academies instructed lovers of art with both the rudiments and fine points of correct aesthetic taste, corrupted public morals, fostered an American professional class of artists and thereby eliminated European cultural dominance, and created and/or perpetuated an elite class of individuals who attempted to direct the otherwise free conditions of American art through the power of patronage. There are more discrepancies swirling within the academy's discursive formation, but the gist of the matter is that the professional feebleness of the artist and the nascent state of art's production and reception at the beginning of the century meant that the ideas academies endorsed, such as the primacy of history painting and the superiority of study from the live model in figural art, struggled for acceptance.[4]

The first American academies

Academies provided credentials for artists *and* patrons. As Copley foresaw, artists' quest for professional recognition would eventually be consolidated with the goal of inculcating taste in a country where, visitors and natives agreed, it was in extremely short supply. In New York City at the turn of the nineteenth century, a group of wealthy, well-bred men professed themselves willing to take charge of the cultural education of the masses, who were made of 'malleable stuff, readily susceptible of polish', but liable—such were the dangers of democracy—to sink to the lowest common denominator unless guided by their betters.[5] The plan was to open a school, an academy, intended not so much as a vehicle for practical instruction but more as a site for contemplating all that was beautiful and good by means of plaster casts of antique statuary. Admittance to galleries would be monitored so that appropriately behaved and receptive viewers would, like the students, learn to recognize and appreciate fine art, burnishing the moral tone of the republic's respectable citizens. The resulting Academy of Arts, as set up in 1802, had no artist–members; by 1805, when it was chartered by the state as the American Academy of Arts with painter John Trumbull (1756–1843) in a position of leadership, its programme was sagging, weighted from the top by status-seeking laymen and unsupported at the bottom by public enthusiasm.

Before the American Academy of Arts (not unexpectedly) died in 1839, the National Academy of Design (NAD), opened in 1826 and still thriving today, was formed in New York as a counter-initiative by artists led by Samuel F.B. Morse (1791–1872). In setting forth their aims, Morse explained that the new organization would devote itself to

training artists and to exhibiting *American* art. There was to be an Antique School for drawing from casts and a Life School for drawing from models. To compete with the American Academy for members, sponsorships, and the all-important exhibition fee (which provided most of the operating expenses), the NAD promised to show 'Original Works by Living Artists, never before Exhibited by the Academy'. Since the American Academy, in addition to showing new paintings, patently relied on reshuffling its many copies of Old Master paintings every year to give the appearance of a new exhibition, the NAD won hands down. NAD exhibitions also, and not incidentally, facilitated the development of New York art by featuring the work of Thomas Cole (1801–48), William Sidney Mount (1807–68), Asher B. Durand (1796–1886), and Morse. According to Paul Staiti, Morse counted on the NAD to make New York City the centre of the American art world; if this is so, identifying this particular academy as 'national' is both misleading and prophetic.[6]

Academies outside New York burgeoned. The Pennsylvania Academy of the Fine Arts (PAFA), founded in Philadelphia in 1802 by a 71-member board that included only three artists, was firm in its training mission, devoted to drawing from casts and the model. Boston, Albany, and a few other cities established academies that are still in existence; elsewhere—like the South Carolina Academy of Fine Arts in Charleston, which opened in 1821 at the urging of Morse and closed temporarily the next year—academies failed in their infancy. In Cincinnati, Chicago, St Louis, Kansas City, and San Francisco, founding academies (the name might be 'art institute' or 'school of art') signalled the cultural ambitions of rising western centres of commerce.

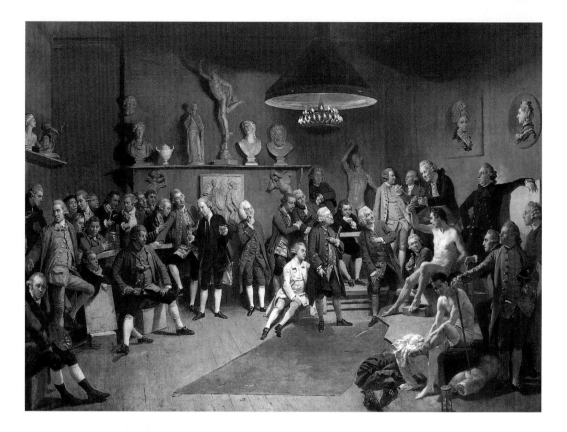

The early nineteenth century: history painting

Making a case for the academy in a democratic society necessitated, among other things, that it be perceived as a moral guide, on the grounds that to have taste is to have virtue, *sine qua non* of a democratic people. Contending that art produced by an academy not only reinforced a national image but was necessary to develop it also bolstered the institution.[7] In the beginning, the argument was made on both fronts through history painting, originally a designation for subject matter of fictional or actual events set in the past.

In general, academies acceded to Leon Battista Alberti's (1404–72) dictum in his 1463 *Bella Pittura* that *istoria* comprises 'the greatest work of the painter'.[8] The reasoning behind Alberti's assertion and its incorporation into academic thinking is something like this: as the human body forms the core of training, so figure painting encompasses the most exalted artistic activity; erudition and a sense of design being equally prized attributes of the artists, the subject demonstrating these qualities most effectively is history. History painting offers in subject matter an example of virtue for the moral edification of the individual and collective viewer, marking its purpose as higher than mere intellectual or technical dazzle. It's worth recog-

nizing that history painting, as construed by the academies, eventually contained a paradox: that is, the rationale for history painting is to create an art that transcends time and place, since its nobility of compositional design must be intertwined with its universality of moral example, but particularity was required by nationalist sensibilities that coursed through late eighteenth-century Europe like adrenaline through a patriot. What makes the colonial-born painter Benjamin West important to the history of art is that he understood, and overcame, this contradiction.

Benjamin West

According to his first biographer, Benjamin West knew from his earliest days that he would be a painter, and as such 'a companion to kings and emperors'. Monarchs being thin on the ground in his Pennsylvania birthplace, West sailed to Rome in 1760, then three years later he moved to London, where he became history painter to King George III and helped to found the Royal Academy in 1768 [**2**]. Although in its character and operation, the British academy did not resemble France's precedent-setting Académie Royale de Peinture et de Sculpture, which began in 1648, the two were in accord on the importance of history painting. West served as the Academy's second president and painted a benchmark of history painting, *The Death of General Wolfe*, exhibited in London in 1771 [**3**].

As art historians frequently observe, the picture was celebrated because West endowed a (more or less) current event with the highly principled demeanour and design his peers believed not only inherent in, but also exclusive to, classical subjects. His subtle pictorial 'quotations'—to Christian Pietàs and Lamentations in the dying Wolfe's pose and that of his hand-wringing attendants, and to classical statuary in the heroic body type of the Indian—constitute the devices by which a contemporary subject transcends its incipiently objectionable mundane form.

In addition, West grounded noble action in the service of nationalism at a time when inducements to national sentiment were of crucial benefit to the expanding, colonizing State. As Dennis Montagna has explained, by the time West depicted the 1759 Battle of Quebec in which Wolfe received his mortal wounds, the general already ranked as a secular martyr, having helped to enlarge Britain's empire to the detriment of France. Fashioning a moral less about the good dying young than about the good of dying, West resolved the specificity/universality dilemma of modern history painting in his treatment of a battle that confirmed, even as it sustained, the national cause (empire).[9]

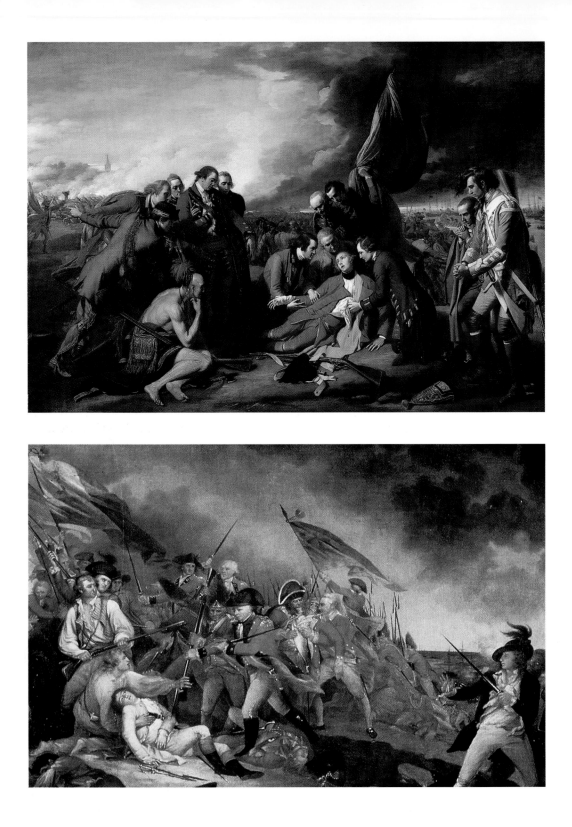

John Trumbull

From the standpoint of American art history, greater even than West's contributions to the evolution of history painting and the operation of the British academy was his generosity to the dozens of North Americans who sought his advice, financial assistance, professional mentoring, and instruction during sojourns in London that could last more than a decade.[10] Among these men, John Trumbull stands out as the individual who pushed the hardest to ensure the future of a West-inspired history painting linked to an academy in the new republic.

Trumbull's *The Death of General Warren* [4] may be a more bewitching picture than West's *Death of General Wolfe*, which it so closely resembles; certainly West's careful draughtsmanship looks stilted in comparison to Trumbull's fluently handled paint, while the latter's placement of reds and use of an action-enhancing diagonal enliven West's more staid design. The canvas was one of six chronicling Revolutionary War events that Trumbull undertook in London between 1786 and 1789. Not quite sketches though not precisely exhibition pieces either, the paintings were conceived as models for engravings to be sold by subscription in the United States, an endeavour that died almost as soon as it was born. They were also intended as stimulants in seeking national commissions from the federal government, a plan that, on the face of it, succeeded: in 1817, Congress ordered four 12 x 18-foot canvases for the Capitol rotunda.

The same year, Trumbull was elected president of the American Academy by a lay board of directors. Thereafter, historical subjects—in particular Trumbull's own—were promoted as a medium of moral and aesthetic enlightenment for viewers, and as the pinnacle of artistic achievement for painters. Being a painter, as Trumbull wrote to Thomas Jefferson in 1789, may be 'unworthy of a man who has talents for more serious pursuits', but 'to preserve and diffuse the memory of the noblest series of actions which have ever presented themselves to the history of man … gave a dignity to the profession'. [11]

Of the four paintings Trumbull made for the Capitol rotunda, the only one to generate enthusiasm relies on portraiture, a genre in which he excelled but which, like Copley, he considered inferior to history. *The Declaration of Independence, 4 July 1776* [5], based on a canvas begun in 1787, garnered rave reviews and paying viewers when exhibited in Boston, New York, Philadelphia, and Baltimore but fared less well after installation (in 1824) in the Capitol rotunda. One Congressman sneeringly dismissed it as 'a shin piece', meaning that its placement above the viewer's head left only an array of hosed legs in sight. While Trumbull cannot be said to have put together *The Declaration* with any compositional flair, he exhibited a keen eye for the striking hair and height of Jefferson, the benignity of Franklin, and other telling features of men whom Americans have been wont to

5 John Trumbull
The Declaration of Independence, 4 July 1776, 1787–1819

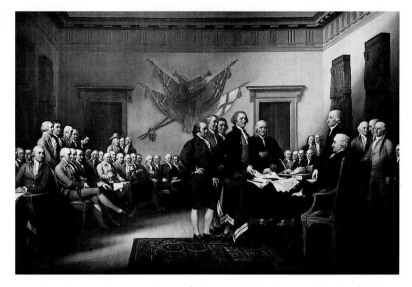

regard as human incarnations of the republic's abstract ideals. As Irma Jaffe remarks, the painting is 'not grand, but it achieves grandeur'.[12]

The critical reception of history painting

Beginning in the 1850s with the acerbic James Jackson Jarves, Italophilic critic and foe of American history painting, art historians derided the United States for its failure to foster a national history painting or for the specimens it acclaimed as such. Trumbull has always received a share of the blame because a visible portion of his work, especially three anaemic canvases hung alongside the *Declaration* in the Capitol rotunda, has little to recommend it, both from a design standpoint and from Trumbull's inability to carry out consistently West's synthesis of the universal and the particular. Moreover, in his 19-year role as director of the American Academy he behaved autocratically, by this and other actions alienating student and lay supporters of historical art; drawing from the live model [**6**], a practice he began abroad where it was the epitome of training, did not enhance his reputation among strait-laced citizens. In the current climate of reclamation in which American history painting basks, Trumbull fares ambiguously. Patricia Burnham singles out *The Death of General Warren* as 'a feistily nationalistic work that appropriates the style of the hegemonic [British] culture … The picture is painted in an English style on English soil while presumably extolling the values and premises of the American Revolution.' Here and elsewhere, she judges, Trumbull treats the 'subject of revolution in the language of the parent culture'. [13]

Unlike the parent culture, however, whose imperial thrust facilitated cohesion and so welcomed West's exemplar, the United States by the second quarter of the century was riven by a sectionalism that its

westward impulse across the continent surely fed even as it retarded the kind of nationalist spirit Trumbull's painting, and history painting in general, wanted to draw upon. Unlike the parent culture, for most of the century America sustained no collective aristocracy of taste, wealth, and birth to govern the art world's economy and financially undergird large-scale history painting. Government remained slow to patronize artists; in fact, an evolving democratic social order regarded the art world with suspicion. Of course, if the 'failure' of history painting in the United States is measured by a gradual drying up of commissions, by gloomy comments about their lack of success from history painters themselves, and by a want of imagination in many of the history paintings they produced, then it cannot be severed from the dethronement of history painting in Europe during the same period, which manifested the same symptoms.

The late nineteenth century: life classes

Paris

Thomas Rowlandson's (1756–1827) eighteenth-century satire on the British Royal Academy puts the erotic resonance of an academic life class in the baldest terms [7]. Due to this resonance, more than a century later, American art students training in Paris were there because American academies had been unable to initiate or maintain working from the nude as part of their curriculum. Ironically, the

6 John Trumbull

Reclining Female Figure, 1795

Trumbull displays a grasp of nuanced shading and line, and a delicacy of touch, that elevates this chalk drawing above the standards of 'technical exercise'.

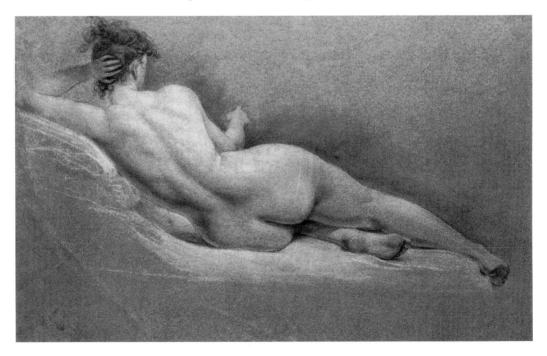

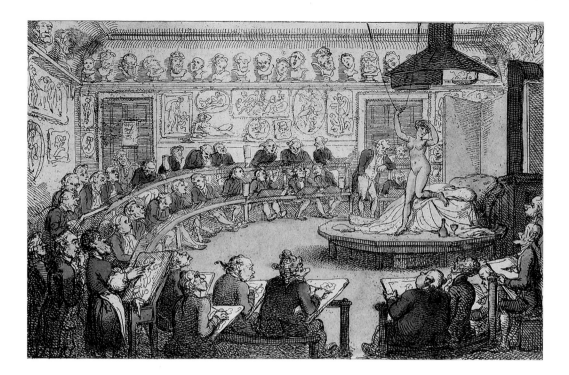

sexual tension embedded in the practice only increased within the competitive and intense atmosphere of the Parisian ateliers.

The letters of Kenyon Cox (1856–1919) to his folks in Ohio wonderfully document a typical experience. Cox left Cincinnati's McMicken School of Art in 1876 to study at the PAFA; one year later he fled to France, bored with the American schools' reliance on rote drawing. In Paris, he tried out for ateliers of the Académie Julian and for entrance to the Ecole des Beaux-Arts, eventually studying with academic stalwarts Emile Carolus-Duran (1838–1917), Alexandre Cabanel (1823–89), and J.-L. Gérôme (1824–1904) over a period exceeding seven years.

Drawing from casts again—'very severe and useful study ... [but] it would become dull if kept up for any length of time'—Cox strove mightily to go 'upstairs' to the ateliers where students drew from the live model, and lucky ones painted the model [**8**]. To succeed, Cox needed to be placed high in the regularly held competitions that were judged by the professors. Even after entering the paradisical studios above, competitions (known as *concours*) kept the aspirants keen, as the 'clearing out' of lesser students was a frequent occurrence. Exhibition in the Salon could be the reward of superior work, and every month a small monetary prize was bestowed.[14]

During *concours* week, students were assigned easel positions in the studio and applied themselves with vigour. 'Instead of being no. 11, as I

8 Kenyon Cox

Study for *Science Instructing Industry* (female nude), 1898
Cox continued to work from the model throughout his career. Despite his prominence as an art teacher and muralist in New York, he frequently felt the sting of rejection when exhibiting paintings of nude subjects; back home in Ohio, even his mother begged him to stop.

9 Jefferson David Chalfant

Bouguereau's Atelier at the Académie Julian, Paris, 1891
What strikes one about Cox's words and Chalfant's picture is the passivity imposed on the (male and female) nude body which is subjected to the male artist's gaze. Competitive as well as aesthetic ardour holds the artists rapt.

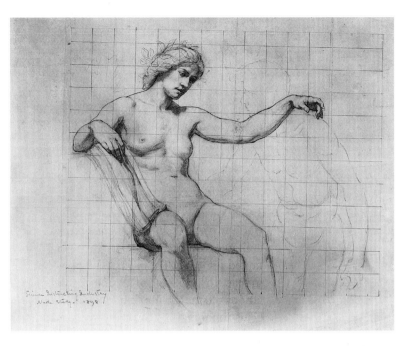

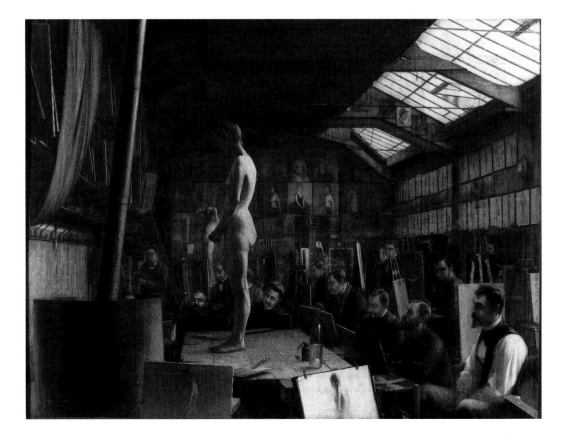

had expected, I was no. 30,' a dejected Cox wrote in December, 'the result was that I got a very bad place jammed in close to the stove, and with an uninteresting and difficult view of the models. My brains were so baked by the heat that, after starting three drawings and a painting of the head, all melancholy failures, I cut the whole thing and determined to rest for a day or two and go to work again on Monday with a determination to do something or "bust".' The rivalry of the *concours* extended to the models themselves. Men and women who posed for up to eight hours a day, they won their jobs by taking off their clothes and striking various poses after which the exclusively male students voted their preference.[15]

Following Cox's Parisian sojourn, Jefferson David Chalfant (1856–1931), a self-taught painter of still life from Pennsylvania, embarked on a course of rigorous training in the life class with the famed French academician Adolphe-William Bouguereau (1825–1905) in 1890. In a painting of a studio *concours*, Chalfant delineated the tribulations of student life that Cox described [**9**]. He conveys the sense of claustrophobia that could undercut a student's absorption in the model and empathizes with the helplessness that results from being assigned a poor easel position. He also catches the low hum of contention emanating from the forest of easels surrounding the models, each student gripped, in equal part, by inspiration and competitiveness. Although the painting is determinedly low key, the sexual tension aroused by the raking scrutiny to which the female and male nudes are exposed in the all-male classroom cannot be entirely suppressed.

Philadelphia

In the United States such tensions could escalate ominously in a mixed classroom, as Thomas Eakins (1844–1916) was to find. Having drawn from casts at the Pennsylvania Academy of the Fine Arts from 1861 to 1865, as well as having been enrolled in Jefferson Medical College's anatomy classes for part of that period, Eakins was no stranger to

10 Thomas Eakins

'Male Nudes in Studio', 1880s
Eakins' zeal to be conversant with the mysteries of the human figure included, in addition to the study of the live model and medical courses in anatomy, the use of photography—his subjects often being his male and female students and, on occasion, himself. If finances or public decorum prohibited the use of a live model, such photographs could substitute.

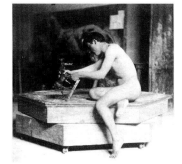

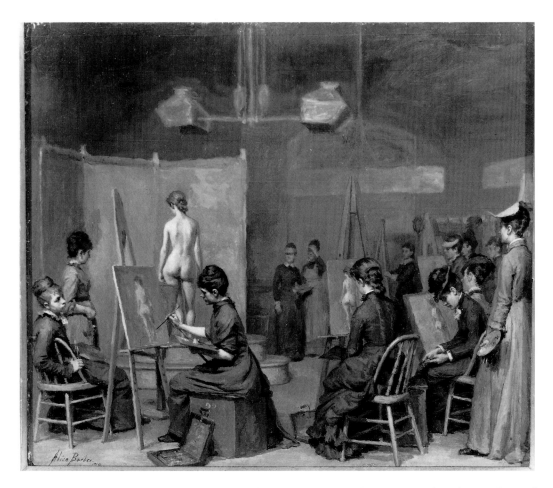

11 Alice Barber (Stephens)
The Women's Life Class, 1879
The demeanour of Barber's colleagues in a Pennsylvania Academy of the Fine Arts life class appears less intense than men observed in similar situations; some of the women do not paint or draw at all but sit or stand in conversational groupings. Their relaxed air and workaday manner dispels the self-consciousness then attached to women looking at the nude body.

portraying the body when, in 1866, he came under the tutelage of Gérôme in Paris. Well regarded as a painter of historical canvases that often featured graphically detailed nudes, Gérôme put Eakins to work on casts for a year but eventually introduced him to painting, rather than drawing, from the live model—a practice Eakins retained in the teaching programme he began at the PAFA when he returned to Philadelphia.

Between 1876 and 1886, Eakins taught every phase of study of the body, his devotion to science as a tool for the artist making itself known in everything from dissecting classes to experiments in capturing movement through photography, though painting from the model was at the heart of his instruction [**10**]. His students were male; on occasion, female. Soon to comprise half the school's enrolment, women students had been offered life classes at the PAFA since 1868 [**11**].[16] At the time, the directors fretted about ways to ensure social proprieties in the studio. When, in one memorable lecture to a mixed class in 1886, Eakins removed the loincloth from the male model, the directors' worry turned to outrage.

Eakins was dismissed, not solely because of this incident but because it brought to a head the dissatisfaction he had provoked among the PAFA's board of directors on many counts.[17] According to one hypothesis, he lost his job because he was (*pace* Trumbull) autocratic—he had treated the PAFA directors on previous occasions as men to be quelled rather than obeyed. In exposing women students to the male nude, he had pushed the directors too far. Another, more interesting, explanation is that he lost his job not so much because he offended women art students by revealing a male nude (there seems to have been no outburst of condemnation from women in the PAFA) but because he offended men. In this reasoning, which gives credence to the idea that one who looks holds power over one who is looked at, women in an art school gazing long and hard at a naked man—naked and so defenceless—obtain a position of dominance over the male body, a situation that insulted men and may have scared them too.

The nude

Learning to draw, paint, or model the nude body does not, of course, imply that an artist will utilize nude figures in his or her work. However, this distinction between practice and pedagogy did not necessarily relieve American ambivalence, not to mention outright censure, about the propriety of looking at or representing nudity at any point in the art curriculum, from instruction in the rendering of anatomy to the exhibition of ideal statuary. Although turning on fraught attitudes towards many things—gender roles and sexuality among them—and with causes and implications obviously too complicated to be addressed here, the difficulties audiences and artists experienced with the nude in art have often been assigned reductively to a 'puritanical' element in American culture, with predictably limiting consequences. Sometimes, historians have even used Eakins' dismissal, which tends to pit the 'progressive' artist against philistine opponents, as a paradigm for all cases in which nudity in American art has been under-appreciated by its audience. Until recently, shifting the 'blame' to the viewer has obviated thinking about any other aspects of the nude's abortive reception.

The Greek slave

Take Hiram Powers' (1805–73) *Greek Slave*, 1843—astonishingly pedestrian in conception and execution but so famous in its own time that it cannot be ignored today. Vermont-born Powers, whose mature career was spent entirely and profitably in Italy, made his name with this softly modelled marble statue based on classical statues of Venus, a use of the Antique recommended by academic precept. In subject she was contemporary: a Christian captured by infidel Turks during the Greek War of Independence, 1822–30. Stripped and chained, the Greek

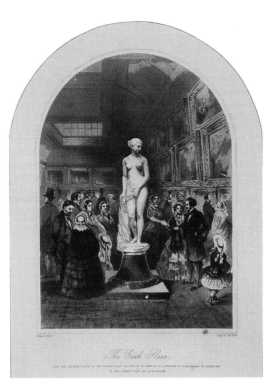

The Greek Slave

woman stands on the block to be auctioned, her virginity imperilled but her modesty intact. Demonstrating, as Joy Kasson comments, 'a finely tuned appreciation for the moral and intellectual context in which his work would be reviewed', Powers equipped the *Slave* with a story that explained how to look at her nudity, that is, by acknowledging she was 'clothed in her own virtue'.

'The Slave has been taken from one of the Greek Islands by the Turks,' Powers intoned, 'in the time of the Greek Revolution, the history of which is familiar to all. Her father and mother, and perhaps all her kindred, have been destroyed by her foes, and she alone preserved as a treasure too valuable to be thrown away ... she stands exposed to the gaze of the people she abhors, and awaits her fate. Gather all these afflictions together, and add to them the fortitude and resignation of a Christian, and no room will be left for shame.'

Thousands saw her. The source of six full-size replicas, dozens of smaller ones, and busts as well, *The Greek Slave* was exhibited at London's Crystal Palace exhibition in 1851, in Powers' studio in Florence, and in towns across the United States. In some places, giving the lie to Powers' denial of her nakedness, women and children viewed the statue on different days than male spectators, but—as an engraving [12] published in the *Cosmopolitan Art Journal* reveals—when men and women looked at the statue together, the fiction must needs be main-

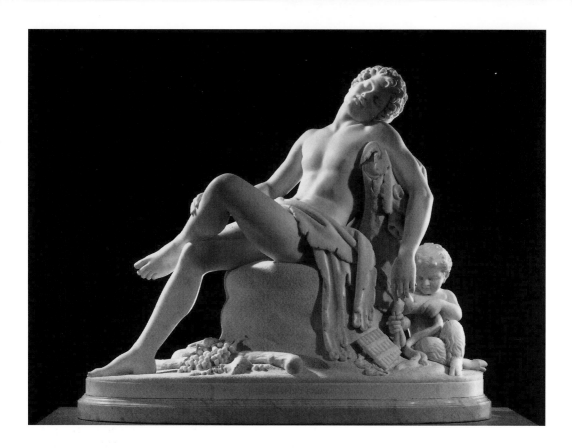

13 Harriet Hosmer

Sleeping Faun, after 1865
In this work, more than any other of her career, Hosmer submitted to the aesthetic dominance of classical sources in Rome, where she lived from the age of 22.

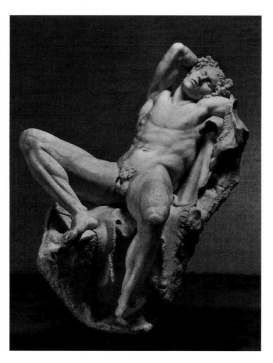

14 Hellenistic

*Barberini Faun c.*200–50 BCE

tained: in the presence of the naked image towering over the audience (it was only 65 inches high), men respectfully remove their hats and are instructed in the *Slave's* moral significance by women, in whose domain belongs the inculcation and regulation of culture and virtue.[18]

Boy nudes

For most of the century, male nudes were even more rare than female nudes and required some form of social management for their public acceptability, a case in point being Harriet Hosmer's (1830–1908) *Sleeping Faun* [13], modelled in 1864. Like Powers' *Greek Slave*, Hosmer's marble—quarried of a fine grade available only in Italy and one of the primary reasons American sculptors resided in Florence and Rome—is tenderly modelled, the planes of figure and face blurry and the musculature pliant. Over-busy with detail, the sculpture seems to want to distract the viewer from the boy's nudity, understandably perhaps, since the statue was based on the lubricious *Barberini Faun* [14], *c*.200 BCE. In this case, what permitted Hosmer's sculpture of an unformed youth to succeed, as did similar boy nudes by other artists including Powers, was a conventional wisdom that denied, or was blind to, the sexuality of immature male bodies.

Self-invention: itinerancy

'Ours is a country', announced an American writer in 1844, 'where men start from an humble origin … and where they can attain the most elevated positions or acquire a large amount of wealth. This is a country of self-made men, than which nothing better could be said of any state.' As John G. Cawelti points out, Americans wrongly believe the concept of, and opportunities for, self-making are exclusive to the United States; it is true, however, that American attitudes toward self-making, assumed to be synonymous with financial success, come near to veneration.[19]

For early American artists, self-making—or its less economically determined twin, self-invention—occurred chiefly in the near absence of training institutions outside the metropolitan areas, and within dispersed market conditions common to many other occupations. Itinerancy marks this phase of self-invention, a key element in the shaping of the artist's professional world in the ante-bellum era. During the century's first four decades, though later examples are not unknown, itinerancy figured as a major component of American enterprise because certain continuing demographics necessitated that the supplier go to the market rather than vice versa, in the rural south and west (which at that time centred in the Mississippi Valley) in particular.[20] Lawyers, doctors, farmhands, ministers, educators, peddlers, and labourers often practised or trained as itinerants; and it's not surprising to find artists among them. After the Civil War, self-making among

15 Charles Bird King

The Itinerant Artist,
c.1825–30

A still life and portrait painter
who worked in Philadelphia
and Washington, DC, King
studied in London with West
from 1805 to 1812; despite its
apparent authenticity, the
canvas is not
autobiographical.

artists responded to a different economic situation, one in which the artist must fit himself and his work to a commodity-driven urban market; display is the watchword of this period. The ingredients for artistic self-invention throughout the century—a gift for dynamic invention, an omnivorous untamed curiosity, a proclivity for adventure and mobility, among them—also constituted prized qualities of American masculinity. This close tie between self-making and masculinity almost precluded acceptance of self-made women artists and presented nearly insurmountable obstacles to the professional recognition of black men (who were prevented from inhabiting, psychically and otherwise, the masculine realm defined for white males).

The Itinerant Artist

Charles Bird King's (1785–1862) *The Itinerant Artist* [**15**] offers a visual artist-narrative that reveals some of the ways a desire to self-invent and a need to work itinerantly mixed—or didn't. In the painting, a travelling portraitist pauses before his canvas with his tools at the ready, the matron of the house his sitter. The sitter's daughters, her female servants, and a slave passively admire the painter's work, while the boys on either side of the room practise carving (whittling) or sketching. A

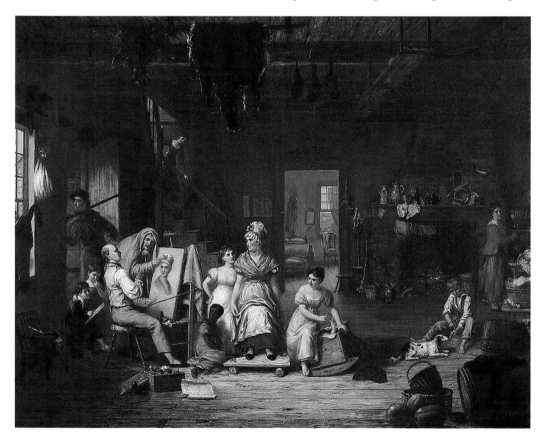

disgruntled man, perhaps an exemplar of American antipathy to the arts, hastens out the door as if to say, 'I'll have no truck with this foolishness!', and an old lady, who stands for know-it-alls everywhere, aggressively kibitzes. The itinerant painter himself testily eyes the rustic mistress perched atop her crude throne as she awaits her epiphany on canvas from the work-worn and plebeian to the indolent and privileged. King himself seems caught on a cusp too, between desire to celebrate his profession and longing to air his chagrin with its actualities.[21]

Thomas Cole

Itinerancy served not only as market resource but also as a kind of initiation rite in the wilderness, an adventurous trial by which a man could be strengthened, or made. Later to be the country's leading landscapist, Thomas Cole experienced vicissitudes as he walked from Steubenville, Ohio, to the state's southern villages, unerringly choosing a route via the only serious hills in that part of the midwest. His contemporary biographer William Dunlap recounted that, although Cole's first day on the road dawned 'bright, like the morning of life', later, 'walking became laborious'; then Cole fell through ice and had to run two miles to the next town where, 'seated by a blazing fire … he felt like one who had overcome all difficulties … so terminated the first day of a journey, in search of fame and fortune.'[22] The aspiring painter gradually came to self-knowledge through the act of his wandering, enabling him to strike out for the urban east, possessed of maturity if not much technical skill. There, after training in an academy, he painted the wilderness, in landscapes filled with all the remembered menace of the forest.

The allegory of Cole's wilderness ordeal derives from another, even more transparent model of artist-identity, one that was constructed by historians and that blended self-invention (with itinerancy implied or explicated) and professional training. In numbers significant enough to matter, artists' biographies in the first half of the century followed this pattern: a boy of humble origin reveals a gift for art in some homespun way, maybe by drawing with a bit of charcoal on the hearth; he reaches maturity and begins to learn his craft, sometimes on the road and sometimes under a local practitioner; by dint of diligent self-improvement, he attains recognition and perhaps attends an academy in the United States or, more often, abroad; he ends his career as a respected, professional, American artist.[23] In addition to the absence of women from such artist-narratives, one other feature of the story descends from European tradition, first laid out by the Renaissance biographer and painter Giorgio Vasari (1511–74): artists-to-be from Giotto (1267–1337) to Thomas Cole give off a glimmer of their greatness in childhood. The remaining elements—journeyman beginnings, especially on the road, leading to the eventual success of the self-made

16 Anon.

Harriet Hosmer's Studio in Rome, Visit of the Prince of Wales, *Harper's Weekly*, 7 May 1859

On a March 1859 visit to Hosmer's studio, Hawthorne and his wife, Sophia, found 'the bright little woman hopping about her premises. … She has a lofty room, with a sky-light window; it was pretty well warmed with a stove; and there was a small orange-tree in a pot, with the oranges growing on it, and two or three flower shrubs in bloom.' Hosmer's patrons included, in addition to British aristocrats, the Czar of Russia and several lesser crowned heads of Europe.

man—are peculiar to the United States, as is the paradox implicit in the equal weight given to both academic training and self-teaching as professionally formative.

Harriet Hosmer

If women do not figure in such narratives, they could nevertheless be well served by them in the United States. It was not unusual for women to be excused for their anomalous behaviour in becoming artists if their development could be accounted a form of self-making, circumspectly male-inflected. Harriet Hosmer, for instance, cultivated amateurism and a boyish/girlish demeanour. She grew up, Tuckerman reports, 'vigorous in body', 'untamed', 'full of boyish freaks'—all of which gave a context to, and permission for, her early work in sculpture. From St Louis, where she travelled to obtain the anatomy instruction denied her in her home state of Massachusetts, Hosmer made an unchaperoned trip to the far west and climbed 'to the summit of what was deemed an inaccessible bluff'. When she went to Rome in 1852, where she spent the rest of her professional life, it was as a student whose formation paralleled, in point of distances covered and trials faced, the wanderings of some of her male colleagues.[24]

Studio display

In her Roman studio, a favourite stop for tourists and collectors, including the Prince of Wales and the Czar, Hosmer played to tomboy type. When novelist Nathaniel Hawthorne (1804–64) met her there in 1858, he thought her quite winning, 'though her upper half is precisely that of a young man'—by which he meant she wore male attire—and concluded, 'on her curly head was a picturesque little cap. There was

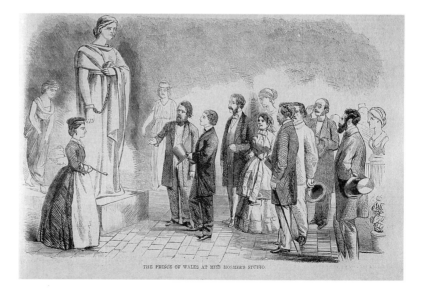

THE PRINCE OF WALES AT MISS HOSMER'S STUDIO.

never anything so jaunty as her movement and action.' [25] Perky, youthful, and a success, Hosmer sold her work directly from the studio. As were most studios in Rome and Florence, Hosmer's rooms were both sales gallery and workplace, stocked with clay models, plaster casts, and finished pieces of marble, the latter carved by the 20 or so workmen she employed [16].

Because guidebooks frequently published the names, addresses and specialities of the international artists in Rome, and because the market in replicas so flourished that copies of selected items became requisite for a steady income, sculptors' studios tended to resemble warehouses, chock-a-block with stone bodies. To a lesser extent, sculptors' studios at home maintained the same outlines, and neither varied much throughout the century. In contrast, the appearance and purpose of painters' studios underwent something of a revolution, from the mobile base of itinerants or the simple rooms of stationary artists at the beginning of the century, to elaborate stages designed for (self-)display in the post-war era. These studios, at home and abroad, were dressed up to look like jewellery boxes, *cabinet des curiosités*, seraglios, even museums, to entice and impress prospective buyers. The enticing part was, naturally, important, but so was the element of making an impression, since it turned on efforts by artists to comply with an emphasis on business acumen prevalent among Americans in the latter part of the century.

William Merritt Chase

Among American artists whose work holds some claim on Impressionism through the colour and bravura brushwork of sunny landscapes, William Merritt Chase (1849–1916) also ranks as a master of interiors, which can sometimes glow like jewels. His special talent in the latter realm was to recreate the painter's habitat. *In the Studio* [17] is filled with 'artistic' trappings—rugs, wall hangings, bric-à-brac, paintings, flowers and plants, casts, copies, and a model. Wearing a strikingly old-fashioned dress, the woman becomes one more precious object among many. Consumable as well as consumer, she is engrossed in a portfolio of prints and drawings. In other instances Chase pictured himself painting, drawing attention to his luxuriant moustache and goatee, worn in a style not coincidentally called a 'Van Dyke'. Although, on occasion, Chase included an unfinished canvas in these interiors, his craft, like its product, merged with the decorative ambience. So, for example, Chase frequently positioned amid the bric-à-brac a vase filled with paintbrushes: ironic flowers, not tools.

In the circles in which Chase moved, expensive and beautiful things were very nearly sacralized. Small wonder that the Metropolitan Museum of Art in New York, the Boston Museum of Fine Arts, the Philadelphia Museum of Art, and the Art Institute of Chicago—all

18 William Merritt Chase
Tenth Street Studio,
c.1881–1910
Chase's studio scenes enlist
the artist as purveyor of his
own economic well-being.

founded in a single decade, the 1870s—were acclaimed as 'temples' of the beautiful, 'palaces' of art. Chase aimed himself directly at their worshippers, their courtiers. What *In the Studio* and another, similar, painting, *The Tenth Street Studio* [18], imply is that both he and his audience are cosmopolites, collectors, tastemakers.

Perhaps such urban sophistication could only have been imagined by a provincial. At 20, in 1869, Chase had shaken the dust of Indiana from shoes soon to be protected from Manhattan's mud by expensive leather spats. Six years' study in Munich (1872–8) were succeeded by a triumphal return to New York to teach at the new Art Students League. He became the foremost painting instructor in the country, a long-time president of the breakaway Society of American Artists, and a member of another rebel group, The Ten.[26] In 1896, hostage to the expenses necessary for the display of his image as a patrician artist, and despite critical success, he had to auction off the contents of his rooms in the Tenth Street Studio Building [19]. The sale went so poorly that Chase threatened to live abroad, where, one of his friends commented, he would be able to contrast 'the beggarly recognition accorded him outside of the profession with the splendid treatment of men occupying a similar position in London, Paris, or Berlin'.[27]

Collecting Asian art

The fittings of Chase's studios included Japanese screens and Chinese porcelains, signalling that the painter, like a large part of the western art world at the century's end, admired what was then known as 'Oriental aesthetics'. East Asian art became known in the United States through a variety of means, one of which was trade. In addition to the investment of American business abroad, international expositions—like the Philadelphia Centennial in 1876, and the 1893 Chicago World's Fair—brought the architecture and decorative arts of Japan in particular to public appreciation, although the press condescended only slightly less to the 'little brown men' of Japan than to the 'yellow menace', as Chinese people were scurrilously labelled.

The first department to specialize in Asian art in an American museum (the Museum of Fine Arts, Boston) was devoted to Japanese art. Appointed in 1890, its curator was Ernest Fenollosa, an American-born Buddhist scholar and connoisseur.

Fenollosa met Charles Lang Freer, a Detroit industrialist, in 1901. Initially a patron of American and British painting and graphics, including James McNeill Whistler and George Inness (see Chapter 5), Freer had begun to acquire Asian art in 1894. With Fenollosa's advice (and despite his frequently expressed concern that western money might depreciate the Asian cultural patrimony), he purchased some of the finest objects ever to enter the United States. In 1904, Freer offered his entire collection to the nation, transferring more than 9,000 pieces to Washington by 1920. The Freer Gallery of Art, opened in 1926, was the first fine arts museum in the Smithsonian Institution complex.

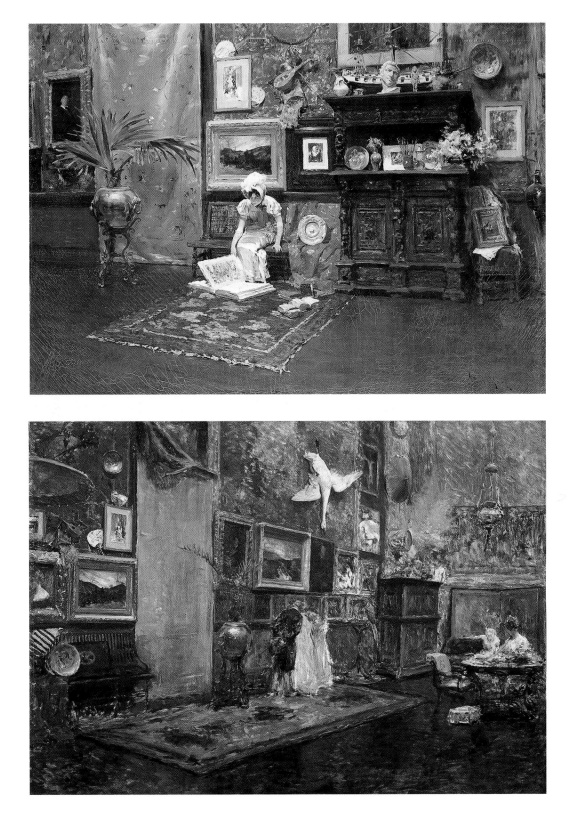

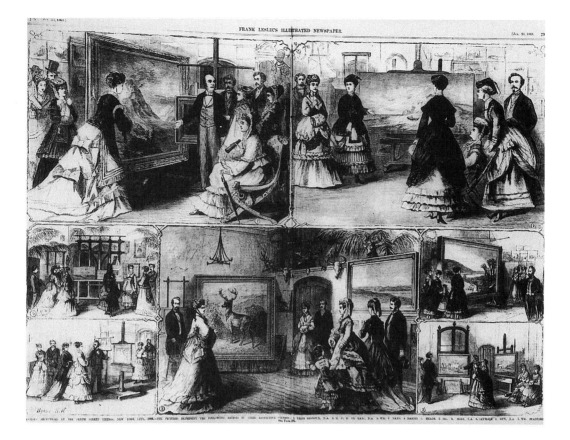

19

Receptions at the Tenth Street Studios, 1869, Frank Leslie's *Illustrated Newspaper*, 29 January 1869

The idea for a studio building, with all the rooms given over to painters and sculptors, may have originated in Rome, where guidebooks listed the city's international artist population by building, and publicized the calling hours of individual artists. Prospective patrons could view an artist's work in the studio or in a designated exhibition area in the New York complex.

Chase consciously fashioned his artist-image, evolving from a youthful, workmanlike painter to a public figure in the arts; his midwestern roots, perceived as wholesome, raised him above the suspicion of degeneracy which fell upon other fancy-dressing men of more eccentric habits, the art-for-art's sake aesthetes. Viewed as an import, in the main, from Europe, art for art's sake was associated with Oscar Wilde (1854–1900), who visited the United States in 1882 and, Sarah Burns writes, 'symbolized what was most feared for artistic maleness at the century's end', namely, effeminacy or homosexuality. Such biases had little to do with art production, being mostly centred on anxieties about possible decadence induced by beauty and replete with dark thoughts about sexual licence within the unconventional artistic milieu. In 1895, when a photographer's model disappeared after a racy dinner with artists and patrons, during which she had toothsomely emerged from a pie, Burns notes that New York newspapers charged that 'bacchanalian revels' took place in 'fashionable studios', exploiting poor young girls who were subject not only to the leers of artists when employed as models but to their depredations in erotic after-hours.[28] In the artist's studio, foes of aestheticism feared, display could have more than one meaning.

Looking at the changes in the artists' professional world over the decades—the establishment of academies and other institutions for the encouragement and support of the arts, the adaptation of artists themselves to different market conditions—it seems clear that external conditions for the professional artist had markedly improved since Copley enumerated the disadvantages of living in North America. Still, Chase's friend believed, as did West and Copley a century earlier, that Europeans esteemed artists and Americans did not. Only specific circumstances in particular cases can be a reliable gauge of something so nebulous yet crucial as prestige. That, and, as the following chapters will demonstrate, accomplishment.

Portraiture

2

In the decade before American independence, John Singleton Copley's complaint (see Chapter 1)—'was it not for preserving the resembla[n]ce of particular persons, painting would not be known in [Boston]'—could have been made about conditions of patronage in any of the North American colonies. Despite his own pre-eminence, Copley decided in 1775 to give up a lucrative career as the east coast's favoured portraitist in order to experience the greater variety of patronage and opportunity in England. He never returned. Nonetheless, the profession he and his predecessors did so much to foster in the colonies thrived. This led Gilbert Stuart (1755–1828), as renowned as Copley among the next generation of portraitists, to remark sarcastically, 'By-and-by, you will not by chance kick your foot against a dog kennel, but out will start a portrait painter.'[1]

It's possible, then, to think of portraiture as America's first art, in time, and, on occasion, in repute. What made portraiture so appealing to patrons in the United States applies to the genre as a whole: whatever their formal impetus or merit, portraits secure or mark social position, endorse fame, chronicle genealogical distinctions, and rehearse personal memory. Of all types of painting, it is the least likely to be executed without a commission. In this chapter, I include a range of portraiture's formats and media, from full-length to bust, in oil and in marble. This is less an exposition of stylistic development or an enumeration of standards than an enquiry into some of the historical conditions that make portraiture produced in the United States intriguing. One such historical condition finds portraiture operating within a democratic social system that seeks to define itself in ways that accommodate impulses to status-seeking and egalitarianism both: portraiture, like other social and economic relationships, helped to map paths of class and gender containment through the maze of the New World's democratic garden.

Early on, American artists frequently complained of being stifled by their patrons' insistence on mimesis to the exclusion of all else, and sometimes scorned them for it. Stuart growled that, in England, his portraits had been 'compared with those of Vandyck, Titian and other

great painters—but here they compare them with the works of the Almighty'. Of course, resemblance (sometimes called referentiality) is a paramount goal of portraiture in most western cultures. Testimony from various sources (painters to patrons), however, suggests an exaggeration of that desire in the young nation until well past mid-century. On the other hand, there is always a complex exchange between personal likeness and class ideal that Paul Staiti's assessment of Copley's best portraits—they demonstrate 'not his descriptive technique alone but [his] unsurpassed ability to reify the bourgeoisie's mythic perception of itself'—illuminates [20]. An extraordinary artist like Copley understood that status is 'a projection, not a possession', dependent upon accompanying material objects which produce meanings that reach beyond physical likeness while—and this is the tricky part, why genius is necessary—appearing to be merely auxiliary to that likeness.[2]

In order to address what is at stake in the balancing act performed by artist and collaborator–patron in weighing referentiality and what might be called materiality, this chapter first examines some of the distinctive ways American portraitists went about their business at home and abroad. A second line of enquiry looks at circumstances governing portraiture's terms of reference in its social roles in relation to body protocol (or codes of decorum) as well as gender and age models.

The business of portraiture

Nineteenth-century American portraits belonged to a proliferating material culture that itself formed one facet of the kaleidoscopic reshufflings of social and economic structures that enlarged the range

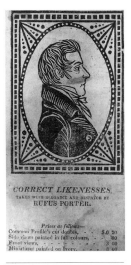

CORRECT LIKENESSES,
TAKEN WITH ELEGANCE AND DESPATCH BY
RUFUS PORTER.

Prices as follows—
Common Profile's cut double, - - . $0 20
Side views painted in full colors, - 00
Front views, - - - - - - 3 00
Miniatures painted on Ivory, - - 8 00

21 Rufus Porter
Handbill, 1820–24

of persons who could reasonably be painted. From 1800 to 1850 what one historian has called 'a very real democratization of the constituency for portraiture' spurred painters of portraits in oil, their work complemented by an active, talented cadre of miniaturists, men and women whose inexpensive and accessible productions were diminished and, eventually, eclipsed following the introduction of commercial photography.[3] In the second half of the century, portraiture in oil, marble, and bronze served a smaller but not inconsiderable constituency.

A journeyman

Early on, demand created supply and set prices, with highly trained artists being paid handsomely for even small canvases and substantial sums for large showpieces, while a growing flock of journeyman painters charged amounts commensurate with their local reputation and their outlay for materials. A jaunty New Englander, Rufus Porter (1792–1884), distributed a handbill [21] laying out the fare for '*Correct Likenesses*', and swearing, 'No Likeness, No Pay'. Cheap in price his portraits certainly were, and his turnover was unbeatable: a homemade camera obscura enabled the itinerant Porter to make a portrait in as little as 15 minutes.

Since his (seldom *her* in the itinerant trade) patron might pay for canvas and paint, the travelling portraitist made available more than one grade of material. Supports could be anything from wood panels to bed ticking or linen. Itinerants reluctant to tarry could even leave sitters with instructions on how to varnish their own portraits after the oils dried. Likewise, patrons chose from a variety of formats, with corresponding price scales: bust-length, 'kit-kat' (midway between bust and three-quarter), half-length (with one hand, with two, with accoutrements), three-quarter and full-length. The woods were full of enterprising itinerant artists like Porter (when landscapist Thomas Cole was beginning his career in the 1820s by walking from town to town, he tried out 'heads'). They had to carry most of the necessary equipment, and it must have been a relief when a transportable, collapsible tube for paints was invented in 1841 by a little-known American artist working abroad named John G. Rand.[4]

A rising professional

As the nation's cultural opinions matured, portraitists began to be expected not only to provide viewers with grounds for discriminating a sitter's rank but to certify themselves socially as well, for rank mattered in the collaboration between sitter and portraitist, especially among cosmopolitan audiences. Artists occupying a higher station than their sitters were perceived as boosting the sitter's prestige, though the opposite situation did not do as much for artists. To be sure, artists could achieve social credibility for professional reasons.

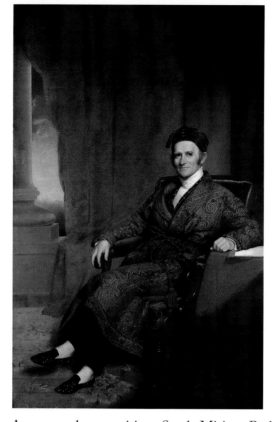

Among early portraitists, Sarah Miriam Peale (1800–85) came not only from an impeccable artistic lineage (her father, uncle, and cousins were painters) but from an urbane family on terms of familiarity with George Washington (1732–99), the country's nearest thing to a celebrity. Thomas Sully (1783–1872) offered his patrons whatever cachet might accrue to artists trained abroad and, in his case, that appears to have been substantial. At the very least, sitter and artist were expected to meet on common ground. But for scores of provincial would-be portraitists, associating with the kind of people who commissioned portraits, even those who themselves lived in the provinces, entailed a stretch.

Chester Harding (1792–1866) possessed no economic or social advantages, yet even during his journeyman years, he had ambitions that surpassed Porter's wayfaring life. He grew up poor in rural New York and marked his twenties by failing in several attempts to support himself. Arriving unpropitiously with his family in Pittsburgh by raft, he set up as a house painter, a sign painter, and ultimately—as if by natural progression—a portraitist. Around 1819 he moved to Paris (Kentucky) to bolster his career, an excellent choice as it turned out because, as he explained, 'My price was $25, which to the highminded Kentuckians was a trifle. … In this small town I painted near a hundred heads.'[5]

With the money he made, Harding spent two months of 1819 in Philadelphia, mostly looking at paintings, though with some tutelage at the Pennsylvania Academy of the Fine Arts, his only formal instruction. The next year the artist sought out Daniel Boone (c. 1734–1820), whose exploits as a backwoodsman had been well publicized. Harding's increasingly entrepreneurial skills were realized in marketing one of his two portraits of Boone as an engraving. By the time he moved to Boston in 1823, his home-grown charm, salesmanship, and ability attracted a large clientele, so that when he travelled to London the same year it was as professional artist more than student.

Even at his most suave, however, Harding retained an artisan's mentality. In his portrait of Amos Lawrence [22], for example, Harding's palette is rich and varied, the lighting complex, and the sitter proportionally suited to the canvas. The textile manufacturer sits in front of a majestic cloth swag that exposes an equally majestic column, both items near obligatory portrait accoutrements of status. He wears the highly fashionable attire of a gentleman at home, reminiscent of many a merchant's portrait of the preceding century, and in keeping with the additive fashion of colonial art, the finely worked details of Lawrence's robe stand out, insubordinated to the general effect. Harding's sitter isn't easy in his body (a consequence of the treatment that pushes Lawrence's head a little too forward of his neck), curls his hand rigidly, and positions his legs stiffly. While the painter has clearly worked from a learned knowledge of class, he lacked the ability to fuse Lawrence's person with his material possessions.

The portrait sculptor

Although busts inhabit the margins of portraiture's history and in sculpture itself play merely a supporting role to the central drama of statuary—that is, large-scale commemorative or subject-orientated pieces—virtually every well-known American sculptor spent some part of a professional career sculpting heads. ('Supporting' applies literally as well as metaphorically, incidentally, since these commissions were more readily obtainable and constant, if less lucrative individually, than patronage for monumental statues. Portrait busts brought many an artist a long way, both geographically and economically.)

An example is Powers (see Chapter 1), who began as a journeyman making clock mechanisms and waxworks. Upon his move first to Washington in 1834 and thence to Florence in 1837, Powers became pre-eminent among portrait sculptors in marble, his residence in Italy in fact predicated on the need to be assured of carvers and stone for the busts and ideal figures he modelled in quantities. If anything, Powers' patronage increased abroad, since an Italian location attracted a class of wealthy Americans for whom a European origin guaranteed art's aesthetic credentials.

23 Hiram Powers

General Andrew Jackson,
c.1835

The seventh President,
Jackson was the first Irish-
American to serve in that
office. His famously hard-
bitten features and his age are
emphasized by Powers' bust.

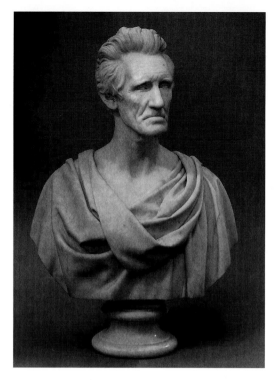

24 John Quincy Adams Ward

William Hayes Fogg, 1886

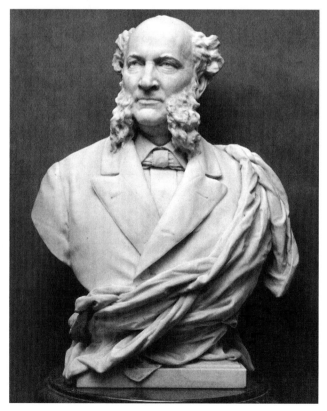

What complicates portrait sculpture is the way its reifying physicality overwhelms other considerations for the viewer. Without setting, accessories or other narrative devices common to painted portraits or full-scale sculpture, the bust carries its revelatory burden chiefly in the sitter's face. Physical likeness is confused with 'realism' and enlisted in European and American debates concerning sculpture's goals, while the rewards of contemporaneity versus the value of timelessness are exploited in the meagre elements available for expressive manipulation in a portrait bust—mostly eyes, hairstyle, and attire.

It wasn't just the trappings of his Florentine studio that elevated Powers in his sitters' esteem. Rather, he was able to gratify the insistence on likeness that runs through the American sculpture of the nineteenth century, its makers and its consumers, as a distinctively American characteristic, and to do this even while vacillating on the question of timelessness versus contemporaneity. While in the United States, Powers appeared to have chosen the former in his famous bust of President Andrew Jackson (1767–1845), whose craggy, weather-beaten features—so homely everyone assumes they could not be made up—sit atop a classicizing Roman drape [23]. Later, however, Powers decided he should take 'the actual costume of the age and [do] his best with it'. It wasn't much. When he visited Powers' Florence studio in 1858, Nathaniel Hawthorne protested, 'though [present] costume might not appear ridiculous to us now … two or three centuries hence, it would create … an impossibility of seeing the real man through the absurdity of his envelopment, after it shall have entirely gone out of fashion and remembrance …'.[6]

In looking at marble portrait busts from later in the century, the viewer may feel some regret that Hawthorne's adjurations generally went unheeded in American and European sculptural circles. In the United States the mania for actuality resulted in busts like that of William Hayes Fogg, 1886, by Ohio-born sculptor John Quincy Adams Ward (1830–1910), which reproduces not only ineffably mundane Victorian male clothing but also facial hair that could only be plausible at the moment of its fashion [24]. Restrictions of space prohibit exploration of portrait reliefs in bronze, which attracted some visible patronage at the end of the century, but conscience bids mention of their existence as an antidote to marble's potential for deadening factualism.[7]

Portraiture's sidelines: ethnography

In the annals of portrait patronage, little notice is bestowed upon those people—chiefly Native Americans—whose likenesses were taken not always as a result of their own commission or even desire but that of others. Such groups may show up in portraiture because they are helpless not to. This does not mean that coercion was employed; on the

CHIEF RED-CLOUD.
SIOUX.

25 Elbridge Burbank

Chief Red Cloud, 1899

A Sioux chief renowned for his integrity and rigour, Red Cloud held the government to its treaties with his people. He is shown here old, blind, and palsied, but with none of toughness lost.

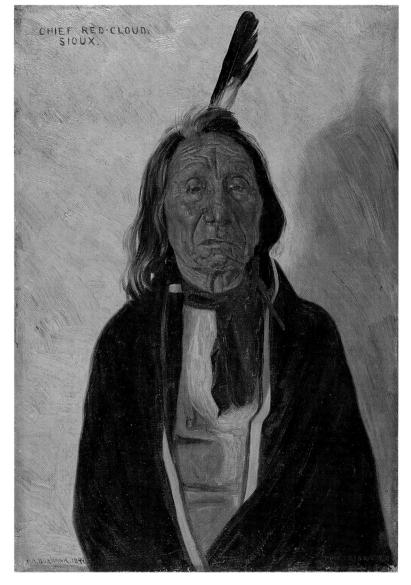

contrary, in regard to the most aggressive of such projects—like Elbridge Burbank's (1858–1949) grand scheme to portray individuals of every tribe living in the American West—written evidence confirms that the subjects collaborated with the artist.

Burbank's patron, Edward Ayer—first president of Chicago's Field Museum of Natural History, the artist's uncle, and an anthropology enthusiast—initially sent Burbank to the Oklahoma Territory in 1897 to paint a portrait of the famous Apache, Geronimo (*c.* 1829–1909). Deciding to remain, Burbank persuaded Ayers to fund an ambitious course: he eventually recorded more than 1,000 Indian sitters. The project generated portraits as cultural and historical documents not of

individuals but of racial types. Adopting principles of a branch of ethnography known as 'salvage ethnography', the painter labelled his canvases on the front with the sitter's name, tribe, location, and date [25]. Burbank combined this 'scientific' embellishment with overbearing visual scrutiny, creating portraits in oil that resemble the so-called 'physical type' photography used by anthropologists at the turn of the century.

Portraiture's social purpose

Given the range and scope of the work portraiture does in many cultures, not just American, from recording important biographical information for families to setting forth the features of honoured statesmen for the nation or serving 'science', what is interesting about portraiture in the United States is how the business of social confirmation is transacted aesthetically. In what follows, canvases demonstrating the intertwined portrait destinies of gender and class in regard to white women and girls of privilege—chosen because they are subjects for whom visual display was synonymous with class definition—are addressed chronologically. At the end of the century, the heterodoxy of a master painter, Thomas Eakins, intervenes in this survey, and, among other things, overturns the expectations it creates.

The ante-bellum era
In addition to the obvious hallmarks of a materially profuse culture, including but not limited to neoclassical furniture and dress, *Family Group in New York Interior* [**26**], by French-born François Joseph Bourgoin (dates unknown), evidences details of behaviour that supply

26 François Joseph Bourgoin

Family Group in New York Interior, 1808

Signed and dated, this portrait is the only one readily attributable to Bourgoin, an academically trained painter driven to the New World around the time of the 1789 French Revolution; its social and aesthetic value nonetheless outweighs its singularity.

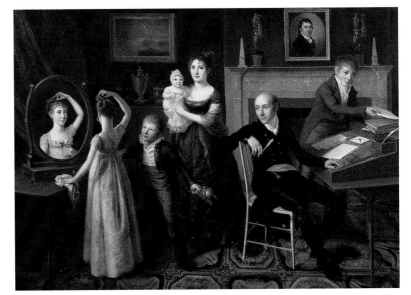

clues to who, in a social sense, the family was. The manner in which Bourgoin depicts his sitters' activities and their implied relationship to each other and to their house set a standard for the remainder of the century in the ability of portraiture to register, along with likenesses, evolving family dynamics and fashions in material culture. For instance, the father's desk, covered with what appears to be correspondence and ledgers, agrees oddly but not uncomfortably with the *toilette* taking place opposite, perhaps because the combination seems set up to display warm parental involvement with children concomitant with the father's less intrusively patriarchal role, a new feature of family life.

Still, it is the arresting mirrored image of the golden-gowned daughter that controls the picture visually. Nexus of gazes, the girl is central to the portrait [see chapter opener image, page 34]. Her transition to womanhood is announced in her upswept hair and adult frock, and the flower offered as ornament. Poised on the brink of her new status as a young lady, she smiles slightly yet knowingly. Since in the history of western painting, mirrors often reflect Venus' provocative gaze, it is not surprising to find that something like dawning sexual awareness glints in her eyes. In contrast, her older brother, to the right of the group, has already become a part of the adult world and, for males from the class to which this family belongs, that meant business. Dressed like his father, he is absorbed by the paraphernalia of the desk and turns away from the others. Only the baby, whose gown was the customary attire for both genders, and the small boy, whose 'hussar suit' sartorially demarcates the passage for males between infancy and adolescence, linger in the protected space of childhood, at play.[8]

Comparison with a portrait group by Philadelphia's leading artist in the late eighteenth century, Charles Willson Peale (1741–1827), throws into relief the variations on family portraits Bourgoin's picture introduced. In *John Cadwalader Family* [**27**], Peale depicts a wealthy Philadelphian and supporter of the arts, standing close to his wife and daughter, his most conspicuous feature being a generous belly in profile. The swell of his torso no less than his bent head directs attention to the peach he hands his daughter. Dominant as design and as actor, Cadwalader belongs to his times as a patriarch to whom the other family members are subordinate. The baby, absorbed by the proffered fruit, and the mother, who gazes fondly, if complacently, at her husband, form a tight circle, which is not a little suggestive of Holy Family images and is indicative of what Diana Strazdes calls 'the sovereignty of informal intimacies in domestic life' during this era. Only Cadwalader's hat recalls a world outside, for, despite the dressiness of the family's clothing, the single piece of furniture, a card table, refers to the privacies of their home, as does the studiedly incidental moment.[9]

Bourgoin's New Yorkers stand on the threshold of a century soon to be tested by momentous change, a platitudinous phrase, unfortunately,

but one accurately gauging the metamorphosis of social, spiritual, and physical existence for people in the United States that began in the early nineteenth century and gathered steam over the succeeding decades. Differences in living conditions—from a materially subsistent, mostly rural and comparatively homogeneous citizenry to a consumer-minded, heavily urban and more diverse population—furnished the most apparent changes. The real alterations did their work in less immediately observable ways. Economic and political confidence attending the successful end of the Revolutionary War of 1812 powered an incipient (and international) market revolution that, for the purposes of this discussion, can be deemed transformation's catalyst and consequence in the United States. A potted history, which touches neither on complexities nor on effects, goes something like this: the country moved from local, agricultural, subsistence economies to an industrial economy dependent on efficient transportation, a two-tiered workforce divided between the managerial–skilled sector and unskilled labour, and consumers who could be persuaded to buy from a hugely increased supply of goods. Works of art can be thought of as part of this commodity eruption. Objects that register some of these changes as they occur in the passage of time, they also should be recognized as agents that both promote and embody social expectations.

For example, even if viewers were confined only to the family's visitors, the depiction in their parlour of such well-to-do, attractive, and proper inhabitants as Bourgoin's New Yorkers lent credibility and, more important, desirability to ideas about the American home and its contents. Bourgoin's canvas is less a painting for the parlour than of it. Previously, ordinary sitting rooms served as a repository of materials associated with domestic comfort, entertainment, and relaxation that became increasingly available over the century. Parlours descended from drawing, originally *with*drawing, rooms required for the private moments of European nobility forced to spend a good deal of time in public. Throughout most of the eighteenth century only the genteel ruling elite—in Europe and the colonies—possessed such a chamber, but after the War of Independence, the polished and elegant manner of life that parlours signalled was gradually appropriated by a nascent middle class that considered itself licensed to democratize the aristocratic monopoly of gentility. Refinement, which is what Richard Bushman calls the condition of gentility's enlargement and dilution in the United States, typified the cultural behaviour of the American middle class when this class emerged more fully in the economic order.[10] Parlours in the American home, and depictions of parlours, were to be emblematic of this broadening of social power.

Social historians have long agreed that portraiture helped to index middle- and upper-class social conventions regarding gender and any changes therein. But it wasn't an infallible guide: ambiguity of role

clouds the otherwise pure luminosity of the mother's portrait in Bourgoin's canvas. A beautiful woman, her spotlit and hieratic position ought, like her looks, to draw the viewer's eyes. Instead her dark gown and passive stance diminish her presence. She alone has no accessory, except her baby. These details make for uncertainty in defining her place in the family. Is she a matriarch: nurturer, educator, domestic manager, and social guide? Or is she an appendage to her spouse, a convenient and prescribed armature for infants and, like her children, subordinate to her husband, the provider and patriarch? Both of these roles as well as modifications of these extremes were possible for women in the nineteenth century, of course, though the matriarchal model waxed strongest as the decades passed.

To follow portraiture of socially conscious young women beyond Bourgoin's charming delineation of femininities leads one to a consideration of sexuality, included in gender construction but not exclusively constitutive of it, which can expand portraiture's systems for production of meaning. In later paintings it is possible to find nuanced alterations of the sexual subcurrent that flickers in the eyes of Bourgoin's young girl; a subcurrent, to be sure, usually suppressed—by female as well as male painters—but sometimes definitely aglow.

Thomas Sully's *Lady with a Harp: Eliza Ridgely* [**28**] seems to be one such portrait, an instance in which art is utilized to reveal not only

the sitter's entitlement to genteel accomplishments and embellishments. To begin with, however, the impression that all the charms of this portrait are on its surface, given the fluidity of Sully's paint and the gloss it lends to satin and skin, requires getting around. Sully was one of those painters, like his Boston tutor Gilbert Stuart—and their British colleague and mentor Sir Thomas Lawrence (1769–1830)—whose brushwork glides seemingly without effort or even will. Such a technique, with its potential for eliding physical flaws, frequently attracts a socially ambitious clientele with aspirations to glamour. Small wonder Sully was Philadelphia's leading painter in the first half of the century, producing more than 2,000 portraits.

Yet it is clear that *Lady with a Harp* goes beyond mere decoration. And Eliza Ridgely's sexuality doesn't preclude refinement; it's coated with it. The harp, as William Gerdts has noted, pre-eminently figures an idea of Woman: it swells in curves; its sound is melodious, soft, sensual, and calls on the emotions rather than the mind.[11] One might also observe that the manner in which a harp is clasped, intimately, by the performer, implies an embrace by proxy. For all her idealized, porcelain-like facial features and restrained manner, Miss Ridgely's robust body, broad-hipped and long-legged, fairly exudes sexual potential. Although he received little in the way of formal instruction from Stuart,

28 Thomas Sully

Lady with a Harp: Eliza Ridgely, 1818

29 Gilbert Stuart

Mrs George Plumstead, 1800
During his 12 years in England
(1775–87), Stuart was
frequently compared to, and
even confused with, his British
colleagues, especially Thomas
Gainsborough. In the new
United States, he painted
more than 1,000 portraits.

Sully's trick of simultaneously bringing forth and suppressing sexuality in his subjects binds him to the older man as closely as the freely painted surfaces they have in common. Stuart's portrait of Mrs Plumstead [**29**], for instance, joins her cloud-like mass of powdered hair and high colouring in support of her sloe eyes to insinuate, rather than announce, all that was sensual in this fashionable and wealthy young matron.[12]

By Eliza Ridgely's time, with the market revolution's new money fuelling at least the outward trappings of refinement, membership in a class above the very lowest orders entailed a claim on the authority and privileges of a perceived ruling elite by means not only of greater access to objects but also of attainments in deportment. In the early nineteenth century, the rules of deportment by which one part of society distinguished itself or defined its roles within a social segment ordained the correct way for women and men to stand, speak, listen, cough, sigh, laugh, go to the opera, or board a public conveyance—everything, in short, required to act, in public or private. Hence, the item of furniture on which Anna Maria Smyth apparently comfortably sits in her 1821 portrait by Sarah Miriam Peale [**30**] is a hideously unyielding but stylish 'hard' sofa, and the most obvious sign of the assimilation of deportment's code is the ease with which Miss Smyth holds herself.

Etiquette books advised young women on the suitable disposition of hands, carriage of head and shoulders, and facial expressions in various circumstances, though it would be unwise to assume that those who read these manuals practised blanket adherence to their strictures. In the event, Peale's likeness of Miss Smyth mixes public and private, a

public audience, however limited, of this family portrait being addressed in the presentation of the sitter. Her understated jewellery, modest gown, and candid gaze impart an air of sensibleness in contrast to the highly glamorized Eliza Ridgely, but both portraits, the homely as well as the grand, served to exhibit on some level the eligibility of the highly refined subject. As Catharine Beecher explained in the ironically titled *Truth Stranger than Fiction* (1850): '... woman is educated to feel that a happy marriage is the summit of all earthly felicity ... she is trained ... to make it appear as if it was a matter to which she is perfectly indifferent, and such is the influence of custom and high cultivation, that the more delicate, refined, and self-respecting a woman becomes, the more acute is the suffering inflicted, by any imputation of her delicacy in this respect'.[13] In the broadest sense, this behavioural prescription was in force for the century, sometimes covertly.

The 'Gilded Age'

Over the course of the century, American portraiture's social work continued even as its stylistic model shifted. Through training and travel abroad, artists maintained close ties to European portraiture, but the sway of British influence was replaced by French and, to a lesser extent, German art. The work of portraiture also changed in the degree to which the culturally phenomenological element of display was circulated. At century's end, increasingly ostentatious self-advertisement, not only of privileged material environment but also of cultural

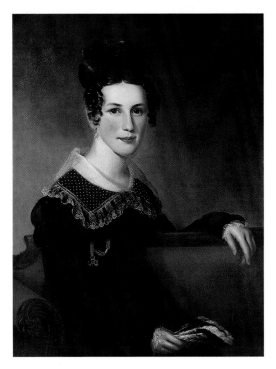

30 Sarah Miriam Peale

Anna Maria Smyth, 1821

Peale learned to paint within the confines of her talented family. One of the few women portraitists in the early part of the century, she spent the latter part of her life in St Louis, where she was among a number of women for whom portraiture had become an accessible profession.

hegemony and even philanthropic activity, appeared in exceedingly visible ways, harking back to the colonial era's candour regarding social hierarchies and the accoutrements of wealth. Turn-of-the-century portraiture of an economic elite contributed to the normalization of what, in the republican simplicities of the early 1800s, might have been considered egregious.

Mark Twain and his co-author Charles Dudley Warner called the decade following the Civil War a 'Gilded Age' because swankiness prevailed over grandeur. Severe depressions, including but not limited to the nadirs plumbed in 1873 and 1892, merely hobbled the swagger. France, caught up in a cycle of boom and bust urged on by colonial expansion (deflected only momentarily by its loss to Prussia in 1872), enjoyed a similar taste for display and a similar national obeisance to a wealthy cultural and political sector. The many American artists who studied in France with various masters during the last quarter of the century may all have been inoculated to excess before they returned home.

Some, like John Singer Sargent, who painted in the Paris studio of Carolus-Duran in the mid-1870s, could render unabashed the sheen of what money could buy, though he also usually glimpsed what lay beneath economic or cultural veneers. Others, like Thomas Eakins,

31 John Singer Sargent

The Daughters of Edward D. Boit, 1882

The Boit family, like many wealthy Americans of the period, divided their time between the United States and homes in foreign capitals, in their case Rome and Paris.

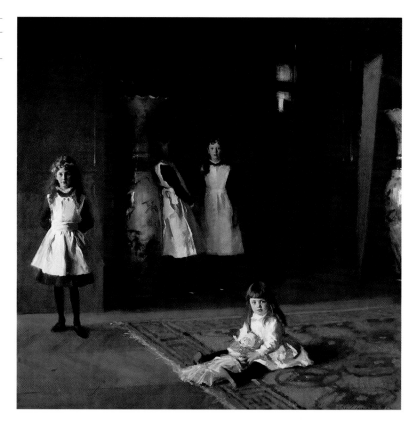

who studied intermittently with J.-L. Gérôme from 1866 to 1869, consciously or unconsciously worked at the fault line of display, portraying men of achievement and women with muffled lives, who hint, in watchful face or averted eye, at psychological hazards beneath the flash of ambition or (in terms of the artist himself as well as his sitters) the performance of bourgeois respectability. Although in his own day he attained nothing approaching the international acclaim that was Sargent's, Eakins today is regarded as towering above all other American portraitists of his time, perhaps in his century. For the purposes of the present discussion, it is germane that he has been canonized as an artist of genius in the depiction of troubled sexuality and sombre psychological states.

John Singer Sargent's 1882 portrait, *The Daughters of Edward D. Boit* [31], offers food for thought in comparison with Bourgoin's family group of eight decades earlier. The Boit sisters are pictured in the backlit foyer of their Paris residence, where a certain kind of cosmopolitanism speaks, in discreet but unmistakably more distinct tones than the Bourgoin family's little New York parlour attained, of comfort, as witness the beautiful export-ware vases, the mellowed carpet, and the gem-like lighting of the two youngest children. The two older, 14 and 12, clad in chaste pinafores like convent girls, take shelter in the shadows, while the two younger are positioned publicly, if informally. Like other items in the interior, all four girls convey a sense that they are property. I think this message is preconditioned by the picture's title, which has to do with the status of the canvas as a gift to the museum from Boit's daughters themselves, but it also springs from the showcase atmosphere: the expensive lushness of Sargent's light, the ratio of the girls' size to the canvas space and to the furnishings of the room, and the adult setting, which betrays no hint of the life of these children as children, aside from the doll casually held by the youngest.

Though far from being unusual in a group portrait of children, the absence of their father, a wealthy amateur artist from New England, and their mother, whom Sargent elsewhere painted gaudily bedecked, abets the frank treatment of these young females as items circumspectly on display. In contrast to Bourgoin's young girl, supported in her entry into adulthood by her family and the domestic security of her parlour environment, the placement of the Boit girls by themselves in a foyer, chosen probably for reasons of compositional design, is unnervingly evocative of the threshold of sexuality on which the two oldest are poised.

While mutuality of purpose between portraiture and social expectations for women seems not to have changed in kind from Bourgoin's shy vixen to Sargent's lustrous, proper and liminal girls, in fact a variety of, and, withal, a perplexity about gender roles, for men no less than women, co-existed with class-bound orthodoxies. Well-to-do women,

whose refinement offered relief from the soul-soiling grubbiness of business, attempted to use their gender no less than social position to bolster the claims of high culture, but in the end they were restricted to a traditional role of moral and educational guardianship with limited economic power.[14] Unlike the culture queens, some women blended social status and inactivity so thoroughly that by the end of the century Thorstein Veblen (1857–1929), outspoken critic of the 'luxury classes', could decry anew the female whose existence merely confirmed 'evidence of her economic unit's ability to pay'.[15] For still others, espousing an emancipated 'New Woman' by behaving more freely—in trivial pursuits like riding bicycles to serious endeavours like agitating for social and political reforms—did nothing to dismantle the established obligations of their sexual destiny, which abided in force. Pressed to deny seeking male attention but forced to believe that such attention was required for a full and happy life, installed as moral police of private social structures but powerless in many other tangential arenas, the contradictions designed for nineteenth-century women loom within their portraits but in the latter part of the century were often suppressed.

I raise this issue because art-historical sensitivity to the era's sexual psyche in recent years has turned on issues related not only to the engendering of the female sitter but, in the case of Eakins, to the related consequences, for sitters and artist alike, of the era's concept of masculinity. Although a preoccupation with topics like gender and sexuality is frequently bemoaned by art historians who fear political rather than aesthetic agendas thereby set the terms of discourse, detecting the almost invisible web of gender expectations in which painters and their sitters not entirely unconsciously colluded establishes an artistic as well as social context for some of Eakins' most enigmatic portraits. His disturbing paintings have elicited some good to outlandish interpretative readings, but even the latter have speculative energy in a discipline from which intuitive insights are sometimes purged as if contaminated. In the vein of speculation, I want to suggest that the oft-remarked effort by Eakins to establish or perhaps reinstate his own (and his profession's) masculinity may have come at the expense of some of his subjects. By putting certain sitters in clothes that did not fit or in costumes that made them uncomfortable, by intensifying portraiture's reliance on a static pose, or by exposing apparently private reflections to raking public gaze, Eakins may have wanted to control, to instil, gendered notions of strength and weakness.

Elizabeth Johns states that Eakins portrayed 'the heroism of modern life' as measured in intellectual and physical achievement rather than economic success. Certainly, a painting like the justly admired *Gross Clinic* [**32**], in its own day regarded chiefly with distaste for its lurid topic, now finds its niche in the pantheon of American masterpieces as 'all that Eakins stood for at the time he executed the painting', and

'Eakins's response to Philadelphia's, and more broadly the nation's, pride in itself and its achievements on the eve of the Centennial'.[16] These modern interpretations are based on understanding Gross as a scientist, a minority opinion in the 1870s itself, and Eakins himself as a rationalist or an artist–scientist, characteristics attributable as 'manly' if intellectual and physical prowess are equated. In this regard, it is important to recognize that both men, individually and in the implicitly joint enterprise of the *Gross Clinic* canvas, wanted to rid the medical profession of its popular association with quackery. If, as Sarah Burns urges, one qualifies the realm Dr Gross occupies as cerebral but socially marginal, then Eakins' view of surgeons may also allude to his feelings about the position of the painter in American society.[17]

It is tempting to conjecture that Eakins' concern about what might constitute manly success expressed itself in antipathy to female accomplishment. *The Artist's Wife and Setter Dog* [**33**], depicting Eakins'

32 Thomas Eakins

Portrait of Dr Gross (The Gross Clinic), 1875
Painted as though operating on a patient's diseased thighbone in his clinic at Jefferson Medical College, Gross stands exposed by a strong light within an almost smoky atmosphere. His squinting eyes and grim preoccupied face encircled by an aureole of grey hair evince a mind fascinated by medicine's intellectual challenges.

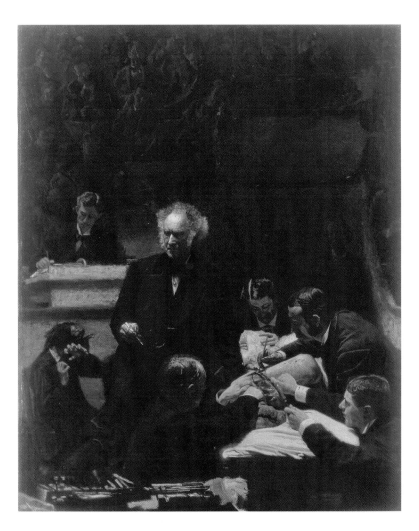

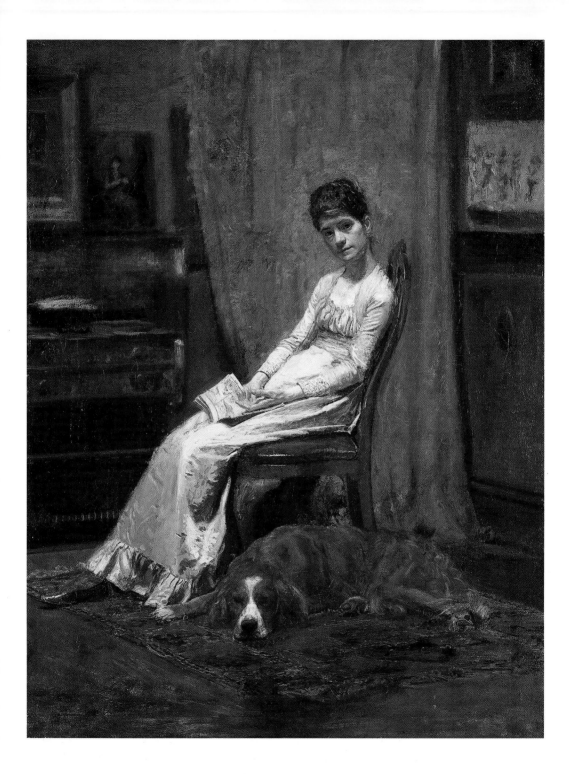

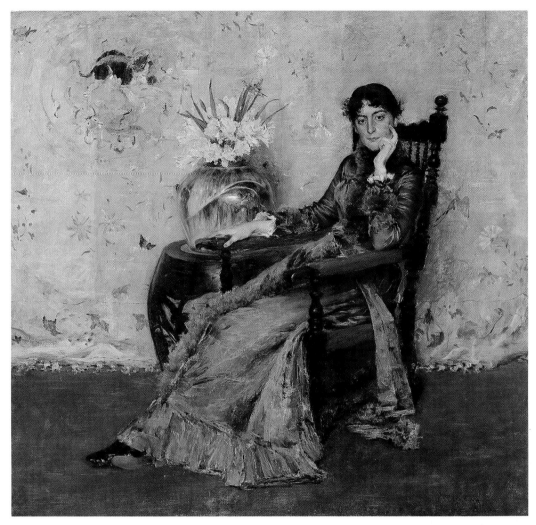

33 Thomas Eakins

*The Artist's Wife and Setter Dog, c.*1884–9

The irony of the painting as portrait is in placing Susan Macdowell Eakins, the artist's former student, in a studio and then making it inconceivable that she could be anything other than part of its furnishings.

34 William Merritt Chase

Portrait of Miss Dora Wheeler, 1883

spouse, the former artist Susan Macdowell Eakins (1851–1938), comes to mind. She was 33 when the painting was begun and a photograph of the canvas taken a year later shows that her face was originally fuller, softer. H. Barbara Weinberg points to autoradiographs which reveal that Eakins painted over his wife's face, warping it into its present hollow-eyed mask, though whether he changed the face and neck colouring then (and why he did so) is unknown. This was not, as may be proven by comparing photographs with canvases, the only time he aged a female sitter. Seated in Eakins' studio, surrounded by examples of his art and holding a book of Japanese prints, Susan Macdowell Eakins looks constricted by the tight bodice and sleeves of the unflattering and old-fashioned blue gown she wears. Eakins' student, she gave up her work when she married the artist in 1884, but her own 1878 portrait of her father seated in a room with his dog appears to have been a germinating influence on Eakins' choice of design. In the

present instance, it may be argued that the garment Susan Macdowell Eakins wears is chosen to accentuate the portrait as a picture relating to Eakins as much as to his wife. No tribute, *The Artist's Wife* has been cast as, 'in great measure', a self-projection.[18]

A useful comparison to Eakins' problematic portrayal, William Merritt Chase's portrait of his student Dora Wheeler [**34**] puts a similar pose and a studio setting to different use. Arguably New York City's premier portraitist in the 1880s and, like Eakins, a renowned teacher, Chase paints a bold picture or, perhaps, a bold woman, if not one the portrait acknowledges is an artist herself. Wheeler's eye contact, unlike Susan Eakins' inscrutability, invites approach and, since Chase's canvas is twice the size of Eakins' portrait, it does so aggressively. The alert poise of her body hints at energy and strength, traits the brilliant juxta-position of rich yellows and electric blues amply reinforce. The opulence of Chase's studio setting—the sumptuous fabric against which he audaciously placed vibrant daffodils, the resplendent vase—declares differences between the two artists even better than the word each used to refer to the studio, which Chase often grandly called 'atelier' while Eakins stubbornly clung to the artisanal 'workshop'. (Sargent, feeling trapped by his success at painting what he called the 'mugs' of high society, occasionally derided his studio as a 'factory'.)

In contrast to Wheeler, who looks as if she might leap up at any minute, words used to describe Susan Eakins' wilted body include 'slumped', 'slouched', and 'enervated', leading to one scholar's recent conclusion that Eakins portrayed here and elsewhere neurasthenia, a condition thought to be the result of 'nervous exhaustion'. Characterized by symptoms like weariness and depression, neuras-thenia was held to be common among women and not unknown among men; Eakins himself was said to have suffered a bout in 1886, when he was forced to resign from his teaching position at the Pennsylvania Academy of the Fine Arts.[19]

As Johns astutely observed, Eakins so thoroughly imbued his female sitters with passivity and vulnerability that none of them, not even pianist Edith Mahon (1904), accompanist to opera divas, or Amelia van Buren (*c.* 1891), who was another of Eakins' students, 'appear in charge of their own lives'.[20] Eakins' late portraits of unmarried women, like van Buren or Maud Cook, present a special conundrum. Despite their variety, his portraits of these women fundamentally resemble one another: his palette is generally low key though often an incandescent colour flares, the lighting ranges narrowly from dim to gloomy, his brush strokes are carefully put down and without a hint of bravura, though his surfaces are rarely smooth and his contours are not linear. In format, he inclined to close in on the sitter's head and shoulders only, although the customary term 'bust' seems allied too closely with a public image to characterize the almost harsh way Eakins lays open

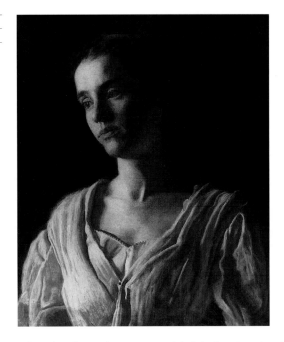

what the viewer is meant to think is the sitter's private moment of intro-spection. Many of these canvases, Maud Cook's portrait for example [**35**], eerily echo and reverse Copley's portraits, like *Mrs Thomas Gage* [**20**]. The contemplative air, the dark amorphous background, the lighting from the left that pulls out the volumes of the face and bathes the dress: in Copley's hands these features contribute to the fluent presentation of a refined woman; in Eakins' portraits the same elements psychologically reshape and sometimes even denature the sitter.

Among his male sitters, 14 portraits of Catholic clergymen, 13 of which were painted between 1900 and 1906, have been overshadowed by the greatness of his modern 'heroes', medical men like Gross or athletes like the Biglin brothers (see Chapter 4). Though unheralded, these canvases are significant because the same aura of drained stillness that renders his female sitters as helpless as marionettes with severed strings haunts them and casts a similar cloud of uncertainty over their import. An agnostic, Eakins asked in his later years to paint some of the priests at St Charles Borremeo seminary, outside Philadelphia. Why he did this remains unknown: he hoped to gain a formal, lucra-tive commission? he esteemed or was mystified by the clergy's discipline? as he grew older, he was compelled or repelled by the mysteries of their faith? One recalls that Philadelphia's notoriously ugly anti-Catholic riots in the 1840s [**40**], part of a wave of such urban antagonisms and immigrant biases, left the city with emotional scars, but was Eakins heir to their social disfigurement? In composition and type, many of these portraits beg comparison with the great Renaissance clerical portraits of Raphael (1483–1520) or Titian (*c.*

36 Thomas Eakins

Archbishop Diomede
Falconio, 1905

Although the canvas is
unfinished, Eakins listed this
portrait, along with *The Gross*
Clinic, as one of the most
important paintings of his
career.

1485–1576), or, since Eakins admired him, of the Spanish Baroque painter Velasquez (1599–1660). But European portraits all embrace the power and strength of the Church and the contemplative (or cunning) intellectual prowess of the religious, so that despite their celibacy the appropriate adjective for the likenesses of these holy men is 'potent'. In contrast, Eakins painted men from whom all will has seeped away; their immobility, their sometimes stunned or at the very least blank expressions, do not put the Church in a manly light nor do they furnish them with much intellectual wattage.

It is especially difficult to dismiss Eakins' manipulations in the portrait of *Archbishop Diomede Falconio* [**36**], commissioned by the Catholic University of America. Notably humble in appearance, even while serving as Apostolic Delegate in Canada—one source maintaining that he 'never' wore the type of vestments in which Eakins pictured him—Falconio was the subject of 'facetious' comments by Eakins, and what one art historian has read as a look of 'meditation and reverie' on Falconio's face is seen by another as 'unpleasant self-importance and … sourness'.[21] When I look at Falconio, the adjective that comes to mind is a word coined to describe a condition produced by modern warfare, 'shell-shocked', but I am not sure who is suffering from it.

While Eakins' portrait series of Catholic clergymen has all but escaped psychoanalysis, not to mention gender policing, they yet supply fertile fields for both. In regard to Eakins' attitude toward religious and masculinity, one might do worse than consider that Eakins was openly derisory about Christian notions of an afterlife, which he tellingly found unscientific. Like ministers and priests, artists were consigned to the feminized professions, an attitude Eakins abhorred. Like Catholics themselves, Eakins had been scorned by Philadelphia's conservative core. Would it be impossible to believe that painting Archbishop Falconio as so weak and unmanly a figure was an act of self-rejection for the profoundly secular Eakins?

On the eve of 'the American century', as the twentieth century has been called, Copley would have been pleased to know that portraiture no longer constituted North America's chief artistic occupation. That it flourished, there was no doubt, and Copley's own contribution was duly and deservedly remembered in the form of an exhibition of his works in 1935, near the anniversary of his birth. Like Eakins' portraits, Copley's canvases teem with psychological import, much of it hiding under highly materialized detail. Like Copley's paintings, Eakins' likenesses contain more than physical description, though it is a toss-up whether the self-reification at work in them pertains to the sitter or the artist. In the following two chapters, rather than the individual, a different form of 'self' is construed, one that encompasses the collective.

The Early Nineteenth Century: Democratic Models

3

The word 'democracy' only began to be commonly used in English during the last quarter of the eighteenth century—tellingly, in the decades of the American and French Revolutions—yet all manner of people, both citizens and foreigners, hastened to appraise the American democratic experiment straight away.[1] Some were disturbed (or elated) by the thought that democracy might be not only a political practice but a principle of social egalitarianism as well; others, from the wide community of the disenfranchised, complained that neither social nor political principles of egalitarianism obtained, being negated by an electoral system that barred many people from the full exercise of citizenship on the basis of race, sex, and class. Still others suspected that democracy might be, at heart, 'mobocracy'. Yet whether they mistrusted or treasured democracy, almost everyone came to believe that, uniquely, the United States as a nation and as a democracy were interchangeable. As Richard Jenkyns observes, 'There is no real parallel [among other nations] for the use of "American" as an evaluative as well as descriptive term.'[2] This chapter and the following one give a prismatic account of the ways in which the visual arts participated in the reciprocity of meaning that exists between 'democracy' and 'American'.

Personifications and national symbols

A range of 'types'—models—of art directly or circuitously helped to imagine the nation as democratic, the most obvious being traditional personifications.[3] The figures of Uncle Sam and Columbia are equally well-known images associated with American identity. Although they represent separate constituent elements of the 'national', and although they have markedly different social connotations that affect their cultural distribution, the two are never less than interdependent. To be sure, gawky, volatile Uncle Sam and serenely regal Columbia appear both aligned and mismatched. In looking at the sources of their appearance as well as some manifestations of their visual character in

the first half of the nineteenth century, I am not interested in trying to make each symbol match 'reality', a vexed proposition. Instead, questions about Uncle Sam and Columbia as personifications, low and high, lead to another enquiry: *how else* might the early American nation as democracy have been imagined visually?

Personifications, the embodiments of symbols, have been employed by western artists in both sacred and secular contexts since at least the Middle Ages. When they function as emblems of nations, they raise two important questions: why these particular symbols? and what aspect or what segment of the 'nation' do they represent? In fact, national symbols are not really tokens of the whole; their ubiquity or official usage merely gives the illusion that they are. Interests competing for or confirming political power, economic primacy, social acceptance or social dominance produce them. Of course, it can be argued that, despite diverse agendas, such groups nonetheless constitute a single unit—a power bloc—that manages national imagery as collective expression. Most important, patterns of negotiation between artists and sponsors reveal that an image intended to be emblematic of the nation can become the site of conflict, and throughout its production may be reshaped, its new lineaments relentlessly testing the understanding of the idea(s) of nation or national constituency it supposedly incorporates.

From Indian Queen to Columbia
At the dawn of the nation's existence, the United States government signified appreciation of service to the revolutionary cause with a gesture in time-honoured European fashion, the awarding of commemorative medallions. In 1789 a Parisian, Augustin Dupré, struck six different medallions, some of which drew upon a legacy of New World personification in circulation since the Renaissance. 'America', the fourth member of the 'corners of the world' in early geography, was a nude woman warrior decorated with feathers and usually accompanied by an exotic-looking animal, a bow and arrow, and the odd severed limb nearby (certain South American indigenes were reputed to be cannibals) [**37**]. Well into the eighteenth century, this Indian Queen stood iconographically for both hemispheres of the New World.[4] Being all that came to hand immediately after the Revolutionary War, the Indian Queen initially also personified the new United States, which is why, on Dupré's medal dedicated to Brigadier-General Daniel Morgan, a muscular, barefoot and befeathered Indian woman grasps her bow with one hand and places a laurel wreath on Morgan's inclined head with the other [**38**].

During the decades immediately following the revolution, as the infant nation began to produce its own artists and to assemble the elements of something that could reasonably be called American art,

37 Ferdinando Gorges

'Cannibal America', America Painted to the Life, 1659

While the print employs standard iconographic elements of the geographic personification of the Americas, a poem on the verso links the graphic exaggeration of anthrophagic practices imputed to some natives with malignant aspects of the American environment.

38 Augustin Dupré

Brigadier-General Daniel Morgan Medallion, 1789

Dupré's imagery is typical of the traditional allegorical means that were enlisted to provide a national iconography for the new country.

imagery identifying the United States underwent a transfiguration. The hefty Indian Queen turned into a slender white princess. References to cannibalism and armaments likewise disappeared, but large plumes, feathery antennae that were like souvenirs of her Indian past, sometimes bobbed from the headband wrapping the figure's classical coif. In some variations, she wore instead a so-called Phrygian (or liberty) cap, or an eagle hovered beside her. On occasion, startling hybrids fashioned in Britain but circulated and copied in the United States produced an 'America' with a new accompaniment: an indeterminately gendered dark-skinned child, wearing a feathered head-dress and skirt obviously meant to invoke Native American attire, alongside the white goddess [**39**].

The development of a princess-type icon has generally been treated by scholars as an example of a neoclassical impulse coming to the fore. Certainly, the establishment of republican virtues made its best and most ubiquitous case visually through the pure lines and classical references of neoclassicism. But if this emblem belongs to that mode, then the child of confused race and sex must be identified as an attribute. The child of colour is exactly what she/he looks like: a possession of the white-skinned figure. It denotes not only place, as for example an armadillo or parrot represented the exotic fauna of the Americas, but, through infantilization, this child also exemplifies the condition of the dependent races in the white race's care. Such imaging of the idea of nation forecasts the later role of art as an actor in the tragedy of race that was to play (but not be played out) the entire century. It also antic-

An EMBLEM of AMERICA.

ipates the intermediary role that certain kinds of American art served in confirming and naturalizing paradoxical stratifications within democracy.[5]

By mid-century the female figure of Columbia—whose name derived from that of Christopher Columbus (1451–1506), 'discoverer' of the New World and by extension a founder of the United States (see Chapter 7)—predominated as *genius loci*, or spirit of place. More or less synonymous visually with the white female figure 'America', Columbia seems to have been merely a title change rather than an alteration in representation, stimulated perhaps by an increasingly pressing need to distinguish the United States from the rest of North and South America. (She was only awkwardly called 'United States', confirming Thomas Jefferson's opinion that 'United States' was a good description of, but no name for, a nation.) Concurrently, Columbia carried attributes designating her as a *genius virtutis*, a personification of what many Americans hoped were the nation's special virtues—for example, industriousness and strength—or important arts, like agriculture. As the century wore on, Columbia varied little in her goddess-attire of white flowing gown and diadem or other headpiece [**40**]. That she grew increasingly buxom reflects changing ideals of beauty for women and the decline of neoclassical style.

While Columbia reigned as a national image, she never held the throne alone, since, in addition to Uncle Sam, a clutch of allegorical

female figures, Liberty and Freedom most prominently, appeared as one or another isolatable portion of Columbia's corporate character. Perhaps the United States is too diverse or too nebulous an entity and an idea to squeeze into a single embodiment, although surely the same could be said of any nation. Or, perhaps, as one suspects on occasion, personifications were on some level transposable.[6]

For example, in 1855 Thomas Crawford (1813–57) was asked to design a statue for the pinnacle of the dome over the US Capitol and, according to a letter from his sponsor, Crawford's topic was arrived at nearly by default. 'We have too many Washingtons, we have America in the pediment ... Liberty I fear is the best we can get', confessed Architect of the Capitol Capt. Montgomery Meigs in his letter of commission. The sculptor's first drawing proposed a classically clothed, demure 'Freedom' holding an olive branch and supporting the shield of the United States with her sheathed sword. Subsequent revisions saw gentle Freedom transmogrified into a bulky and aggressive 'Armed Liberty', sheathed sword to the fore, heavily cloaked, and head raised imperiously [41].

Concessions of a different order explain the strange helmet, encircled by stars and garnished with feathers, on Liberty's proud head. Crawford acquiesced to objections put forward by Meigs' superior, Secretary of War Jefferson Davis, that the figure should not wear a liberty cap. Why? Because such headgear was used by the Romans in ceremonies of manumission (the release of slaves), not a condition of freedom that Davis, future President of the Confederacy, thought it suitable to recall. Crawford appears to have been exceedingly co-oper-

40

'Columbia Mourns her Citizens Slain ...', 1844

In the gory anti-Catholic riots of May 1844 in Philadelphia, both sides incurred losses. 'Native Americans', in this instance meaning white Protestants born in the United States, pressed Columbia into service as a guardian of 'martyrs' who died fighting Irish immigrants.

ative during the entire affair, undertaking every change, removing every irritant that Davis or Meigs suggested. Yet somehow the feathers on Liberty's helmet remained, recalling, however faintly, her ancestry in the Indian Queen.[7]

One constant in the ante-bellum metamorphosis of the geographically personified 'America(s)' into a poetically named national emblem, 'Columbia'—and then through the spawning of her synecdochic progeny, 'Liberty' and 'Freedom'—was the traditional siting of allegory in an idealized female body. As Crawford's 'Freedom' side-stepped the paradox that a democracy permitted, and even encouraged, slavery, his use of a female figure to convey notions of continuity, respectability, and purity elided the fact that women themselves had little power in the national body. At century's close, when women launched collective actions to gain their rights, the point was driven home publicly by suffragists who piled on to a boat and circled Bedloe's Island to protest the unveiling ceremonies of the monumen-

tally female Statue of Liberty that numbered only two women guests amongst scores of dignitaries.

This is not to say that men did not serve as personifications and national symbols too.[8] After all, Uncle Sam is recognized globally. In literature and the visual arts, Columbia is usually conceived as rising above the hurly-burly like a beautiful, distant goddess. One can unhesitatingly acquiesce in her claim to timeless perfection, even when she engages 'womanly' moments like mourning or instructing. The cartoon character of Uncle Sam, on the other hand, has always looked and behaved a lot like other faulty mortals [**42**].

Uncle Sam and the Yankee
Everything about Uncle Sam reads as easily as an American newspaper: the initials of his name; his red-and-white-striped pants and blue jacket; his star-trimmed top hat; and his gangling, raw-boned physique advertising how rapidly he grew. Obviousness alone does not account for Uncle Sam's legibility. While Columbia and her allegorical sisters were mostly creatures of the fine arts, with offshoots in popular prints and decorative arts, Uncle Sam entered visual culture in the 1830s through mass reproductions and remained there. Uncle Sam's lineage, visually and behaviourally, included regional characters created for early American theatre and vernacular literature, like Yankee Doodle and Jonathan Ploughboy, along with real-life kin like Davy Crockett, 'b'ar killer' and Congressman, and Uncle Sam Wilson (a Troy, New York, supplier of goods to the United States military during the War of 1812 and the purported origin of the Uncle Sam/United States wordplay).[9] Ultimately, Uncle Sam's fictional and actual sources were woven into the simultaneously emerging literary and pictorial pattern marking an ante-bellum male type, the Yankee.

In the 1820s, a character borrowed from the English stage named Jonathan Ploughboy, a cunning rustic who outsmarted city slickers with his disarming and not entirely dissembled provincialism, inaugurated a raft of similar literary and dramatic protagonists. Like Jonathan Ploughboy, other early American theatrical figures with bumpkin names—Curtis Chunk, Solomon Swop, Jedidiah Homebred—spoke with the same fearsome accents and colloquial diction that 'Yankees' on the London stage employed to make fun of Americans, subverting ridicule for their own ends. This was not the first time Americans mocked the mockers. Every colonial version of the eighteenth-century ditty called 'Yankee Doodle' counter-satirized British scorn of North American provincialism—one set of verses, for example, celebrating a New England militia's victory over the French army at Cape Breton, Canada, in 1745, by pretending the colonists were cowards: 'But when Ephraim he came home/He prov'd an arrant Coward/He wouldn't fight the Frenchmen there/For fear of being devour'd.'[10]

UNCLE SAM'S PET PUPS!
Or, Mother BANK'S last refuge.
Sold at EATON'S, 18 Division-Street, New-York.

Posters, engravings, and, later, photographs reveal that ante-bellum
Yankee theatre actors wore striped pants and tall hats, attire that
showed up on Uncle Sam's rangy body in 1840, one of his first appear-
ances in print, leaving him all knees and elbows. Nervous, energetic,
money-driven, quick to anger, frequently caught off guard, boastful,
and—above all—independent, Uncle Sam's foibles no less than his
clothing openly subverted European rules of decorum and ideals of
character. Worried that what animated American life might be what
would eventually destroy it, de Tocqueville had warned, 'In Europe, we
are wont to look upon a restless disposition, an unbounded desire of
riches, and an excessive love of independence as propensities very
dangerous to society.'

Jonathan Ploughboy, Brother Jonathan, and other Yankees on stage
generated models of sharp-eyed, comic rusticity in genre painting as
well, especially in depictions of the Yankee peddler and farmer. Certain
canvases of the 1830s–40s by William Sidney Mount, whose uncle was
prominent in New York's theatre world, epitomize the latter. In her
analysis of the ways Mount 'built his career on representations of the
Yankee farmer', Elizabeth Johns locates the antecedents for *Bargaining
for a Horse* [**43**] not only in popular caricatures of rural life but also in
Mount's knowing combination of drama and colloquial humour.[11] A
Long Island painter deemed 'absolutely American' by his contempo-
raries, Mount painted his regional subjects for eastern patrons who
may have looked with nostalgia and amusement on the high hat and
waistcoat of the shirt-sleeved whittler and the dandified nature of his

whittling companion's red-and-black vest. Johns believes that Mount's viewers would have been aware of the vernacular wordplays embedded in the picture: these include the still-employed 'horse trading' to allude to making a deal in politics; the dupe in such a deal, who is a 'pigeon' like the birds Mount paints on the barn roof; and 'coming to the point', conveyed in the very act of whittling. The allegorical meaning of Mount's painting, in other words, was couched in terms every bit as familiar and 'everyday' as the work's visual detail, something crucial to the accessibility, and therefore success, of genre.

Until recently, histories of genre painting argued, tautologically, that the portrayal of American subject matter created a national art in the nineteenth century. Current scholarship has fruitfully pressed beyond this point, making evident the significance of what is beneath appearances. In this spirit, I suggest that Mount's farmers may be positioned among Uncle Sam's kin, in dialogue with, and resistance to, Europe. Mount's allusions to American vernacular speech through east-coast colloquialisms, and his characters' idiosyncrasies of dress and posture, are exactly what came to the minds of Europeans when they criticized American men as provincials.

Europeans did not deride American speech and manners out of sheer maliciousness or even errant cosmopolitanism. In the behaviour of many white American men (women were less publicly exposed), carelessly dressing and eating and sitting and reading, some observers thought they glimpsed what might ensue from an unrestrained American democracy—the collapse of those rules of status and conduct that made society, as they comprehended it, civilized. Plenty of Americans too were convinced that not only social distinctions but also social restraints had been abandoned in the name of democracy, empowering the rabble. James Fenimore Cooper (1789–1851), author of novels featuring mavericks like Natty Bumppo/Hawkeye, derided a levelled social order where 'every man swaggers and talks, knowledge or no knowledge, brains or no brains, taste or no taste'. Control, at the heart of political philosophies, could dissolve in a democracy, especially one built on the edge of a wilderness. Others feared that excessive concern with the consequences of democratic behaviour misdirected political energies. De Tocqueville, for instance, deplored the American propensity to equate 'democracy with [individual] freedom', for to do so reduced to trivialities of manners higher social responsibilities, such as how a democratic nation tolerated, much less actively encouraged, slavery.

If one were tempted to theorize the American-male type on which Uncle Sam is based, and which he embodies, a post-colonial view might have some bearing. The quality of being different or 'Other', known as alterity, is an invented one, something a dominant or imperialist group imposes on a less powerful or colonial one for the purpose of controlling or policing the latter. Some post-colonial theorists, intending to reduce the victim-hood of colonials and restore to them an element of agency, have posited that alterity appropriates for its own use, out of an unknowable mixture of collusion and resistance, the very features of differentiation that have constructed it. In like manner, Americans took to heart types like Uncle Sam and the Yankee, creatures born of theatrical burlesque. Burlesque, compounding resentment at European slights, a love of irony, and other, more complicated, motives for unconventional manners, deftly turned outsiders' scorn to insider joke.

Like countless others before them—for example Erasmus (c. 1469–1536), who, in expounding negative Roman stereotypes of northern Europeans, made virtues of what had been intended as slights—Americans subversively refashioned images of themselves as provincials, making of them a positive democratic type. Versions of Mount's shirt-sleeved farmers with no hint of comedy appeared even as Mount was painting, the overlap betraying how resistance smooths into containment in a society constantly in flux.

Frank Blackwell Mayer's (1827–99) 1858 portrait of Squire Jack

Porter, called *Independence* [**44**], inscribes the Jeffersonian dream of an agrarian nation in which the new American man is a self-sustaining, propertied farmer. His simple home is sturdy and comfortable; his farm, if one is to judge by the background foliage, prosperous; and he himself, contentedly smoking a pipe and lounging with hat off and feet up, a man at peace with who and how he is: a positive democratic type. Porter's legs on the railing may violate decorum but the easy arrangement recoups democratic behaviour's oppositional nature and brings to mind Walt Whitman's throw-away phrase, 'the picturesque looseness of [American] carriage', in the paean to democracy's characteristics commencing 'Leaves of Grass' (1855).[13]

Despite idiosyncrasies of origin and development, Uncle Sam and Columbia must be judged standard-issue national symbols. If democracy and the United States exemplified each other, as many nineteenth-century commentators supposed, how might this distinctiveness register, consciously or not, in *American* imagery? Indispensable to imagining the United States must be notions of democracy, 'America's most distinguishing characteristic', as Robert Wiebe points out, and 'its most significant contribution to world history'.[14]

Jacksonian readers

The conjunction of genre's initial popularity with what historians label the era of 'Jacksonian democracy' has traditionally governed art-historical interpretation. Jackson is remembered most often as the president whose two terms in office (1829–37) capitalized on an expanded electorate and populist sentiments. It will come as no surprise to readers cognizant of the dark side of Jackson's populist logic (above all the vicious paternalism of his Indian policies) to learn that uncritical views of Jacksonianism also generated simplistic readings of genre painting. James Thomas Flexner's imprecise characterization of George Caleb Bingham's (1811–79) depictions of a frontier election (see Chapter 4), 'the very spirit of Jacksonian democracy', nicely catches the ease of meshing genre's portrayal of common folk with an ideology that based itself on the will of the 'people'.

Art historians currently encourage viewers to think about competing and complicating ways in which representations relate to their audiences, to history and historiography, and to the functions of representations, within contexts that are themselves representations. At the end of the 1980s—following, and in some cases paralleling, the work of certain scholars of nineteenth-century British and French art (for example, John Barrell, T.J. Clark, and Linda Nochlin)—American scholars ventured to posit the genre image as a constructed one and not, as one of the first studies of American genre painting had it, 'a mirror to the American past'.[15] From this vantage point, it is worth

44 Frank Blackwell Mayer

Independence (Squire Jack Porter), 1858

Ralph Waldo Emerson's famous 1841 essay, 'Self-Reliance', extolling common sense, non-conformity, self-trust, and independence as individual and national ideals, reminds readers that 'there is a time in every man's education when he arrives at the conviction that envy is ignorance; that imitation is suicide; that he must take himself for better or worse as his portion …'. Squire Porter appears to have found that time.

taking a second and closer look at genre in the Jacksonian era in order to consider how else, apart from personifications, the United States has not only been imagined but imaged as a democracy/nation.

I take as my test case a subgroup within American genre topics which began in the 1830s and dropped off after the Civil War: informally dressed men in postures of 'loose carriage' and in relation to newspapers.[16] Seated, these men may prop up their feet, tilt backwards negligently, or lean forward aggressively; standing, their shoulders may support a wall or hunch over. Since they are always in proximity to a newspaper, quintessential organ of the masses, these men might be called 'Jacksonian readers'. A late (1854) sheet music cover for 'Uncle Sam, an American Song' sums it up: newspaper crumpled at the side of his chair and feet propped up, 'Uncle Sam'—here a Jacksonian conflation of the United States and its people—whittles nonchalantly [**45**].

Sometimes men depicted reading newspapers appear to contradict not only European but American chains of assumption involving news

reading, intellect, and social control. Whether artists portrayed cigar-smoking men in the heart of the city or in one-horse towns, they pictured hats jammed on stringy hair and heads buried in newspapers, booted feet propped on a table or hooked on to the rungs of tipped chairs. Were these figures louts, numbed into mindlessness and coarsened into vulgarity by newspapers' sleaziness and democracy's absence of control? Or were such exercises of male bodily performance linked to the oppositional elements of Uncle Sam and the Yankee as national sign? Did some American men simply lack knowledge of the proper way to sit?

It wasn't a regional problem. Even in the halls of government, Mrs Trollope had encountered sprawling men: the House of Representatives in 1828 she found 'filled with men, sitting in the most unseemly attitudes, a large majority with their hats on'.[17] Yet there were masses of American etiquette books to offer advice on sitting, standing, and other matters of social conduct. Given the scorn heaped on ill-bred behaviour by Americans themselves, it seems reasonable to believe that such men were not simply churls. The reader in Eastman Johnson's 1863 *The Evening Newspaper* [46] certainly is not.

The painting's date, midway through the Civil War, may explain the pains the artist has taken to make the reader a veritable specimen of democratic good health, an untroubled and sturdy farmer with eyes and skin alight with wholesomeness and a gaze as honest as his surroundings are plain. Yet he behaves like his less savoury brethren, his chair tilted back, his demeanour distinctly unceremonious. If, when reading the newspaper, only a portion of the male population behaved 'vulgarly', that's the point: American genre depicts the portion, generally, that in Europe would not have been able—from want of skill or money—to read a newspaper. As late as 1840, illiteracy in France and England ran to nearly half the population. In Russia at that time, as much as 98 per cent of the population couldn't read. So when Franz Lieber, a German, noted 'two characteristics of the Americans, their lounging habit, and their eagerness to read', he linked behaviours not often found in conjunction outside the United States.[18]

Reading communities

Benedict Anderson writes that all nations are only 'imagined' because 'the members of even the smallest … will never know most of their fellow-members, meet them, or even hear of them, yet in the minds of each live the images of their communion'. One activity critical to the formation of these images, he says, is newspaper reading, normally regarded merely as a form of communication—by some, even as a form of covert control—but Anderson sees it also as an instrument of connection, one that gives logic and root to the idea of community. Through newspapers, a readership not only sees itself mirrored in the

reading of others but also learns about the events, opinion, plans, and conditions of those like and unlike itself, all members being incorporated in the newspaper as subjects and objects.[19]

In two celebrated genre paintings, Richard Caton Woodville's *War News from Mexico* [47] and William Sidney Mount's *California News* [48], newspapers compositionally occupy a central position, in both cases manifesting important aspects of shared newspaper reading.[20] Distributed as an engraving to thousands of American Art-Union members in 1851, *War News* makes its appeal through a conspicuously stage-like setting, combined with tight design and narratively graphic facial expressions. The drama taking place on the porch-stage arises from the content of the news being delivered. Familiarity was achieved by typecasting the characters: in the words of the promotional copy of the Art-Union, 'the slouching barkeeper, the tavern-haunting scapegrace who finds something in the news to arouse him from his ordinary indifference, the deaf man, the exultant boy … and the poor old negro upon the steps'.[21] Today, however, the viewer may feel that the histrionics of the white men, and even the glance of the white woman leaning out of a window, are unconvincing; everyone is working too hard to be credible. Instead, the expression on the face of the 'poor old negro's' raggedy daughter as she stares soberly at the ensemble kindles the only real spark of humanity in the entire painting.

Mount's *California News* is less stilted but not without anecdotal narrative. The newsreader and, opposite him, a man whose far-focused gaze, that no less than the ticket in his pocket announces he has succumbed to the hypnotic attraction of gold discoveries in California, frame a shiny-eyed boy and a stalwart adult, two who can answer the *New York Daily Tribune*'s siren call for pioneers. A young woman squeezes her hands to her breast with longing, the lure of California mediated for her by the moustachioed suitor whose arm inside the circle of the newsreading signals his participation. Outside the group, an elderly man and a black man, to whom the call is audible even though it is not directed at them, listen ardently. Johns thinks that the empty chair and writing equipment in the left foreground 'may be inviting a potential "California emigrant"' to sign on, a plausible reading considering the painter's sly embellishment of the wall with advertisements for the sale of a local farm, prospecting tackle, and passage on ships sailing west, all of which are punctuated with a little picture of pigs at a trough.[22] Like Woodville's painting, Mount's *California News* centralizes the newspaper in order to encircle it with a community of citizens, simultaneously and almost incidentally (which is why it rings true) deploying it as an agent of class, gender, and racial exclusion.

Anderson thought that readers of newspapers, seeing other readers, learned to acknowledge their collectivity, their imagined nation, but

paintings like these, produced in democracy's youth, are more concerned with hierarchies than homogeneities. I want to make it clear that this sense, and the judgement it implies, is built out of present-day sensibilities rather more than those of Woodville's or Mount's audiences, who, being mostly collaborative in the order represented, did not hint of anything amiss in this regard. What news the papers ran was, as today, determined in part by what the market would buy, and all but a few newspapers ostentatiously if not entirely sincerely—for they were heavily partisan—aimed their circulation at a mass-market audience.

The newspaper carrying the information in each painting registers democracy in ways that are entirely consistent with democracy's mid-century practices; it is expansionist-orientated and white-male-dominated. Victories in the Mexican contest meant swift enlargement of the United States: Texas had been annexed in 1845, when the war began, and with Mexico's defeat in 1848 the government purchased land that later became Utah, Arizona, New Mexico, Nevada, California, and parts of Wyoming and Colorado. The gold strikes in 1848 enticed thousands to cross the continent. Among national news-

47 Richard Caton Woodville
War News from Mexico, 1848
Woodville began painting in 1845, the year he went abroad; he never returned to the United States, dying a decade later in London. All of his 'American' genre scenes were painted in Düsseldorf, famous for its artist community. His art recalls especially work by Düsseldorf genre painter Johann Peter Hasenclever, whose *Reading Room* (Remscheid) of two years earlier portrays a men's club with portly burghers silently, absorbedly reading their individual newspapers.

48 William Sidney Mount

California News, 1850

papers, for instance, Horace Greeley's *Tribune* stands out as a great booster of expansion: it was this paper that famously urged young men to 'go west'. Genre paintings of this period, like the ones by Mount and Woodville, rarely showed non-voters as authorized newspaper readers; instead they reassured audiences of the status quo, as perhaps at the end of the century some still-life painting endeavoured to do.

Reading alone: still life with newspaper
An Irish immigrant in New York, William Michael Harnett (1848–92) continued to affirm the importance of newspapers in his still-life paintings long after their popularity as a genre motif waned. Opinions vary as to his motives. Thomas C. Leonard has a view that ties the newspaper

firmly to a readership of men—Harnett 'pegged news as a male vanity'—but which finds the artist's paintings so hermetic as to be destructive. 'Harnett's life work', he concludes, 'was the smashing of the neighbourliness and civic-mindedness that had carried the newspaper into American art.' Laura Coyle restores the paper to a readership when she points out that many of Harnett's patrons were businessmen and would have been comfortable with newspaper motifs; newspapers carried their own company's advertisements and if these men read anything at all, she declares, they read it in the newspapers.[23]

The newspaper possesses formal as well as social value. In Harnett's *New York Daily News* [**49**], the newspaper looks as though it has been dropped into a shadow behind the mug and so is a negligible detail. Bleakly absent-minded though its disposition may appear, the paper does a lot of work within the painting: it ties the pipe with the mug compositionally, lightens the middle ground, and throws the pebbled surface of the mug into relief by its smoothness. In the end Harnett

Newspapers' growth in importance

Throughout the century, newspapers were omnipresent in the United States. The invention of steam-driven presses in 1830 and the expansion of the postal system's transportation circuit increased production, reduced price, and permitted spectacularly wide distribution of newspapers. By mid-century, American newspapers possessed the largest circulation in the world. The presence of immigrant groups like Swedes, among whom literacy was not confined to the upper classes, and a growing number of public schools, soon made literacy more extensive than in any other western country at that time. Along with the doctrine that asserted the necessity of an informed citizenry in a democracy and the constitutionally safeguarded freedom of the press, these conditions secured newspapers a central position within American culture.

achieves something like poetry. Adding newspapers to traditional still-life elements, he betrayed a desire to connect to something outside the self and its senses.

Reading and social control

The content of ante-bellum newspapers—which in addition to reporting events adhered chiefly to political issues, to public affairs—was directed to white male readers. In most cases, only white men of a certain class inhabited public lives and this may explain why the rare paintings of black men reading are solitary figures. A good example is Edwin White's *Thoughts of Liberia* [**50**]: a slumped black man's reading matter—perhaps a description of a northern loss, or tales of slavery's horrors—summons up a dream of emigration to the west African country founded in 1822 by and for freed slaves and made into a republic of predominately English speakers in 1847. The fire's dull light forces the viewer to scrutinize the man's dark face carefully. Absorbed, his expression divulges little, but the very shadows of the room look as though they might breed a melancholy phantasmagoria of the escape and warmth and community that Liberia, not the newspaper, represented to African-Americans.

Anderson asserts that 'reading classes' refer to 'people of some power' in Europe; in the United States too, reading existed as a demonstration of power economically and socially, a condition newspaper-reading and -sharing white men in genre painting helped elucidate and reinforce.[24] In the justifiably congratulatory atmosphere surrounding the astonishing levels of literacy the new nation was achieving so swiftly, however, powerlessness as a function of illiteracy interjected a sour note. In the visual arts, another subcategory of genre painting—triangulating power, reading, and access to literacy—compensatorily shifted power's emphasis from politics to morals. Comprising scenes too sentimentalized to be taken seriously or too close to slavery not to be taken seriously, genre paintings of white mothers teaching their young to read character-improving books (see Chapter 4), or slaves pondering scripture, sacralized the teaching of literacy by refusing to taint it with the topicality, and the attendant worldly authority, of newspaper reading.

Reading as a form of social control operated not only by commission but also omission. Until the Civil War, many slave owners feared that slaves only needed to get their hands on a book for revolt to follow (a conviction suggesting that slave owners didn't read overmuch, since a literature defending and rationalizing slavery circulated as vigorously as did abolitionist material). Even teaching the alphabet was construed as a plan on the part of abolitionists to foment unrest; and, looking at the frontispiece for *The Liberty Bell*, published in Boston in 1839 [**51**], unrest was clearly an idea the African-American engraver, Patrick

50 Edwin White

*Thoughts of Liberia:
Emancipation*, 1861

The Düsseldorf-trained artist keeps the slight man's chair firmly attached to the floor of the decrepit room, his body small in relation to the canvas, thus removing the image from association with white 'Jacksonian Readers'.

51 Patrick Reason

Frontispiece for *The Liberty Bell*, 1839

Holding aloft a book, a radiant white female personification of Liberty stretches out her hand as though empowered to release a group of chained slaves.

Reason (1817–98), had in mind with the Gospel message, 'the truth shall make you free'. The artist, and his sponsors, folded together an abolitionist and a Christian precept with the same logic of the owners who denounced literacy for their slaves.

Winslow Homer (1836–1910) quietly but effectively put before his viewers Reconstruction's efforts to bring literacy to newly freed African–Americans in *Sunday Morning in Virginia* [**52**]. A young woman, her well-kept clothes and hair proof that she does not come from the decaying plantation system, teaches willing but shyly frightened pupils in threadbare garments. An old woman lifts the scene into higher realms than its incipient sentimentality might otherwise attain, her expression deeper than wistfulness and more impenetrable than

sadness. The title, 'Sunday Morning', assures that it is the Bible the teacher is intent upon and, as Nicolai Cikovsky rightly avers, the picture is 'by far the greatest image of the cruelest and most crippling intellectual legacy of slavery—illiteracy—and of its rectification'.[25]

One wants to be careful not to bear down too hard on a charge of poor black illiterates denied the power of reading by their evil white owners, however. An uncounted but distinguishable number of slaves were in fact literate, taught by their white mistresses, by other African-Americans, slave and free, or by northern members of mostly white organizations like the American Bible Society.[26] In this regard, what's crucial about the painting isn't that ex-slaves are being taught to read

52 Winslow Homer

Sunday Morning in Virginia, 1877

The *Southern Episcopalian* (Charlestown, SC) of April, 1854, provided extracts from an oral catechism for slaves: 'Q Who gave you a master and a mistress? A God gave them to me. Q Who says that you must obey them? A God says that I must. Q What book tells you these things? A The Bible.' Homer's depiction of Bible reading took on profound resonance in the war's aftermath, all the more powerful for being low key.

but by whom they are led. Although Homer ventures to the edge of bathos—impoverished African-Americans gaining comfort from the Bible—he is never in real danger; his almost uncanny insight into the psychologies as well as conditions of the ex-slaves he painted in Virginia grasped African-American agency in the race's own condition—here through a black woman teaching black children.

A democratic system of government, a free and inexpensive press, and high literacy rates distinguished the United States from Europe, though these features, being far more complicated and opaque than civics textbooks want to acknowledge, did not ensure or even allow a national consciousness with pictorial possibilities. Still, as Joshua Taylor has observed, writers and artists conceived 'a conscious way of thinking about America, not simply a reflection of what America was', a way that included projecting (and then actualizing) rural and regional behaviours, like the newspaper-reading Yankee, as national.[27] In the second half of the century, an era of transition from rural to urban communities, growing cities and their citizens provide the typology of democracy.

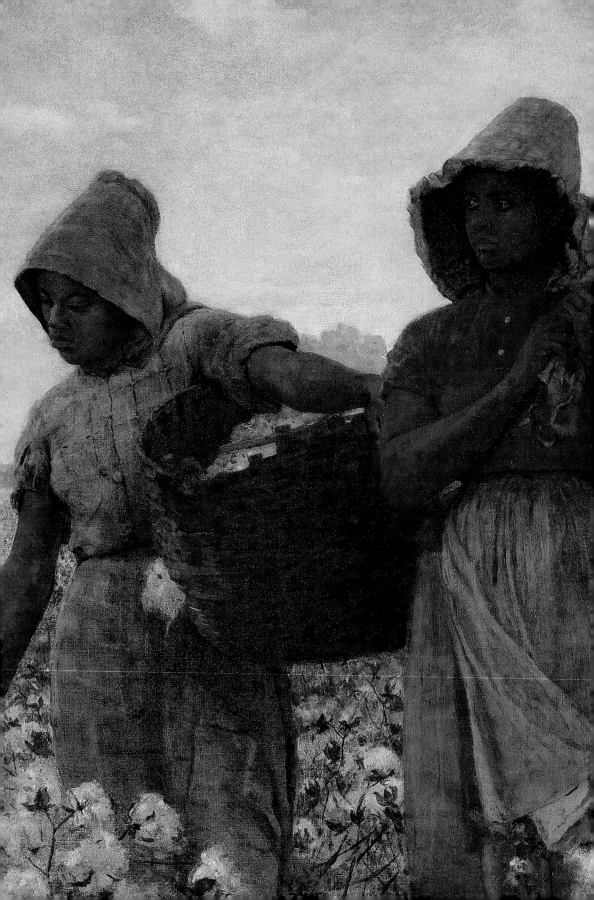

The Late Nineteenth Century: Democracy at Work

4

In the preceding chapter, traditional means of symbolizing the nation visually—a high-art personification, an emblem from popular art— were placed alongside less direct avenues charting the imaginative dimensions of democracy as national metaphor in the first half of the century: namely, typical genre motifs of newspapers and reading. The social uses of portraiture, the embellishment of public buildings, the delineation of cherished or unique terrain, and the iconography of heroes also contribute to the process of imagining the nation in painting and sculpture, creating an idea of 'national', as they do in the art of any country that seeks a reciprocity of identity between 'nation' and its ideological basis. Mention was also made of this exchange as an element in the attraction of the United States for foreign visitors come to report on the new country and to observe its progress as a democracy. Friend and foe alike grappled with the difficulty of defining just what it was they were examining. To use a hackneyed but apt simile, one could say that those attempting to sum up American democracy in words, or to summon it up in pictures, were like the blind men who tried to figure out what an elephant was by passing their hands over the part of the beast within their reach: everybody found a piece of the puzzle.

A multi-faceted thing, democracy as an idea and a practice can also be described as fluid. As a consequence of transformations wrought by an accelerated urbanism and industrialization, fears of social destabi-lization—democracy's old vulnerability—re-awakened in the second half of the century. Looking at art from this period helps bring to light what was at stake when both democracy and nation were simultane-ously in the process of definition and re-definition.

Detail of 70

Faces of democracy

Town and city

Only 26 years separate George Caleb Bingham's *County Election* [**53**] and Horace Bonham's (1835–92) [**54**] *Nearing the Issue at the Cockpit*, but they look as though more than a generation divides them. In *County Election* white male voters, presented as socially diverse, though uniformly homespun, assemble to enact democracy's central ritual. Smiling or frowning, in coat and tie or shirt-sleeved, the figures discuss the candidates' merits, keep a tally, consult a newspaper, campaign, stop for a drink, mill about, disagree peaceably. Well, not so peaceably that some blood hasn't been spilled, if the fellow with the bandaged head and torn clothing on the right is anything to go by; and on the left side of the painting someone has stopped for too many drinks, but a fellow voter lugs him to the polling place anyway, a gesture that tends to undercut the display of an informed citizenry as democracy's ideal constituency.

Details from 53

Democracy and the frontier

Frederick Jackson Turner's 1893 formulation of the interdependence of American democracy and the frontier has been steadily revised and reinstated for decades. Turner named as essential to the maintenance of democracy a population raised on the frontier, where 'coarseness and strength [are] combined with acuteness and inquisitiveness', creating '[a] practical, inventive turn of mind, quick to find expedients; [a] masterful grasp of material things, lacking in the artistic but powerful to effect great ends … [a] restless, nervous energy … '. The characteristics Turner wanted to see as inherently American/democratic, because impelled by the exigencies of frontier life, perpetuated the agrarian ideal, and both versions of American democracy—the frontier thesis and the agrarian ideal—carried an equally persistent corollary: that is, if democracy rests on farmers, on non-urban populations making a subsistence living on land snatched from the wilderness, then distinctions of social class are minimized. As Raymond Williams has pointed out, while classlessness does not necessarily comprehend a democratic egalitarianism, it is often confused with it.

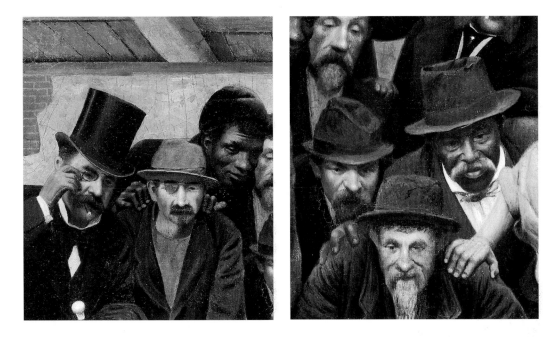

Details from 54

Nearing the Issue at the Cockpit is also 'about' democracy, according to Edward Nygren, using the cockfight as a metaphor for political contests and its spectators as democracy's emblematic constituency.[1] In this case, to the spread of old to young, rich to poor, is added a range of skin colour and an assortment of ethnicities. Unusually, the group includes a light-skinned man of mixed race and, even more unusually, an Asian. Heterogeneity marks the group as urban, since the salient feature of cities in the last quarter of the century was their enormous immigrant population; the tight, shabby quarters in which they gather speaks to cities' density and overburdened resources. Still, there is nothing negative here. Like the frontier folk in Bingham's county, the city dwellers are all healthy, well formed, and absorbed by what is taking place.

Bingham and Bonham both accommodate inequalities based on income as well as race (and, by the absence of women, gender) with the aplomb of habit. In Bingham's painting a black man pours cider for a round and smiling white man. In American genre art, this is what black men of this era *do*: they live on the margins and wait on financially better-off white people, literally and figuratively. The focus of books and innovative essays so central to the present understanding of American art that it's hard to remember they have been treated as though they were invisible for most of their American art-historical existence, the image of black men in the paintings of Woodville and Mount (see Chapter 3), as well as Bingham and many later artists, are nowadays reckoned to be more than props for the ensemble psychologically. They enable the white man, not merely by playing the music of his dance, nor by assisting him in the fields or at table, but by being the

appreciative foil for white men's success, which here, ironically, is the democratic system. While both Bonham and Bingham clearly want to display income differences and imply equality at the same time, Bonham more obviously refrains from stinting the comforts of the rich, as demonstrated by the elegance of the top-hatted man's accessories. Nor does he deny this man's superior advantages, like the monocle that aids his sight while the poor man beside him makes do with one eye.

The manner in which each artist handles space and perspective does not diminish the sense that their differences are more apparent than real. While Bonham's figures cluster behind a barrier, eyes fixed on a hypothetical foreground, they push forwards towards the viewer, an in-your-face perspective that seems, at least within current experience, distinctly urban. Space is so crowded that each man, with the exception of the wealthy one, shoves and jostles his neighbour. Bingham's figures are deployed like actors on a more commodious stage, with the proscenium carefully underscored by the children playing mumblety-peg in the foreground and the backdrop laid out to establish an illusion of deep space, as deep as the far-horizoned prairies of the west. Rural and urban, west and east, pre- and post-Civil War, the two canvases realize distinct yet not entirely unlike ideas of community—it's made

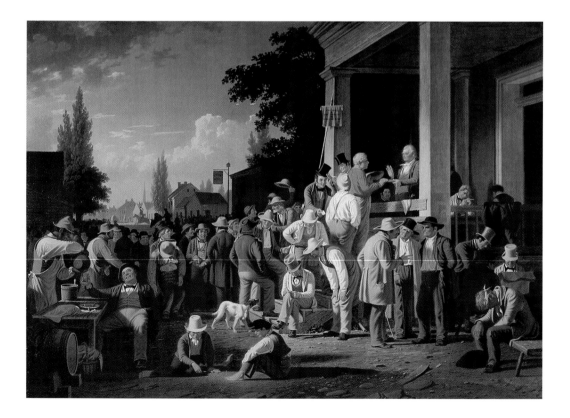

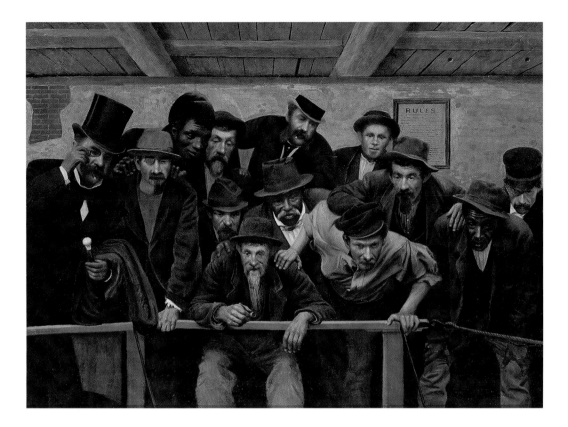

54 Horace Bonham

Nearing the Issue at the Cockpit, 1878

Two northern types, identifiable by their fresh complexions and light hair, anchor a pile of bodies framed laterally by a top-hatted, monocled swell carrying a walking stick and a furrow-faced black man wearing a battered hat. Bonham's mixed group of men constitutes an immigrant-filled, socially diverse voting populace.

up of sound individuals, mostly in the middle ranges economically but unfazed by obvious income disparities, who exist as a compact whole—and agree about the behaviour of an electorate in a democracy that is, above all, engaged. *County Election* and *Nearing the Issue* imagine a community, therefore, that has a disparate membership made coherent by democratic participation.

Although Bonham's picture displaces contention to the unseen pit, in fact both popular and high art frequently wrestled directly with the problems raised by increased heterogeneity. Now Uncle Sam frequently found himself in adversarial situations; the depictions of cartoonists Joseph Keppler and Thomas Nast testify to contention within urbanized communities as well as to the tenacity with which a nativist sector attempted to maintain control over the authority of a white male national symbol. During the same time, the insularity of the initial reception and interpretation of the Statue of Liberty demonstrated another arena in which nativist sentiments struggled for dominance. Projecting boldness, positivism and unity on to a female personification like the Statue of Liberty did not entirely hide the fact that society was shaken—if not torn—by social, intellectual, and political upheavals.[2]

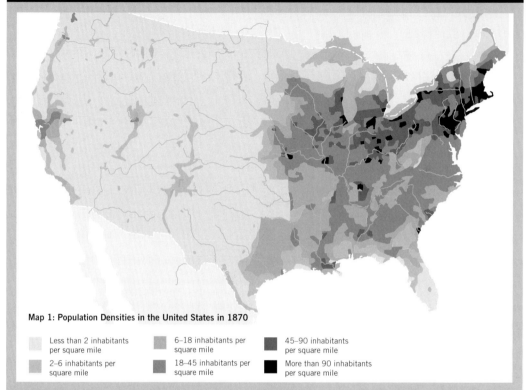

Map 1: Population Densities in the United States in 1870

Less than 2 inhabitants per square mile

2–6 inhabitants per square mile

6–18 inhabitants per square mile

18–45 inhabitants per square mile

45–90 inhabitants per square mile

More than 90 inhabitants per square mile

Although, by 1900, 60 per cent of the populace still lived in rural areas, cities began to grow apace after mid-century. In 1850, when the population of the United States numbered 23 million, only seven cities boasted more than 100,000 inhabitants; by 1900, the national population had reached 76 million, and six cities contained more than half a million residents. These numbers had been augmented by foreign immigration, although migration from country to city still furnished the largest supply of recent urbanites. Not all immigrants remained in the United States and, of those that did, many trekked westwards. Yet east-coast cities in particular bore the brunt of what were often called 'waves of immigration', some bearing a tsunami-like impact in certain decades. In the ten years after the Civil War, more than three million new residents arrived, nearly half a million in one year (1873); from 1882 to 1892, another peak was reached, cut off by the 1893 depression. Newcomers were said to 'help build the city', though downplayed in that bland formulation is the native component—black and white—in urbanization. In the end, struggles for political and economic influence, not only between the established culture and the new arrivals but also between the immigrant groups themselves, shaped the heterogeneous city.

Uncle Sam and the urban masses

Following the Civil War, Uncle Sam developed the graphic life by which most Americans know him today. In his earliest incarnation, he had taken the role of 'government' as against Brother Jonathan's or the Yankee farmer's 'citizen', but especially after the decline of Jonathan on the stage, Uncle Sam increasingly inhabited a civic sector. Uncle Sam now exchanged isolation for insularity, buffoonery for black humour,

55 Joseph Keppler

55 Joseph Keppler

'A Family Party', *Puck,* 1893

With a decided bias toward blonds, Uncle Sam and Columbia host a party for the 'healthiest' of their brood, a German, oblivious to squalling Asian and African 'infants' as well as to more grown-up party members like the sulking Irishman or the blithe Italian organ-grinder.

A FAMILY PARTY.—THE 200th BIRTHDAY OF THE HEALTHIEST OF UNCLE SAM'S ADOPTED CHILDREN.

56 Anon.

The Great Fear of the Period/The Problem Solved, 1876

In a reversal of the myth of Saturn devouring his son, in which a tyrant retains power by eliminating his offspring, the artist pictures Uncle Sam swallowed up by an Irishman and a Chinese man, who in finishing off the native Uncle Sam become themselves a monstrous hybrid.

within the exigencies of an industrialized, urbanizing, immigrant-rich United States. Newly exhibiting the traits of Bingham's westerners, their alacrity as well as their skittishness, Uncle Sam retained the shrewdness and looks of the Yankee farmer along with the awkwardness that branded him a provincial. In the hands of cartoonists of the calibre of Thomas Nast (1840–1902)—whose work was published in big city newspapers and in periodicals like *Harper's*—and Joseph Keppler (1838–94)—publisher of *Puck,* a humour magazine resembling the British journal *Punch*—Uncle Sam also gained a patriarchal manner to go with his grey hair and whiskers [**55**]. To be sure, Keppler's creation resembled the dopey dads of American television comedies more than literature's gravely wise fathers, since his Uncle Sam angered quickly, preened himself in front of his wary family, acted

first and thought later, and quite often didn't fully understand his children or his spouse (the last two fabricated from recent immigrants and Columbia). Nast is chiefly remembered as the artist who created a Lincolnesquely gaunt and tall Uncle Sam enmeshed in political policy, domestic and foreign. But it should not be forgotten that Uncle Sam's ubiquity allowed artists to play him for mean laughs, as when an anonymous lithographer depicted that clownish figure encountering Catholics and other 'foreigners' [56].

Liberty enlightening the newcomers
A European artist created the most famous and most visible female symbol of the United States: Frédéric-Auguste Bartholdi's 1886 *Liberty Enlightening the World*, now known simply as the Statue of Liberty, arrived as a gift from 'the people of France' [57]. On the day of her unveiling, clouds, drizzle, and the smoke from dozens of boats around the island shrouded the monument in haze but failed to depress the crowd's jubilant mood. The sculpture's appeal was universal, for her most obvious attributes—a torch and a seven-rayed crown—were directed to the illumination of the human spirit that liberty offers to the people of the seven continents and seas. In fact, at one point, both torch and crown were intended as literal illuminants: *Liberty* was originally planned to be a lighthouse. The statue's two other references to freedom—a tablet inscribed 'July 4, 1776' and a broken chain under her foot which alludes to the emancipation of slaves—are more easily overlooked.

 Liberty's current role as beacon of 'world-wide welcome' and 'mother of exiles', in the words of Emma Lazarus' 1883 poem, belie the first attempts to link the sculpture with immigration to the New World and, especially, to asylum in a democratic land: 'Give me your tired, your poor,/Your huddled masses yearning to breathe free,/The wretched refuse of your teeming shore/Send these, the homeless, tempest-tossed to me:/I lift my lamp beside the golden door!' Lazarus' exalted second stanza of 'The New Colossus', lines now synonymous with the statue, was placed on a plaque inside the hollow structure more than two decades after it was erected, and proposals to have immigrants actually debark at Liberty's feet on Bedloe's Island had been quashed. Even then, as a consequence of the restrictions on immigration legislated in 1921 and 1924 during a rush of 'anti-foreign hysteria', the statue's famous message essentially applied to 'those fortunate enough to have immigrated before the "golden door" slammed shut', as one scholar dryly concluded. Yet because her site in New York's harbour signalled to millions of immigrants that they had reached American shores, the 'grand old girl', visually and metaphorically linked to Columbia, has remained an American figural symbol whose work is as political as it is patriotic.[3]

Labour in genre paintings

Pretty much at whatever point one enters the continuum 'Industrial Revolution', euphoria and enthusiasm dominate the American mood, a mood instigated by faith in technology and engineering but not without its dark side. Especially at the end of the century, intensification of production, which compelled consumption and invited fervent materialism, also incited resistance, the demands of management versus the needs of labour sparking confrontations in the social realm. What alarmed many of those who believed in democracy as egalitarianism was not only the growing gap between rich and poor but that principles of social equality, in the past at least honoured in the breach, now passed entirely unacknowledged by money-making Americans intent on accumulating goods, including art, to out-display each other.

It may not be too much to say that the era underwent a kind of moral crisis. Novelists who literary historians have labelled 'realists'— such as Theodore Dreiser, William Dean Howells, and Harold Frederic—took a mostly jaundiced view of American prosperity, wondering what values were being jettisoned to take so many material goods on board. For religiously minded Americans, the secularity and avariciousness of a consumer-based society provoked apprehension about the fate of the nation's spiritual life. Even travellers who had earlier been dismayed by egalitarianism's manners now lamented the passing of the 'theory that every man born in the country should have a fair and equal chance'. Sir Philip Burne-Jones, for instance, who published the unflattering *Dollars and Democracy* (1904), decided that money in the United States 'seem[s] to be an end in itself', while James F. Muirhead gave 'a Briton's view of his American kin' (1902) summarized as *America: the Land of Contrasts*.

In the second half of the century, the market for genre painting veered ever more strongly towards industrialists. These men and their middle management, if one considers within genre's compass the modestly priced Currier and Ives' prints purchased by the latter, provided a ready audience for nostalgic scenes of a rural life untouched by change. For such patrons, bucolic images offered the escapism, rootedness, and catharsis of rural myth as what Angela Miller calls their 'therapeutic function'.[4] Yet, to a far greater degree than ever before, post-war American genre also depicted urban labour and labourers. These scenes appear to have served a similarly intercessory and stabilizing purpose, for they often minimize transformations in the nature of work itself over the course of the century. What is more, disagreeable consequences of industrialization are neutralized in American genre, for the most part, and unavoidable alterations to the fabric of daily life assimilated. Perhaps these features explain why industrialist–patrons favoured work-themed genre, rural or urban, in addition to the pastoral idyll.[5] Men, like the purchaser of Winslow Homer's *Cotton Pickers* [**70**], who owned or operated the means of production (in this case a 'spinning mill' in England) of the commodity portrayed in painting could experience the canvases as guilt-free zones.

The culture of work
In that it also performed something of a rearguard action in the latter half of the century, the theme of work in genre can be interpreted as an effort to sustain values earlier associated with democracy and now under stress. The ante-bellum period vaunted labour as the motor of self-reliance, hence independence; independence, of course, intertwined with democracy. It is commonplace to describe the pre- to post-war economic transition as a passage from an agrarian economic base to an industrialized one, and refinement of that generality puts

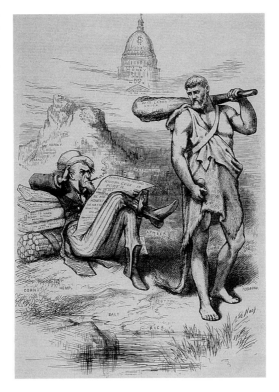

58 Thomas Nast

'Earn More than you Spend', *Harper's Weekly*, 13 April 1878.

In the caption, Uncle Sam asks: "How is it that, living in the most productive country in the world, and with all my law-making power, I am not prosperous?" Hercules replies: "Go to the Ant, thou Sluggard, and find out."

emphasis on a gradual overtaking of entrepreneurial capitalism by corporate capitalism. As part of those changes, work sites moved from home or small workshop to factory, and task-orientated activities gave way to time-managed labour. Perhaps in response to the standardization imposed by these changes, in the second half of the century urban images of work underscored qualities attached to 'character', industriousness and self-control above all, rather than specific activities.

Industriousness was prized as a work-related facet of the energy and drive—the engagement—Americans tended to attribute to the success of their democratic enterprise. Self-discipline became an increasingly serious concern as disquiet related to the impersonal work site and a subsequent loss of autonomy seeped into fears of losing control socially, fears common to nativists and newcomers both, which threatened democracy's ongoing accommodation of inequality. Assiduous application to one's work was counselled, and even leisure was imbued with constructive purpose, a purpose located not only in the edifying nature of art and literature but also in the hard work of play. A new conceptual framework for time, the linchpin of these pursuits, instilled dread and resistance even as it provided coherence and the conditions of discipline and control. The nation's conversion to standard time, an artificial homogeneity imposed to meet the needs of commerce, strained rather than strengthened the idea of democratic community.

59 Frank Blackwell Mayer

Leisure and Labor, 1858

The legend 'Stop Theif [sic]' under Father Time's flying feet, waning light, long shadows, and allusions to autumn, like fallen leaves on the roof and haystacks in the field, are details intimating that time runs out, for everybody and everything. The painting's alternative title, 'Doing and Dreaming', puts a further moralizing spin on the contrast between the elegant grasshopper–horseman frittering away his time while the industrious ant–blacksmith bends to the task.

Cultural histories of work valorize their object of study with such encomiums as 'America is and always has been a nation defined by a devotion to work', and 'the work ethic remains a central theme in the American experience'.[6] Melissa Dabakis' study of labour and American sculpture particularizes industrial work's ideological character as 'a lightning rod in the struggle over social change', and she explains how representations of workers in literature and art 'assumed a variety of social guises … serving the ends of reform as the hapless victim of industrial oppression or bolstering the forces of the status quo as the demonized agent of anarchy and violent change'.[7] The protean nature of work and worker as vessels for meaning, meaning in which social rather than economic ends are paramount, leads me to suggest that in the second half of the century images of work and workers may be construed as models of democracy's dimensions under pressure.

In such conditions, the moral nature of work could not be over-estimated, and everyone, it seemed, took the side of the ant, invoking Aesop's fable of virtuous diligence and application versus grasshopper-like indolence and laxity. In the visual arts, idleness was excoriated on grounds that occasionally reached beyond biblical interdictions against slothfulness and, significantly for the portrayal of male workers, led to the junctions where class and manhood intersected. In Thomas Nast's cartoon of 1878, Uncle Sam in his guise as an avatar of Congress, querulously enquires of a Herculean representative of a 'Hard Labor Union' why, living in 'the most prosperous country in the world', he does not prosper and is told to 'go to the Ant' for answers [**58**]. In this context, the features of the Jacksonian reader that scrawny Uncle Sam exhibits, especially his lazily crossed legs and the stack of newspapers by his side, imply that reading the news is a waste of time, time that could be devoted to more productive pursuits.

On a more complex level, Frank Blackwell Mayer's 1858 *Leisure and Labor* [**59**] interlaces a formal and thematic account of the moral value of industry. Propped against a sunlit stable door, a well-dressed man watches desultorily the contortions of a farrier shoeing a horse. The lounging man shares with his dog a beaky profile and trim lines, though the human's lazy posture is offset by the greyhound's nervousness. Earthy and absorbed in his task, the farrier works within a shadowy stable interior. Genre paintings are often constructed like nesting boxes, rectangles within rectangles, each holding a vignette in place with an equilibrium of design that brings about a transcendence of time usually only achieved by still life. In this instance, a lean-to frames a doorway, which in turn frames a window, which in its turn both frames a landscape and is itself broken into smaller frames, while stable doors contribute a geometry of their own. A design that locks into place genre's transient moment serves a particular purpose here, universalizing the thematic contrast.[8]

Men at work
On the farm
During the ante-bellum years, Jefferson's vision of a democracy based on an agrarian ideal was promoted and assured by idealizations of farm life in art and literature. Genre painting of agricultural work, for example, frequently built in not only nostalgia but also virtue, while eliminating unpleasantness. In William Sidney Mount's representative *Farmer's Nooning* [**60**], sweat, exhaustion, worries about crop yield,

60 William Sidney Mount

Farmers Nooning, 1836
Mount relies on nearly outmoded technologies of farming as well as the notion of deserved rest from individual labour to legitimize and at the same time distance his contemporary scene.

or other disagreeable aspects of harvesting do not intrude on the painter's vision. Such omissions were, in Miller's word, 'therapeutic' and it was this element that probably recommended the scene as a print distributed by the American Art-Union in 1843 and as a frontispiece for the July issue of *Godey's Lady's Book* in 1845.

On the other hand, Mount complicated his narrative with tantalizingly ambiguous mentalities of racism that may have been necessary girding for an agrarian myth arbitrating a white democracy. A white man readies a strickle to use on the scythe suspended from a tree branch overhead. Concentrating, he sits with upright posture, a counterpoint to his relaxed and sprawling companions. His clothes appear curiously unaffected by a morning's strenuous hay cutting. Two other white men, less self-consciously busy, retain sufficient muscular tension in their bodies to indicate that, for them as well, this noon break is for recuperation. A reclining black man, in contrast, entices the viewer to accept him as an object of desire—he is comely and strikingly sexy—but, asleep, he also calls for derision, an emotional duality for which a white boy playing with and jeering at the black man serves as the viewer's surrogate. That the man's pose and physical type unmistakably derive from the erotically charged second-century BC *Barberini Faun* [14], which Mount could have known from engravings, merely underscores the way the painter plays with the attraction–repulsion polarities that galvanize stereotypes. For the purposes of this discussion, however, the point rests with Mount's not very subtle differentiation between the way white and black men spend their time; although the physical strength of both black and white men seem to be on a par, only the white men 'noon' usefully and rationally, preparing and recharging for more work.

In industry

Comparison with Thomas Anshutz's (1851–1912) *The Ironworkers' Noontime* [61] helps to place distinctions between Mount's synoptic pre-war conceptions of work, workers, and time and those at century's end. A genre scene unusual for being set at a factory, Anshutz's image includes youths as well as adult working men, a range of types and heritages that are ethnic rather than racial and so faithful to the white-dominated urban workforce. Italian, German, Slav, and Irish males solemnly reveal themselves, underdeveloped or with mature waistline spread, stringy armed or fully muscled. Some play, others rinse the grime from face and hands. Only a few seek the shade; the majority freeze in the cold glare of the sun, their pallid flesh at odds with scattered exhibitions of strength. Despite the very great beauty of the figures, and their anatomical accuracy, the men resemble automatons. Their transfixed postures bring to mind wind-up toys that have run down at different points in their pattern.

The Ironworkers' Noontime,
1880
A student of Eakins at the
Pennsylvania Academy of the
Fine Arts and then a long-time
instructor there himself,
Anshutz made preparatory
sketches for this, his
masterwork, at a factory in
West Virginia; despite critical
acclaim, it remained unsold
for two years, when it was
purchased by the
entrepreneur–collector
Thomas B. Clarke.

Perceived as a masculine occupation, ironworking gains some of its emblematic maleness from an ancestry in blacksmithing, which Randall Griffin describes as 'embod[ying] the American work ethic … craftsmanship, hard work, virility, and independence'. Both jobs require brute strength exercised with discipline and diligence, leading Griffin to see industry's metamorphosis of the blacksmith into iron-worker as 'a new type of democratic American hero'.[9] How, then, does one account for the mechanical quality governing the movements of Anshutz's ironworkers, which robs them of both virility and independence? *When* the picture takes place provides a clue. *Noontime* signals not so much the control of the machine as the irresistible auspices of the machine's legislator: time.

The standardization of time

One of the most sweeping transfigurations of American life occurred as the result of what looks in hindsight to be a minor addendum to the larger alterations of industrialization and urbanism shaping mass culture. At the beginning of the century, time and work belonged together, twin offspring of the same parent—God—for whom they existed and by whom they were regulated. A pious regard for time involved the utility of work for the good of God's creation. Play grew out of work, as when cornhuskings gathered neighbours and family in one chore, or a break for lunch brought time to sharpen a scythe and chat a little under a shady tree. What a farmer did and when he did it was regulated by the cycle of the seasons and the diurnal passage of the sun; this time was 'natural', as Michael O'Malley says. 'Natural time' embraced biblical ideals of harmony with nature that included, even mandated, the parallel course of seasonal cycles and life cycles.[10]

From the order generated by cyclical time and companionate human passage sprang values for work and rest, for autonomy and interdependence. The print firm of Currier and Ives catered to this idea of appropriate time, their popular *Four Seasons of Life* [**62**], for instance, providing an imagery that reinforced itself by rewarding the virtuous life, one in accord with nature, with a comfortable 'winter'.

As a counterpoint, one might compare with Currier and Ives' famously homey scenes a painting celebrated at the 1893 World's Columbian Exposition. *Breaking Home Ties* [**63**] earned much of its popularity from the sensitive manner in which the artist, Thomas Hovenden (1840–95), poised a family on the brink of separation. A young man taking leave of his family before going off to his seek his fortune, *Breaking Home Ties* sentimentalizes a country-to-city tale, so crossing metaphorically from natural to standardized time, and thus falls into a larger category of late nineteenth-century genre in which cyclical time held some remnant of its mythic meaning. The young man is leaving the farm and its natural seasons of life and growth for the clock-driven routines of urban life, a rupturing experience with which its viewers on both sides of the divide could empathize.

THE FOUR SEASONS OF LIFE: CHILDHOOD.

THE FOUR SEASONS OF LIFE: YOUTH.

THE FOUR SEASONS OF LIFE: MIDDLE AGE.

THE FOUR SEASONS OF LIFE: OLD AGE.

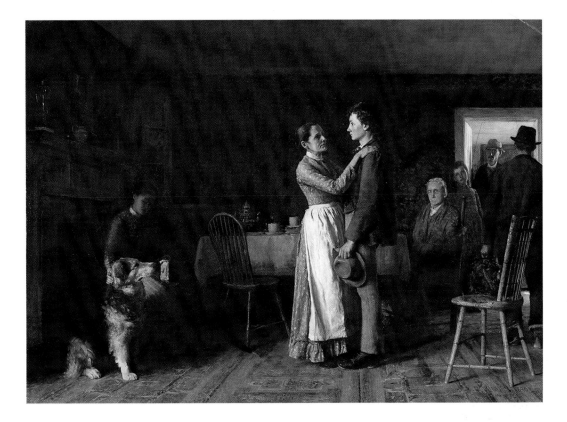

63 Thomas Hovenden

Breaking Home Ties, 1890
The stupefied look on the youth's face appears as a portent of the regimentation awaiting him in the city and helps the viewer make sense of the mother's scrutiny—she doesn't seem to be asking 'Will you be all right?' so much as trying to break through his daze.

It was manufacturing that made time a commodity and transportation that forced time to become standardized beyond the immediate community. At first, railroad clocks punctuated time regionally—in New England, for instance—by a 'true time' located in Boston. Off in nearby Concord, Thoreau noticed 'the startings and arrivals of the [railroad] cars are now the epochs of the village day. They come and go with such regularity and precision … that the farmers set their clocks by them.' What O'Malley calls 'the railroad's claim of temporal hegemony', that is, to be the setter and keeper of time, triumphed.[11]

Despite objections that went all the way to the Supreme Court (on the grounds that the sovereignty of states without temporal hegemony were being violated), time was more or less standardized and zoned by 1883. In cities, the new time reorganized labour and leisure to suit the needs of the factory system, and why not? The railroad industry entwined manufacturing and distribution into a continental whole and, to country dwellers, the new time confirmed the cities' ascendancy. Americans everywhere became regimented by a kind of time that turned out to be more than the sum of its parts: work time; free time; on time; time off; out of time.

Work as play/play as work

One way to think about industrialization's infiltration of American life, and to gauge its intensification, brings in the imagery of sport. In the first half of the century, few though such canvases are, they possessed an ad hoc spirit of spontaneity and play. After the Civil War, sports imagery increased substantially and took on a different cast. At first glance this topic might appear the antithesis of genre's preoccupation with work and workers, but in fact it incorporates a complex relationship to labour on several counts. For men, play assumed the characteristics of work, a complement to the established masculinity of labour. Martin Berger explains that 'in industrial America ... males of the middle and upper classes were engaged solely in labor that [may be] ... called "brain work"', lack of physical activity setting them apart from working men and arousing fears of a loss of manhood.[12] In addition, the number of men who did not return intact from the Civil War had exacerbated anxieties about the relationship of manhood to physical health. Second, and perhaps in compensation, sport began to be comprehended through terminology related to industry's controlling mechanism, the machine.

64 George Caleb Bingham

Boatmen on the Missouri,
1846

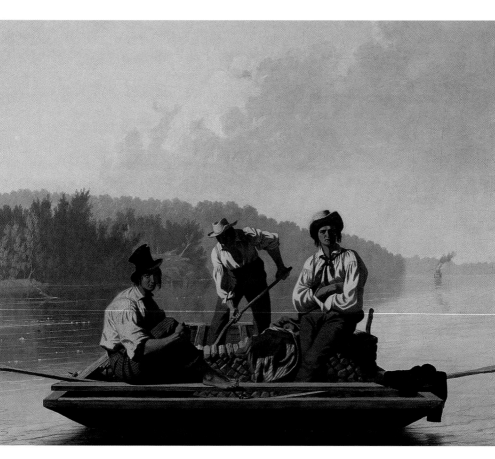

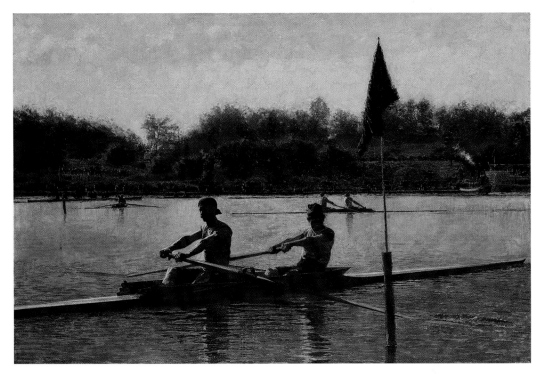

Comparing Bingham's genre paintings of rivermen like *Boatmen on the Missouri* [**64**] with Thomas Eakins' rowing pictures, like *The Biglin Brothers Turning the Stake-boat* [**65**] reveals differences in attitude—in the former work as play and in the latter play as work—that speak volumes about the paradoxical transformatory power of the machine in late nineteenth-century America. Poised and statuesque, Bingham's men are suspended in the river's pale light, their timelessness at one with their sturdy triangular configuration. Two of the men establish eye contact with the viewer while a third looks down at the cargo; none of them acknowledges the steamboat, symbol of the noisy and turbulent Industrial Age, gaining on them in the distance. Rather, the picture is imbued with stillness, compounded in equal parts of the motionless foreground figures, the horizontality of design, the parallelism of the boat's prow and stern with the picture plane, and the tranquillity of water and light. This is work as repose, without machines: what Michael Shapiro calls 'an Arcadian view of the river world'.[13]

Working men, Bingham's figures are remarkably relaxed, stolid of physique and (one supposes) mentality, whereas Eakins introduces intensely playing men with taut, hard bodies and exacting movements, absorbed in a sport that relies on brain as much as brawn. Rowing held a position in amateur sport in late nineteenth-century America very like that of running today. While many people enjoyed it for reasons of physical and mental health, serious sportsmen competed, exerting themselves as thoroughly as professional athletes might. Here the two

66 Winslow Homer

The Old Mill (The Morning Bell), 1871

The opposite of Anshutz's austere palette, Homer's saturated reds and greens soak up and give off light in a manner that makes the canvas almost jewel-like.

men are pictured at different moments of the stroke, their extended arms as precise and as rhythmic as a machine gear, the river's placidity a foil for the diagonals of the boats and oars that criss-cross it as tightly as a net. If Bingham's rivermen work in Arcadia, then Eakins' sportsmen play in a mechanized world ruled by the machine and recognized by period viewers in those terms. Berger points out how often the rhetoric of rowing produced descriptions of the athletes' bodies as 'watch springs' and 'pistons', one writer even comparing rowers to steam engines. In the ultimate accolade, the 1872 *New York Clipper* called John Biglin, a well-known individual sculler who sits in the bow, a 'human mechanism'.[14]

Women's work

If imagery of male workers implied that the value of work—and its meaning for being a man—persisted unchanged, representations of women in connection with work suggest less appetite for shoring up traditional feminine virtues. Of course, domesticity received ample buttressing in paintings that glorified the nurturing, teaching role of mothers and offered more qualified support of housekeeping tasks. But the madonna–mother corollary—that work outside the home robbed a woman of, or at the very least endangered, her virtue (and here virtue would mean both moral character and sexual purity)—was rarely invoked.

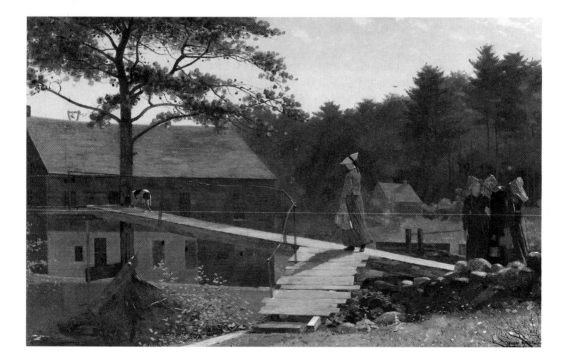

Timetable, 1851

Timetables such as this one may account for the steady head-down stride of the woman heading towards the mill; her gait contrasts strongly with that of the ambling dog ahead.

TIME TABLE OF THE LOWELL MILLS,

To take effect on and after Oct. 21st, 1851.

The Standard time being that of the meridian of Lowell, as shown by the regulator clock of JOSEPH RAYNES, 43 Central Street

	From 1st to 10th inclusive.				From 11th to 20th inclusive.				From 21st to last day of month.			
	1st Bell	2d Bell	3d Bell	Eve.Bell	1st Bell	2d Bell	3d Bell	Eve.Bell	1st Bell	2d Bell	3d Bell	Eve.Bell
January,	5.00	6.00	6.50	*7.30	5.00	6.00	6.50	*7.30	5.00	6.00	6.50	*7.30
February,	4.30	5.30	6.40	*7.30	4.30	5.30	6.25	*7.30	4.30	5.30	6.15	*7.30
March,	5.40	6.00		*7.30	5.20	5.40		*7.30	5.05	5.25		6.35
April,	4.45	5.05		6.45	4.30	4.50		6.55	4.30	4.50		7.00
May,	4.30	4.50		7.00	4.30	4.50		7.00	4.30	4.50		7.00
June,	"	"		"	"	"		"	"	"		"
July,	"	"		"	"	"		"	"	"		"
August,	"	"		"	"	"		"	"	"		"
September,	4.40	5.00		6.45	4.50	5.10		6.30	5.00	5.20		*7.30
October,	5.10	5.30		*7.30	5.20	5.40		*7.30	5.35	5.55		*7.30
November,	4.30	5.30	6.10	*7.30	4.30	5.30	6.20	*7.30	5.00	6.00	6.35	*7.30
December,	5.00	6.00	6.45	*7.30	5.00	6.00	6.50	*7.30	5.00	6.00	6.50	*7.30

* Excepting on Saturdays from Sept. 21st to March 20th inclusive, when it is rung at 20 minutes after sunset.

YARD GATES,
Will be opened at ringing of last morning bell, of meal bells, and of evening bells; and kept open Ten minutes.

MILL GATES.
Commence hoisting Mill Gates, Two minutes before commencing work.

WORK COMMENCES,
At Ten minutes after last morning bell, and at Ten minutes after bell which "rings in" from Meals.

BREAKFAST BELLS.
During March "Ring out"........at....7.30 a. m........."Ring in" at 8:05 a. m.
April 1st to Sept. 20th inclusive.....at....7 00 " " " " at 7.35 " "
Sept. 21st to Oct. 31st inclusive.....at....7.30 " " " " at 8.05 " "
Remainder of year work commences after Breakfast.

DINNER BELLS.
"Ring out"...................12.30 p. m........."Ring in".... 1.05 p. m.

In all cases, the first stroke of the bell is considered as marking the time.

For example, Winslow Homer's *The Old Mill* [66], which pictures young women before a factory, was mistaken in its own day as a depiction of 'an old school house, with a group of country girls, dinner buckets in hand going over the lonely wooden path'. Homer created the potential for confusion by painting the setting as a bucolic idyll, with leafy trees and spangled sunlight. Compositional details scarcely lead the viewer to reflect on the grind of factory work; the attire of the woman setting off across the bridge, for instance, Bryan J. Wolf identifies as 'fashionable'.[15]

Opinions vary as to the degree of onerousness mill work entailed, but in Massachusetts, where working-class women had comprised an ever-increasing segment of the industrial labour force from the early 1800s onwards, employees' daily lives followed the mill's stringent hourly regimen. A timetable of the Lowell Mills for 1851 [67], adjusted for periods of daylight, sternly warns that the yard gates will be opened 'at ringing of last morning bell … and kept open ten minutes', while breakfast and dinner bells kept those pauses to a strict 35 minutes. 'In all cases,' decreed the timetable, 'the *first* stroke of the bell is considered as marking the time.' It may be that Homer's painterly decoys disguise lives commanded by the morning (afternoon and evening) bell, lives as mechanized as ironworkers'.

On the domestic front, Catharine Beecher and other domestic advisers attempted to maintain a distinction between home and the workplace by treating the former as the domain of 'natural' time.

Women were supposed to manage their household tasks according to a sense of duty unrelated to commerce. 'In setting the terms of their labor,' O'Malley remarks, '[housewives] answered to God', a condition which merged 'morally virtuous hard work and religious feeling' with 'natural' time.[16] One of the tenets underpinning the widely admired domestic scenes painted by Lilly Martin Spencer (1822–1902) acts on the interdependence of natural time and women's household chores, especially where preparing or preserving food is concerned. Fancies mingling bountiful harvest, biblically ordained economic thrift, and household cosiness inform every lovingly rounded apple, every crisp cabbage, of Spencer's highly detailed paintings. In the eighteenth century, women even of the elite classes had been intimately involved with the family's prosperity as workmates and economic producers. Now responsible for ensuring that domestic chores were efficiently carried out by someone else, affluent women could not risk their moral position by dispensing with all domestic obligations and so ended up a mixed breed of household manager and servant themselves. From this angle, it matters little whether Spencer portrayed a serving girl or the woman of the house performing work in *Kiss Me and You'll Kiss the 'Lasses* [**68**], for the point of her genre, like the prints of Currier and Ives, lies in its validation of the home run by women as a bastion of comfort and of values linked with God's cycles of time.

As the only professional employment available to women outside the home for most of the century, teaching related to the ideology ruling the importance of woman's work in the home. Not only managers of domestic knowledge, mothers nurtured future citizens,

68 Lilly Martin Spencer

Kiss Me and You'll Kiss the 'Lasses, 1856

Commissioned by the Cosmopolitan Art Association, a more commercial and less high-minded organization than the AAU, Spencer's scene was directed towards a female market, as were the majority of her domestic topics.

whose self-control, diligence, rectitude, and ambition derived from the moral lessons they instilled, especially through reading. Platt Powell Ryder's (1821–96) *The Illustrated News,* formerly *Learning to Read* [**69**] looks like a demonstration—though it's not—for the American Society of the Diffusion of Useful Knowledge's 1837 tract that preached, 'an entertaining book is one of the strongest keepers [*sic*] a child can have'. In fact, not only discipline but class distinctions were imbibed as the mother read to or with the child, for she also chose what was read. Ann Douglas characterizes the 'improving' literature most often appreciated by middle classes in this regard as 'a form of leisure, a complicated mass dream-life in the busiest, most wide-awake society in the world'.[17] In this light, Ryder's fastidiously sentimentalized canvas, and its plentiful brethren, may appear less mawkish to the censorious eyes of a later, reputedly unsentimental day.

From a mother teaching her own children to a woman teaching the children of others, the jump is large, and it was bridged by religion: Sabbath, or 'Sunday', Schools began in England in the late 1700s as a measure to teach poor children to read the Bible. These schools were launched in the United States in the early nineteenth century and were taught by women. Normalizing women's role in education outside the home, the prevalence of Sunday Schools contributed to the domination of women in the American classroom in secular primary-level education. On the other hand, efforts of reform-minded women to extend their educational authority beyond the family and the public school in order to change the culture and values of urban working-class children, especially immigrants, frequently met with failure.

70 Winslow Homer

Cotton Pickers, 1876

In its stillness, its classicizing
of workers' bodies, and its
exposure of those bodies
within or against a light field,
Cotton Pickers resembles
Ironworkers' Noontime **[61]**,
though the element of time as
a control of labour remains
'natural'.

Professional minority and genteel reformers aside, only women worked; ladies didn't. 'Women might work, but not ladies; or when the latter undertook it, they ceased to be such', explained a mid-century woman.[18] In another locutional refinement, which came into currency early in the century, the word 'servant' was bypassed through turning 'help' and 'domestic' into nouns. By 1880, 40 per cent of the working women in New York laboured in someone else's household and the vast majority of these 'domestics' were single white immigrants, English speakers preferred.[19] Urban immigration steadily diminished the role of the black servants who had traditionally filled these posts, until by mid-century they constituted only 3 per cent of that workforce in New York City.[20] Unsurprisingly, American genre paintings seldom dealt significantly with black women workers. Of course, there are exceptions.

One of the most striking examples of Winslow Homer's humane recognition of the conditions in which former slaves restarted their lives as citizens after the Civil War is a painting of black women in the fields, *Cotton Pickers* **[70]**. Two foreground figures stand as though being exhibited. Daringly, Homer paints them neither labouring eagerly nor resting indolently but openly bored with their job. Capitalizing on the women's statuesque dignity and reserve, he refuses to allow the viewer to feel either pity for their poverty or derision for their (presumable) laziness. Homer manifests the so-called double marginalization of black/women more powerfully through emotional and psychological restraint than the most dynamic outbursts on race and reconstruction managed to achieve. Nonetheless, Homer's

painting understands its era through formal means. Black—or more accurately and tellingly, shades of brown—skin against a creamy, opalescent, peach-tinged and gold-flecked white field of fleecy bolls and clouds yokes rather than separates figures and landscape as strategic materials for an industry that ate them both up.

Child labour

Post-war transformations of American life were echoed (but not reflected, I think, genre painting being as much an agent as a result of change) in genre's shift to different motifs associated with newspapers, their distribution by newsboys ranking high among them. If the cultural work genre painting invested the labour of men with manliness, this reformulation of newspapers' role in genre, from being read to being sold, from information exchange to economic exchange, showed boys being introduced to the roles they were to play as men in the marketplace.

The proliferation of newspapers, and especially the introduction in 1833 of the penny press aimed at the working man and woman, snared the impoverished urban child in print capitalism's web.[21] 'Newsies', boys and sometimes girls whose life on the street hawking newspapers marred their childhood and brought them into physical danger, appear in paintings, prints, and photography as an exceptionally resilient bunch, a slant that detoxifies the hardships the majority of them experienced. Like the relentlessly inspiring popular tales of Horatio Alger, these images of labouring children reassure audiences that self-sufficiency, a primary value of democracies, guarantees any clean, hard-working, honest youth ascendance to middle-class salvation: the commercial sphere. Conversely it was possible to blame unmitigated poverty on the failure of the impoverished to work hard enough. Either notion precluded picturing newsies as victims of a volatile, corrupt urban milieu; and if a breath of reform exuded by genre did waft amongst the gallery-goers, it was borne along by a belief that children possessed more pliancy than hardened adults and were susceptible to reclamation, notions that allowed more optimism to be projected on these images than they perhaps deserved.

Edward Bannister's (1828–1901) *Newspaper Boy* [71] qualifies as a hygienic and well-fed specimen of his breed, thus a boy sure to be only temporarily on the street. The whole of a newsie's existence in genre painting—his future especially—is incarnated by a body that is sturdy, square, and healthy. For Bannister, himself black, endowing a mulatto newsboy with a strong and upright body gave the youth a measure of respect. Painted in Boston, where Bannister worked amid the growing tensions of a city newly inundated with former slaves competing with Irish immigrants for low-paying but scarce jobs, *Newspaper Boy* expands the figure to fill the canvas space, a powerful signal.

It is instructive to compare Bannister's static image of a newsie to the boys grabbing packets of the *Daily Evening News* from a delivery wagon like infant animals pushing their instinctive way to a teat in William Hahn's (1829–87) *Union Square, New York City* [**72**]. Hahn had moved east from San Francisco the year before, a relocation that perhaps accounts for the originality and iconoclasm of his urban scene. Unlike most New York artists, Hahn painted a candid scene of urban class divisions, candid because he did not attempt to make the genteel citizens acknowledge the underclass so noisily in their midst. Although the newsboys occupy centre stage on the canvas, they are

72 William Hahn
Union Square, New York City,
1878

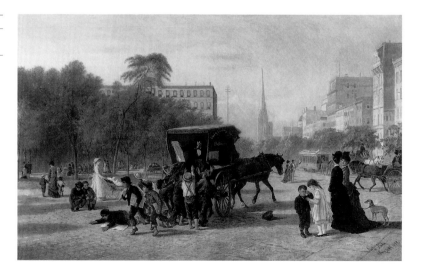

eerily invisible to the other city dwellers around them who, almost trance-like, parade their dogs, perambulators, children, or carriages without glancing at the scrambling mass.

As the number of children labouring in non-farm settings grew, and their plight worsened, not just on east-coast city streets but in mid-Atlantic mining towns and rural southern textile mills, only a limited number of genre artists undertook the subject of working children—not to say destitute ones—at all and when they did, the image almost always laid claim to sentimental notions of innocence rather than childhood's forfeiture to the dollar.[22] The boneless and bloated forms of David Gilmour Blythe's (1815–1865) urchins which rhyme the deformed life such children led are an exception; it is possible his art has been itself bent interpretatively by historians in consequence.

Blythe never glossed over the degradations of city life, which may be why, in company with his unrealistic style, his art receives the appellation 'satire'. Since he began as a journeyman portraitist with only scant training (and his portraits are equally poorly worked out anatomically and grim to the point of flintiness), it could be argued that his shaky grasp of principles of anatomy and form have been mistaken as caricature. On the other hand, in common with his viciously worded diatribes against urban immigrants, blacks, and politicians—he lived in the manufacturing city of Pittsburgh at mid-century—Blythe's merciless images of street children suggest a personal confrontation with evils, in this case corruptions wrought by hunger and vice rather than the ridicule of a morally indignant observer.[23] He did admire cartoons and

73 David Gilmour Blythe

A Match Seller, c.1859

Apropos democracy, which he clearly did not think included social equality, Blythe wrote in 1856, 'I deem him guilty of constructive manslaughter who persists in exercising his privilege of franchise without any intelligent knowledge of what he exercises it on—and a fool can often.'

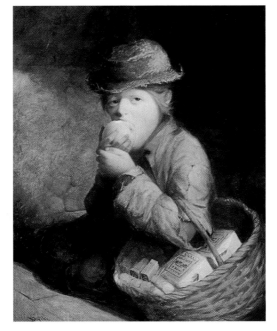

illustrations in journals, so maybe he aimed at being a satirist in paint with pictures other than street children, but *A Match Seller*, also called 'The Boy Merchant' and 'Boy Eating Apple' [**73**], isn't humorous or pointed in any moral way—just painful.

Out of work

The great task of typologizing democracy in the second half of the century lay in addressing, and for the most part countering, challenges thrown up by an increasingly importunate industrialized and urbanized sector. While national personifications manifest something of this dynamic in efforts made by nativist or American-born groups to control or manipulate well-known symbols like Uncle Sam or Columbia or the Statue of Liberty, work-related genre painting consolidated the male role in a democratic society by reinforcing the masculinity of work through characteristics assumed to be the mainsprings of democracy or associated with democracy's early successes. Much of visual art's own work in this regard is enacted on the male body: on the bodies of sturdy boys in tattered clothes whose grubby street jobs will pay off in prosperity, on a relinquishment of 'loose carriage' in favour of a machine-like hardness in work and play. When the challenges of industrialization and urbanization became perceived as threats to democracy, as happened in labour strikes, at least one sculpture met the demand of typologizing upheaval and reaction by commemorating a dead male body and re-employed a female personification as disorder's harbinger rather than harmony's embodiment.

In the spring of 1886, an issue based on time and control of labour exploded in violence at Haymarket Square in Chicago, a city possessing the largest immigrant population in the country. On 4 May a strike to cut the 12-hour day to 8 at the McCormick Reaper plant, which made machines for farming, was disrupted by Chicago police. Four striking workers were shot. To protest the deaths, 2,000–3,000 supporters gathered that night at Haymarket Square in a peaceful demonstration that ended in bloodshed when a bomb went off, killing seven policemen. Retaliating gunfire killed an unknown number of protesters (no official count was ever made) and scores were wounded. After detaining hundreds of people suspected of being radicals, many of them immigrants, the police charged eight anarchists with conspiracy. Although only two of the defendants could be proven to have attended the Haymarket demonstration, all eight were convicted. One escaped the death penalty, while two others were given clemency and another died in his cell under mysterious circumstances.

On 'Black Friday', 11 November 1887, the remaining four were hanged. 'The day will come when our silence will be more powerful than the voices you are throttling today', proclaimed August Spies, a German immigrant, before he died. Nearly 20,000 people attended

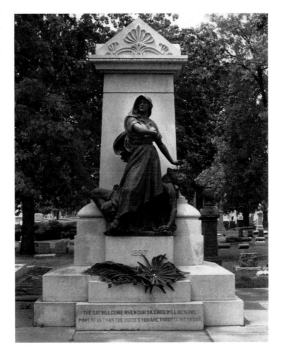

the men's funeral; they were buried in suburban Waldheim Cemetery, a haven for immigrants. (Another German-American, Illinois Governor John Altgeld, pardoned all eight convicted men in 1893.) Now called by its English name, Forest Home, the burial site contains a monument raised to the 'Haymarket Martyrs' [74], one of the few works of American art to recognize labour resistance in an era of relentless social and economic unrest. The Haymarket affair was not the first or the last strike to draw blood, nor, in the coming decades, did any industry, not even farming, escape labour's discontent as the century lurched to a close.

Agitation for a monument began in 1887, partially in reaction to a proposed monument to the policemen killed at the event which, it was feared, would draw commemorative publicity and authorize a flawed version of history. Created by Johannes Gelert (1852–1923), a Danish immigrant, the 1889 *Police Monument* (also called *The Haymarket Monument*) turned out to be an inadvertently comic sculpture of a colossal policeman who looks as if he is directing traffic. Meanwhile, the Pioneer Aid and Support Association collected its funds from 'progressive', that is, left-wing, workers throughout the United States and, after an open competition to choose an artist and a design, selected a German immigrant, Albert Weinert (1863–1947). Inspired by German poet Ferdinand Freiligrath's 'Revolution', Weinert's composition featured Spies' last words, and an aggressively defiant female figure bestowing the laurel wreath of Fame on a supine male corpse. It's

obvious to whom the corpse refers, but what name should be given to the woman? As an allegorical figure with working-class markings (apron, rolled-up sleeves, and powerful arms, not to mention her anger), she contrasts potently and shockingly with the 'solid, staid, and iconic' *Liberty Enlightening the World*, Melissa Dabakis observes.[24]

While Weinert's provocative yet solemn monument within the cemetery's tranquil environs became a focus of commemorative activity by radicals, it never possessed a national audience. Likewise, in part because the press tended to link the Haymarket 'riot' with class warfare and 'savagery', the episode itself has often been presented as an anomaly. In the national realm historically, as in democracy's visual typologies art-historically, only manageable conflict—partisan argument on the frontier, urban gaming—seems likely to be tolerated.

Landscape

The place of landscape

From the Hudson River School of the 1830s and 40s, through the Luminist decades around the time of the Civil War, to the variety of styles emerging at century's end, American landscape painting attracts theoretical and formal interpretations that address visual experience in and of nature. It has also been a flexible and useful iconographic vehicle for the exposition of cultural issues relating to American attitudes towards, and treatments of, the land, from ideology to theology. It might even be claimed that nothing has been quite so preoccupying in the formation of an American art history during the late twentieth century as nineteenth-century landscape painting.

Early landscape painting has been divided between topographical (views) and imaginary (visions), both governed stylistically by an Anglo-American understanding of landscape convention.[1] Popular as a high art about the same time in both Britain and the United States, landscape had a theoretical underpinning of substance in Britain, where the concepts put forth by Edmund Burke in 1757 permanently tied 'sublime' nature to whatever is wild and awesome, and 'beautiful' nature to whatever is lyrical or serene. At the end of the eighteenth century, the writings of William Gilpin made a case for what has come to be another aesthetic category, the picturesque—which meant painting-like and, especially, how Gilpin considered both pictorially represented nature and nature itself should be—more or less a cosier sublime. The picturesque was a welcomed concept in the United States, spread by a thriving Anglo-American book trade and by immigrant art instructors.

Interpretations of American landscape, including those by artists themselves, usually invoke landscape painting's adaptability within a nature–culture polarity. That is, landscape art is said to encompass a moral, philosophical, literary, scientific, and political enterprise, fortunately not all at the same time. It has become apparent that a commercial element, belonging to both the production as well as consumption history of American landscape painting, must be added to this arrangement. In terms of production, one might note that American landscape painting, because it is associated more with wilderness than tilled soil and more with experiences of nature than the

Maine

Vermont White Mts

Crawford's Notch● ●Mount Washington

●Prout's Neck

Lake
George

New
Hampshire

Connecticut River

Niagara
Falls New York

Hudson River

Massachusetts

Rhode
Island

Connecticut

Montclair

Pennsylvania

New
Jersey

Maryland Delaware

Virginia

genre's own aesthetic history, accommodated rather than ignored the business of tourism. On the whole, it sometimes looks very much as if American nature *is* American culture, for many viewers at least, a condition that justifies no less than explains the centrality of landscape painting to American art history.

The late art historian David Huntington used to tell this story of his dissertation's inception: when his adviser George Heard Hamilton, primarily a scholar of modern European art, suggested he write a monograph on an American artist, Frederic Church, the bewildered student sought out a biographical dictionary. Finding therein two Frederic Churches, an engraver and a landscapist, he had no idea which of these Hamilton meant for him to study. Huntington's disser-

tation in 1960 helped to resurrect the landscape painter, so much so that a few decades later, when even more of the lacunae on American artists had been filled in, Frederic Edwin Church would seem as integral a figure to American art history as, say, Turner is to the history of English art. Huntington himself was among the group of scholars concentrated enough by number and training to be called the founding generation of 'Americanists'; a remarkable number of them wrote dissertations on landscape painting.

Whence the impetus for landscape's role as historiographic compass? The answer lies in how and when American art history became academically legitimate. In the academic sphere overall, a substantive discipline called American art history was hard to locate prior to 1960.[2] Around that time, a handful of teachers known as specialists in other fields, like Hamilton, or the Indologist Benjamin Rowland, served as mentors to the founding generation. If their interest in American art was secondary, it was never inconsequential. Rowland, for instance, edited a new edition of James Jackson Jarves' 1864 *Art-Idea*, which, along with the art histories of Jarves' contemporaries, William Dunlap and Henry Tuckerman, was reprinted in the 1960s. (And it was Jarves who announced, 'The thoroughly American branch of painting … is the landscape … It … may be said to have reached the dignity of a distinct school.'[3])

Museums, in contrast, housed active departments of American art or concentrated entirely on it, like New York's Whitney Museum of American Art, which began in 1930, and the Butler Institute of American Art, which opened in Youngstown, Ohio, in 1919. A 1938 American landscape exhibition at the Whitney launched one of its greatest curators, Lloyd Goodrich, on studies of turn-of-the-century painters Winslow Homer (1836–1910) and Albert Pinkham Ryder that—along with the Chicago Art Institute's 1945 showcasing of the Hudson River School—contributed to the received shape of American landscape history: peaks at either end of the nineteenth century. In the 1970s, too, after American art had gained an international reputation culturally via Abstract Expressionist painting, museum exhibitions postulated an American landscape lineage to which this style could be attributed.[4]

Of course, university scholarship did not ignore all things American. Taking seriously the nearly universal acceptance of a Euro-American mythology of a New World Eden, American studies yielded a cluster of books during the Cold War years that perpetuated even as they analysed notions of a special American relation to the land, chief among them *Virgin Land, the American West as Symbol and Myth*, by Henry Nash Smith (1950), *The American Adam*, by R.W.B. Lewis (1955), and *The Machine in the Garden*, by Leo Marx (1964). Huntington's thesis on Church, incidentally, bore the subtitle 'Painter of the Adamic New World Myth', which pretty well sums it up.

Although their approach to art history could be characterized as primarily iconographic, with healthy doses of stylistic analysis, the founding-generation Americanists varied methodologically and philosophically, and their work has not remained static in maturity. Along with incorporation of eco- and social history, a recent crop of art historians folds aspects of theory—prominent among them Foucauldian and phenomenological—into iconographic study, projects conducive to analyses of landscape painting as message in medium, to be read within aesthetic or cultural concerns.[5] What is being written currently, in other words, doesn't leap from the foundational moment; it rests on it. With this in mind, this chapter looks at some of the reasons why we study what we study in American landscape and what we talk about when we do.

Thomas Cole and the Hudson River School

American landscape history notionally begins with Thomas Cole, a painter whose narratives occasionally seem platitudinous and whose draughting skills sometimes failed to rise above the mediocre. In his own day Cole was praised lavishly for what, where and how he painted. Men who made art, wrote about it, or bought it took Cole's art to be national: American wilderness in an American style. In fact, Cole's American subjects are limited to the north-east, where he and his admirers lived; theirs was a parochialism on so large a scale that it ceased to be insular thinking at all but became instead its obverse. Cole's creative and sincere grappling with the combination of aesthetic and spiritual challenges that picturing wilderness presented continues to attract connoisseurs and historians today.[6]

Patrons and promoters

Foresighted merchant–patrons helped Cole make his name in New York—men like G.W. Bruen, who advanced the young man funds to take a first excursion on the Hudson River and so matched painter to picture-prone region, or Luman Reed, who encouraged Cole in his most ambitious meta-landscape projects, among them the five-canvas *Course of Empire* [**78**]. After Cole's early death, his fame increased thanks to the efforts of his minister, Louis Legrand Noble, who in 1853 published a biography of Cole (reprinted in 1964). But William Dunlap, whose influential *History of the Rise and Progress of the Arts of Design in the United States* extravagantly characterized Cole at the beginning of his career as 'now one of the first painters in landscape … that the world possesses', probably gave him the biggest boost.

While Dunlap was writing his book, Cole visited him, leaving behind 'some sheets of biography' which Dunlap read and offered to use to 'manage the story'. All succeeding nineteenth-century accounts of Cole only encrust Dunlap's tale about an immigrant boy from England

who wandered the wilds of Ohio learning to paint, who purportedly swore that he would surrender his left hand to be identified with America, and who struggled 'steeped to the very lips in poverty' until he moved to New York City and his paintings were displayed in a shop window where their genius amazed three artists (one of whom was Dunlap). Within this scenario, in play for most of the twentieth century as well, Cole's early paintings, like *Kaaterskill Falls* [**75**], looked like the realistic renderings of a painter immediately enduring the sublimity of wilderness, instead of the fledgling studio constructions they were.[7]

Kaaterskill Falls

Their name evoking the original Dutch colonial settlement of New York State, the falls belong to a mountain area rich with an ancestry and tradition Washington Irving (1783–1859) utilized (and invented) for fictional characters like Rip van Winkle and Ichabod Crane in two highly popular books of 1809 and 1819. In following years, a visitor could travel up the Hudson River from New York City to the town of

76 William Guy Wall

Cauterskill Falls on the Catskill Mountains, c.1827

The falls and the region—also spelled Catskill, Katterskill, Katskill, and Kaaterskill—were given their name by the original Dutch settlers: a 'kill' is a watercourse.

Catskill on a fast steamboat (later a train, which passed within a few yards of Irving's otherwise idyllic house in Tarreytown), hop aboard a coach to the Catskill Mountain House, which had opened in 1824, check into that hostelry, then take a carriage to an observation platform at the top of the falls or, from there, follow a footpath to their base. It made a great weekend trip from New York City.

This tourist operation was only just beginning when Cole painted *Kaaterskill Falls*, as thrillingly wild, even other-worldly, a scene as he was ever to envision. Eerie light creates the supernatural sensation, clouds shadowing the sky and the sun refracting around them to fall spectrally on orange and gold leaves. The falls run white through a darkened chasm, and this contrast, as well as the three different perspectives from which the falls are depicted, causes the cataract to appear to jump towards the spectator. An interior spectator, a generic Native American of the sort who is difficult at first to see and afterwards hard to lose, amplifies the scenery's primordialism.

William Guy Wall (1792–after 1864) may serve as an example of the path not taken art-historically. Not much older than Cole, and like him an immigrant (though from Ireland), even beginning his career in the United States at the same time as Cole, Wall's views of an 1820 summer spent in the Hudson River area were published as coloured aquatints in *Hudson River Portfolio* in the same year Cole made his first Catskill paintings. Wall's watercolours, and at least one oil painting of the Catskills, were generally well received. In his canvas of the Kaaterskill Falls [**76**], exhibited at the National Academy of Design in

1827, Wall's viewpoint, from a cave behind and to the side of the waters, results in a truncated cataract; though he depicts hills that are forested and wild, he also includes tiny tourists, well dressed and gesticulating, at the picture's heart.[8] What combination of talent, opportunity, time, and place brought success to Cole in his own day and stunted the reputation of Wall? Why did critics like Jarves call Cole a 'father' of American landscape but only glance at Wall? Answers to these questions encompass factors much larger than simply comparing a monumental talent like Cole with the smaller scope of Wall, but one difference that stands out is how consistently Cole was able to purvey the idea of a stupefying wilderness, even one with settlers.

The Oxbow

Cole understood intuitively, I think, that viewing landscape constitutes a learned behaviour, a notion implicit in the word 'picturesque'; and, if picturesque names that moment or process whereby the natural environment became constructed as a 'view', one might consider a work like *The Oxbow* [77] in light of a suggestion that Cole instilled in his audiences acceptance of the 'artist-prophet's relation to [wilderness] in mythic terms'.[9] Widely viewed as a quintessential Hudson River School painting, not only because it is exemplary in subject and style for later artists but also because it is majestic and complex, this

77 Thomas Cole

View from Mount Holyoke, Northampton, Massachusetts, After a Thunderstorm (The Oxbow), 1836

In Cole's nature, blasted trees perform various roles, here acting like a curtain being pulled aside to disclose the scene as well as the agent doing the pulling.

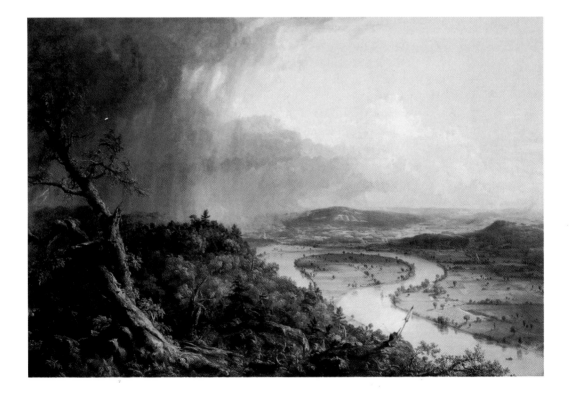

scene of the Connecticut River depicts another locus of growing tourist interest. During the boom years for travellers up the Hudson, while some tourists went west to reach the Catskills, or to the more distant Niagara Falls, others fanned out into the White Mountains of New Hampshire or, as here, the scenic reaches of Massachusetts.

In his composition, Cole lays out the distant view of cultivated land in summer as if from above, though not necessarily from the mountain summit, but he uses a different viewpoint to portray the interior of the woods which contains an artist's painting paraphernalia conspicuously bundled on an outcrop. The artist himself sits deeper in the brush, facing not the view but the viewer. If the image represents the artist–prophet, what bearing does that have on the viewpoint here, which is towards the beautiful, the cultivated farmland, suppressing the sublime, the forested mountain?

The storm revealed in *The Oxbow* by wilderness itself is but a reminder, as it is in almost all of his Catskill paintings, of constant change. Cole's paintings intuitively visualize what ecological historians reiterate today: wilderness, like nature itself, is not stasis but flux. In *Kaaterskill Falls*, flora ('in every stage of vegetable life and decay', as the painter put it), and water, and Native American, do not exist in undisturbed balance. Nature and human history are already, have always been, engaged. The development of the Catskill region, the tourists and manufactories that Cole simultaneously acknowledged and masked, simply continue that interaction, taking it in a new direction. Cole's landscapes admit another related idea that is hard to wrap the mind around, which is that nature 'is not', as William Cronon remarks, 'nearly so natural as it seems … it is a profoundly human construction'.[10]

Most of the *Oxbow* canvas, strikingly, is given over to sky. As the storm passes off, its vestiges cloud patches of the land. Atmospherically, Cole's painting grasps at a kind of authenticity unknown in prior American painting, a point not lost on Barbara Novak, a key figure of the founding generation, who described *The Oxbow* in terms of its 'sensitivity' to matters of light and the 'freshness' of its observation. Her stylistic analyses of Cole, which find their strength in the nineteenth century's understanding of, and fascination with, science, flesh out a side of the artist in danger of being lost amid claims for what is generally assumed to be the ascendant influence in this period of American landscape painting: Transcendentalism.[11]

Novak herself could be named the art historian of Transcendentalism. Cynics might say that Transcendentalism was attuned to American tastes because, though without a dogma or even a precise set of characteristics, it read like a religion and talked like one, too— features that lent every utterance terrific moral weight. So when Transcendentalists perceived God, or the 'Oversoul', everywhere but

only to be known in the act of seeking—especially in solitary communion in nature as recommended by Ralph Waldo Emerson and Henry David Thoreau—the implications for landscape painting were acute. What is more, Transcendentalism valued individuality and nonconformity, qualities many American believe may be equated with their own love of liberty and their pioneering—for this read *expansionist*—spirit. Significantly, the history of class differentiation offers an unexpected bridge between Transcendentalism and the Hudson River School in that, through the endeavour of landscape viewing, upper and emergent middle classes could gauge their separateness from working classes (who were supposed, for reasons social and economic, to be unable to aestheticize nature) but yet rationalize such leisure activity as gave them the opportunity to view landscape—travel, walking in the woods, looking at art—as moral improvement.[12] In the event, there seems to be no chance of escaping Transcendentalism when talking about American landscape because intellectual propinquity has linked the two in a chain of rhetoric that has proved remarkably resilient.

Cole, for whom the wilderness and God were one (One), was much praised by the Transcendental poet William Cullen Bryant (1794–1878). A fixture in New York literary circles for 50 years, Bryant designated Cole's landscapes 'acts of religion', which made them a hard act to follow, and wrote poetry characterizing him specifically as an *American* artist. Bryant's Transcendentalist musings on nature and art weighted future readings of Cole's paintings by the founding generation, and they have monopolized art-historical regard for Cole's cohort, Asher B. Durand.

The Course of Empire

Cole and his contemporaries accorded history's cycles—birth–life–death, but also rise and fall—a premier position in their conception of the past. Cole's five-canvas *The Course of Empire* [**78**] begins with an aboriginal past leading to a pastoral age that then passes into a luxurious but ultimately calamitous state, concluding with nature reasserting itself amid the ruins of humankind's puny agency.

In the sense that all historical theory was teleological until the early twentieth century, Cole's narrative fits into an understanding of the cyclical passage of time common to both the Enlightenment and Romanticism, much like Gibbon's eighteenth-century *Decline and Fall of the Roman Empire*. Cole himself probably drew directly upon *Ruins, or Meditations on the Passage of Empires* written by the imprisoned Comte de Volney, a victim of the fast-changing power structures of the French Revolution. Itself bringing a stop to one empire, on the verge of inaugurating another, the Revolution stimulated the kind of

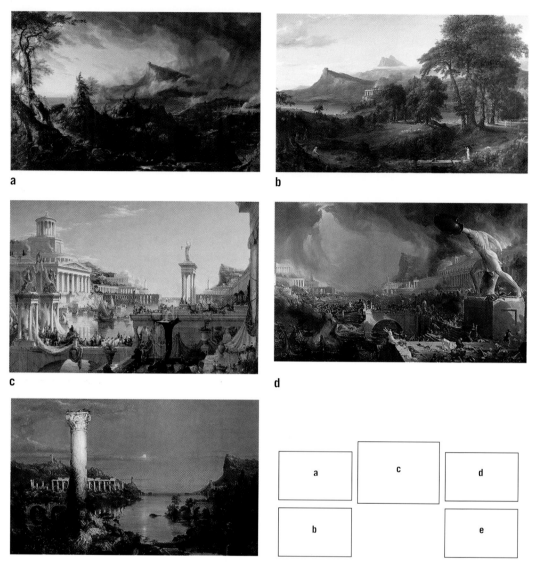

78 Thomas Cole

The Course of Empire, 1836

Originally displayed as shown *right*, the five canvases are identified as a) 'Savage State'; b) 'The Arcadian or Pastoral State'; c) 'Consummation'; d) 'Destruction'; and e) 'Desolation'.

Romantic pondering the poet Percy Bysshe Shelley (1792–1822) turned into a universal symbol of the mutability of power in 'Ozymandias'. Something of a Romantic himself, in these canvases and others Cole revealed ambitions for landscape as history that were probably impossible to achieve, which is why, despite his considerable success, he lamented toward the end of his life, 'I am not the artist I should have been had taste been higher.'

Asher B. Durand

In 1849, the year following Cole's death, Jonathan Sturges commissioned Durand to paint a landscape which Sturges then gave to Bryant. Although one recognizes gestures towards Cole's manner of painting, for instance in the spatial closure of the mountain range and the cycle of life-and-death-in-nature taking place in the foreground, *Kindred Spirits* [**79**] displays the firm but mild hand of Durand as an independent painter rather than, as implied by his second billing within Hudson River School lore, Cole's acolyte.[13] An off-centre placement of the two figures, who are neither prominent in the foreground nor dismissed to the middleground but stand, spotlit, between each register, is balanced by a jutting escarpment forming the right side of an oval landscape frame. Reaching across the bottom of the canvas in a tumble of rocks and trees, the organic frame climbs a dramatically tall birch on the left side to arch gracefully across the top on a tender-leafed bough. Both seamless design and moderated details work about as differently from Cole's alternating thunder and pellucid sunniness as possible.

For David Lawall, whose 1966 dissertation reintroduced the painter, Durand supplants Cole as the 'dean' of American landscape painting. If so, in this capacity, he seems to function more as teacher than patriarch. Durand's 'Letters on Landscape Painting' embody more instructional advice than philosophical or religious reflection, albeit he was a deeply religious man and the name of the 'Great Designer' makes periodic appearances. Published in 1855 as a series in *The Crayon*, the leading art

79 Asher B. Durand

Kindred Spirits, 1849

The painting memorializes Cole, portraying the artist and the poet William Cullen Bryant within an encircling Catskill forest.

periodical of the day, Durand's essays advocate drawing 'with scrupulous fidelity the outline or contour of the object' and, then, 'long practice', methods innate to this painter, who began his career as a well-regarded engraver. So conscientious in observation and representation that, according to Tuckerman, his paintings would be empty-looking if Durand had not managed to make exactitude stand in for quantity, landscapes like *American Wilderness* [**80**] offer the results of a methodology akin to a specimen painter's: 'If your subject be a tree, observe particularly wherein it differs from those of other species … the termination of its foliage …whether pointed or rounded, drooping or springing upward, next mark the character of its trunk and branches, the manner in which the latter shoot off from the parent stem, their direction, curves, and angles.'[14]

In addition to the emphasis on drawing and 'truth to nature' which bring Durand within a naturalist's or specimen painter's purview, the blend of aesthetic purpose and scientific accuracy he espoused also appear in the work of certain American painters who modelled themselves according to the pronouncements of British aesthete John Ruskin (1819–1900). Ruskin's 'artistical geology' won a wide audience in the United States, initially among readers of *The Crayon*. It seems very much to the point in freeing Durand from Transcendentalism's exclusive company that Ruskin's particularizing ('a rock must be either one rock or another rock; it cannot be a general rock, or it is no rock', he decreed) accorded with Durand's proclivities rather more than ideas of universality.

80 Asher B. Durand

The American Wilderness, 1864

A scene of utter placidity, the painting demonstrates the difference between Durand's concept of 'wilderness' and Cole's dramatic one.

Luminism

At stake in the nineteenth century's glorification of a Hudson River School and of Cole in the dual role of parent/practitioner lay claims for a distinctively American art. There exists no means of deciding what 'American' means in such usage; the point lies in making the assertion. Luminist painting has been read by its twentieth-century formulators very similarly: as uniquely and typically American. No individual name stands out among Luminist painters, however, because the idea of Luminism works better if thought of 'as a mode to which artists had recourse whenever it was formally and philosophically viable'.[15]

Lake George in upstate New York, which John F. Kensett (1816–72) in his pre-Luminist days depicted as sprightly and glistening, became the image for a 'formally viable' 1869 Luminist painting, remote and solemn, in consequence of a head-on, tightly chromatic vision. Whereas Kensett's 1869 *Lake George* [**81**] seems to envelope insubstantiality, Martin J. Heade's (1819–1904) 1862 *Lake George* [**82**], another Luminist icon, appears hard all the way through, an overlit stage giving equal attention to surreally meticulous rocks and a boyish figure held fast in the washboard ridges of the solid water. In addition to low-key palette and water-related site, these two paintings, despite their differences, share other characteristics of Luminism as defined by its leading authorities: the key element of light, which 'tends to be cool, not hot, hard not soft, palpable rather than fluid, planar rather than atmospherically diffuse'; horizontal compositions ordered by ideational measure; canvases that are smallish, with smooth surfaces.[16]

First bruited only in 1954, when the word was coined by John I.H. Baur, Luminism initially looked like a project designed to seize for American art something it has rarely held (or sought): a formalist high

The Crayon

Among self-promoting house organs for institutions—like the Cosmopolitan Art-Union's *Journal*, and the *Bulletin* of the American Art-Union—and literary magazines with serious art interests—like *The Portfolio*—*The Crayon* stands apart. Published weekly from 1855 to 1861, it was the first, and arguably the most important, periodical devoted to the visual arts in nineteenth-century America. Editors John Durand (son of the painter Asher B. Durand) and William J. Stillman (spokesman for American Pre-Raphaelites) served the audience for landscape painting particularly well. The senior Durand's 'Letters on Landscape Painting' appeared in *The Crayon*, helping to prolong the influence of the Hudson River School, and the journal's exposition of John Ruskin's aesthetic doctrines furnished support for claims of Nature's moral force, instrumental to many branches of American landscape art. In addition, first-person reports from American artists travelling or studying abroad not only brought readers news of current European trends but also enticed them across the Atlantic. Stillman himself left to become the United States Consul in Rome, and his departure during the Civil War spelled the end of the journal.

ground. That was not to be. The desire to see American landscape painting by Transcendentalism's light burns brightest in explanations of Luminism, though drawbacks to making this association, which has an intuitive rather than an evidentiary base, can be troubling.

Of the Transcendentalist–Luminist nexus, one might also note that while Luminists created canvases that in their lucidity beg to be thought of as parallels to Emerson's famous 'transparent eyeball' in Nature, they did not have much involvement with the reformist activity or rhetoric that increasingly became central to Civil-War-era Transcendentalism. One thinks of Thoreau and his influential 1849 essay, 'Civil Disobedience', laying out a strategy of passive resistance that would still be instrumental for reform in the United States more than a century later, but other examples, like that of the fiercely anti-slavery Transcendentalist editor of *Harper's Weekly*, George Curtis, come to mind too. In Rome in the late 1840s, Kensett began a lifelong friendship with Curtis, but Curtis' influence appears to have been confined to introducing the eminently clubby Kensett to social institutions like the all-male Century Association in New York City and to other Transcendentalists, who constituted an intellectual elite.

Kensett's patrons chiefly sprang from among the metropolitan mercantile class who frequented organizations like the Century Association. In contrast, Heade, a mobile New Englander who also lived in Brazil and Florida, attracted a more economically circum-

81 John F. Kensett
Lake George, 1869
The painting suggests a kind of cushioned silence, achieved by lighting that imparts a mood of august repose and augmented by the stillness of the vapour-shrouded water.

82 Martin J. Heade
Lake George, 1862
Despite calm water, the scene's peculiar glare and low-hanging clouds presage rain.

scribed clientele. Producing some of their best painting in the 1860s, neither was seriously inconvenienced financially by the Civil War. Painters in the Luminist mode were sympathetic to the Union cause, though few participated in the war itself, Kensett being a prominent exception. Paradoxically, both the imperturbability of Kensett's Luminist paintings, and the incipient storminess of Heade's, have struck contemporary historians as war-related elements.[17]

Frederic Church

Briefly a student of Cole's, Frederic Church spent his maturity as an ardent devotee of Alexander Humboldt (1769–1859). This widely read German naturalist, who characterized, taxonomized, and theorized the physical world, vaunted landscape painting as a crucial manifestation of the love of nature.[18] Humboldt called for a landscape painter-cum-scientist whose subject matter would encompass 'a physical description of the universe' and whose accuracy of observation could serve representation without eliding that ideal with the false goal of literal reproduction. Church responded with paintings that were composites rather than reports, and he won his fame with canvases depicting nature's spectacles: icebergs, volcanoes, and waterfalls. He met with extraordinary success, for a while.

Niagara
Although many artists, including Kensett, felt compelled to paint Niagara Falls, Church's *Niagara* [**83, 84**] has always been singled out. As the most acclaimed site in the United States (that the falls are shared with Canada still gets limited notice), Church's painting represented to his contemporaries something 'truly American'. The canvas

83 Frederic Church

Niagara, 1857

Church's composition views the falls from Canada toward the United States but the artist manipulates the design to include both sides.

distinctively mingles a landscape emblem believed to be capable of inscribing national identity with sheer hydraulics.

It's big, for one thing. Lots of paintings are, of course, but in Church's handling size is no frivolous issue because he perceived that boldness would, psychologically, correspond to expectations about the falls that viewers brought to the picture. Even people who had never seen the falls were acquainted with their majesty, thanks to the outbursts of nearly every writer who visited. Typically, statistics of hugeness and emotions of awe vied for authorial attention. For instance, the Argentinean Domingo Sarmiento, in one schizophrenic paragraph of *Travels in the United States in 1847*, panted, '… at Niagara I felt my legs trembling and that feverish feeling which means the blood has left one's face. … The English [Canadian] falls is in the form of a horseshoe and is four city blocks wide … the water falls 165 feet, and the canal carved in the rock which receives it 100 yards deep and 130 wide.'[19] Church performed the same feat on canvas. The painting manages to appear faithful to the falls physically—their location relative to the shore, how very much water there is—while letting compositional audacity take the spectator away from the safety of an anchoring viewpoint on the land. 'This', gurgled one happy account in the 1857 *Home Journal*, 'is Niagara, *with the roar left out!*'

THE 'GREAT PICTURE' EXHIBITION

The 'Great Picture' exhibition being increasingly common in Europe and America, Church well knew how to display a single big painting like *Niagara* as a showpiece to the largest possible audience. For 25 cents each, art lovers and thrill seekers alike could stare at Church's canvas, sometimes using binoculars or other optical aids, transfixed by the sight and by the thought planted by the *New York Times* (May, 1857): 'Behold! the marvel of the Western World [is] before you.' Accompanied by

publicity that even today looks smooth, the painting also made two successful tours of Britain, where the acuity of Church's eye no less than the accuracy of his detail wowed, among others, Ruskin.

Big, bold, audacious—the adjectives that represent the scale and spirit of Church's depiction of nature's extravaganzas do no justice to his manner of painting its details, which is better described with finicky words like 'additive'. Despite their compositional sweep, paintings like *Niagara* or, even more, like *Heart of the Andes* [**85**], are articulated as scores of details, so naturalistic that his contemporaries were put in mind of photographs, though the level of technology that would equal Church's expanses was years away. Art historians of the founding generation generally and rightly placed Church's geological, zoological, and botanical scrutiny of South America (Ecuador in particular) in the service of his devotion to Humboldt. Recently, Katherine Manthorne has broadened the lure of South America, emphasizing that Church was one of several North American artists to journey southwards. Beyond Humboldtian science, Manthorne points out, South America beckoned North American painters as El Dorado, as (another) New World Eden, and as (another) frontier, tropes that help to account for *Heart of the Andes'* spectacular, and unnatural, luminescence.[20]

Cole's biographer Noble wrote a pamphlet that was sold during the 'Great Picture' displays of *Heart* arranged in various cities by Church's agent, John McClure. Tracts by attorney Theodore Winthrop, a friend

84 Frederic Church

Niagara from Goat Island, Winter, 1856

While Church made drawings during the several forays he took to his chosen site, he excelled in the painting of oil studies, usually on paper, which would also become sources but not templates for the finished work.

85 Frederic Church

Heart of the Andes, 1859

This photograph shows the painting in its specially built frame as exhibited in the 1864 Metropolitan Sanitary Fair (the Sanitary Commission was a predecessor of the Red Cross), where it hung opposite Bierstadt's *Rocky Mountains* [**99**] and in the same gallery as Leutze's *Washington Crossing the Delaware* [**122**].

of the painter, also accompanied the canvas on tour. Fearlessly hyperbolic, Winthrop explained that the artist seeking 'the inmost spirit of beauty' never 'dodg[ed] about … waiting until the doors of her enchanted castle shall stand ajar. The true knight must wind the horn of challenge, chop down the ogre, garrote the griffin …', and so on. Like Noble, Winthrop was a hit with Church's audiences; reverentially murmuring viewers wanted their judgements validated, and paid court to the notion that fancy writing raised the tone of the event.

The exhibition of *Heart of the Andes* in the United States and Great Britain (where Church was compared to the great English landscapist, Turner), along with attendant sales for subscriptions of an engraving, earned Church around $9,000 in addition to the $10,000 William T. Blodgett, a New York manufacturer, paid for the canvas. Tremendous sums—such income made Church wealthy enough to build a residential palace in upstate New York.

That Church astutely marketed his own work does not detract from whatever aesthetic quality his works possess. Church's showmanship is

as valid a part of his landscape painting methodology as his oil sk
on paper. In the post-Civil-War American economy, erratic as e.
its booms and busts but with higher stakes than previously, the large
sums attracted by Church's paintings were not out of keeping.
Nowadays, art historians take seriously the entrepreneurship of artists
as the means whereby fame, like landscapes, was constructed. However,
since he went to some trouble to bolster his own reputation in his life-
time, it is ironic that Church's star should have fallen from the
art-historical heavens even before his death. It wasn't money that
revived the painter's reputation, but the coincidence, in 1945, of the
Cold War-propelled quest for identifying a national art and the obser-
vations of museum curator Albert Ten Eyck Gardner that Church's
landscapes 'functioned as something more than just evocations of spec-
tacular scenery', by which he implied patriotism in paint.[21]
Huntington's dissertation on Church and a 1966 exhibition of his work
both continued in this vein, presenting Church's landscapes as episodes
in the pursuit of Manifest Destiny and, simultaneously, as evocations of
Edenic America.

Landscapes of felled trees

Among the familiar sights of the ante-bellum north-east and a land-
scape motif employed by a variety of painters, tree stumps were the
natural residue of development and cultivation, increasing in number
as an industrializing market agriculture required more and more land.
As early as Cole's stump-laden *Crawford's Notch* [86], the landscape of
felled trees stretched so far westwards that, as Charles Dickens
suffered a bone-jiggling coach ride from Columbus to Niagara Falls
over a ribbed mud track known as a 'corduroy road', the author could
distract himself naming shapes made by stumps 'quite astonishing in

86 Thomas Cole

*A View of the Mountain Pass
Called the Notch of the White
Mountains (Crawford's
Notch),* 1839

Cole's dramatically lit forests,
their denseness interrupted by
jagged shapes, appear to
reject civilization.

their number and reality' much in the way another traveller might while away a journey discerning forms in clouds.[22] In contrast, since Cole harboured feelings of alarm about the encroaching 'ravages of the axe', as he put it in an essay of 1845 on American scenery, *Crawford's Notch* brings stumps into an ambiguous relationship with cultivation: do horse and rider traverse a clearing that attests to man's diligence in making a place for himself in the midst of wilderness or are the stumps relics of destruction that line the trail to the distant dwelling like some blackly comic anti-allée?

In a countryside transforming itself rapidly and thoroughly, stumps like those that dominate Cole's painting might be well-nigh invisible to his contemporaries. In comparison, the stumps in one of Winslow Homer's first paintings, a Civil War scene of 1864, *Defiance, Inviting a shot before Petersburg* [**87**], were as noticeable then as now, yet they become almost negligible because they merge with another kind of landscape, unfamiliar but predictable nonetheless: the demolished terrain of a battlefield. Equivocal circumstances here outrace Cole's: the forest has been cleared to assist depopulation, rather than to accommodate population, which is perhaps why the painting feeds on the morbid visual analogy of tree stump and gravemarker.

In its depiction of a train puffing through stump-scattered hills, George Inness' (1825–1894) *Lackawanna Valley* [**88**] has supplied historians with an opportunity to think about the manner in which landscape painting adjusted its conventions to the technological transformations necessitating forest removal.[23] In this period, the railroad exemplified progress as did no other technological feat, not even the canal system or the telegraph. Leo Marx used Inness' painting to illustrate the means whereby the railroad was, visually and psychologically, accommodated in the New World garden or

Eden. The Lackawanna Valley stumps that litter the hillside are requisite elements, in Marx's view, in comprehending the main thing of pictorial interest—trees conforming to train, and train, to trees.[24]

George Inness

Art history's traditional and important task of ordering styles and schools of art in ways that make sense chronologically and conceptually puts Inness in a dominant position at the end of the nineteenth century, as though he belongs to a post-war generation, yet Inness was a year older than Church. Inness' art-historical life holds more than this anomaly. The mid-century *Lackawanna Valley*, today the work of art most closely associated with him, had no public exposure between the time Inness made it and the 1890s, when the artist himself stumbled on it in a Mexican curiosity shop, though other landscapes Inness painted at this time were well known as descendants of the Hudson River School. Reminiscing, Inness asserted that because his career had 'all sorts of ups and downs and [he] could never make a living in my own country', he went abroad. He spent only one year, 1853–4, in France, and passed far more time in Italy, before and after his French sojourn, but his art has always borne a 'Barbizon' label, aligning him with a school of landscape painting originating outside of Paris. Finally, whereas in his early career hints of extremism in his art were criticized, the increasingly radical style of his last years has strengthened Inness' reputation.

88 George Inness

The Lackawanna Valley,
c.1855

In his late years, Inness referred to this canvas as 'a picture I made of Scranton … for the Delaware and Lackawanna Company, when they built the [rail]road. They paid me $75 for it.'

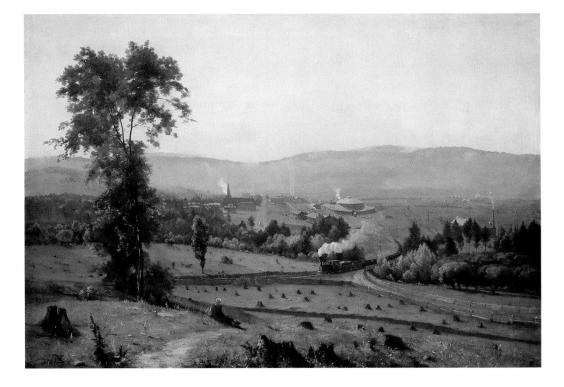

Inness' late landscapes, like *Early Autumn, Montclair* [**89**], belong to a style—an approach to nature, really—shared by certain end-of-the-century American artists who, like Impressionists, responded to nature as visual sensation, painting in France and employing the high-pitched colour and textured surface of their French counterparts, and Tonalists, who used subtle colour relationships and tended to blur form. Repelling labels, Inness' canvas takes up a palette and motif dear to the heart of artists from those regions where autumn's colours suffuse the atmosphere. And that is all: neither scientific, philosophical, literary, political, nor—at least didactically—moral, the painting seems to be merely, and overwhelmingly, an experience of colour and form. Because the pigment and the canvas tend to meld visually, the appearance of the painting comes close to being textured colour.

Albert Pinkham Ryder

A contemporary of Inness, Albert Pinkham Ryder (1847–1917), wrote poetry and painted landscapes of simplified, though far from reductive, vision. For all their personal, even spiritual, qualities, Ryder's works are grounded in compositional considerations, described in an epiphanic moment in 1905: Ryder reported catching sight of

an opening [framed] between two trees … like a painted canvas—the deep blue of a midday sky—a solitary tree—a foundation of brown earth. There was no detail to vex the eye. Three solid masses of form and colour—sky, foliage, and earth—the whole bathed in an atmosphere of golden luminosity. I threw my brushes aside … I squeezed out big chunks of pure, moist color and taking my palette knife, I laid on blue, green, white and brown in great sweeping strokes.

One is reminded of a similar moment described by the Russian modernist Wassily Kandinsky (1866–1944), who opened his studio

door one evening in 1908 to discover 'an indescribably beautiful picture ... on which I could discern only forms and colors. ... It was a picture I had painted, standing on its side against the wall.'[25] Kandinsky's revelation, coming as it did from painting itself, advanced his effort to develop 'pure painting', which in his *oeuvre* is something like a spiritually charged abstraction. Ryder's way of seeing nature resulted in landscapes that adhered to representation but not transcription.

Nuanced light adumbrating the gentle shape that binds upper and lower registers of water and sky, *Toilers of the Sea* [**90**], like all of Ryder's marines, has nature as a theme but scarcely as a topic. The picture is pure rhythmic design in darks and lights; from the elastically shaped, abstract lights, luxuriantly colour-flecked, and from the undulating darks, rich with indeterminate hues, form emerges. Paintings that appear after the Civil War, like this one or like Inness' autumn scene, clearly do not comprise a 'school', though the art in question shares a distinguishing characteristic: it engages the mind primarily through the senses.

Reception of such work has been favourable for the most part, though its later twentieth-century appreciation differs in focus from earlier analyses. In 1907 Charles Caffin praised 'nature poets', creators of introspective landscapes of mood, in his selective *Story of American Painting*. Other critics of the period, like Samuel Isham, recognized how 'mysterious and elusive' these diaphanous and subtle canvases might appear but insisted that their 'poetry is built upon solid fact'.[26] In

90 Albert Pinkham Ryder

*Toilers of the Sea, c.*1882

Idiosyncrasies of painting practice, such as stopping work on a canvas for a period of years and then resuming, have made dating Ryder's work a matter of approximation for the most part.

contrast, Nicolai Cikovsky, who wrote his dissertation on Inness in 1965, leans towards analyses of Inness's art that eschew narrative responses in order to concentrate on formal issues—the nature of paint, of the picture plane, of colour. As with Luminism's interpretations, however, fully articulated formalist readings of Inness or Ryder remain in the minority.[27]

Winslow Homer on land and sea

It would be hard, but not impossible, to argue that almost everything Winslow Homer painted, beginning with Civil War episodes and closing with stormy marines, could be classified as landscapes. At stake in such an argument would be Homer's use of nature as a protagonist in his art just like more obviously performative figures. As a city-bred outdoorsman, Homer was acquainted with nature from a different standpoint than Cole, but both painters sometimes experienced landscape as tourists and betrayed uneasiness in doing so. Of course, Homer lived in a period of better transportation and communication facilities as well as in a society with more leisure time for travel and lots of money to spend on tour. Immediately after the war, however, one gets the feeling that Homer looked aslant whenever he viewed a landscape peopled with America's new tourist classes.

For example, in his 1869 *Mount Washington* [**91**], a spot notorious for its unstable atmospherical conditions, Homer painted the White Mountains with everything, more or less, in the way. Foreground boulders cut off access to the middleground; horses and riders, the latter not looking at the view, form a wall of flesh; and clouds hang so low they contrarily obscure the view as well as the mountain itself. Ever terse, Homer is not Cole, who had one eye on nature and one eye on what people were doing to it. Rather, in this and related post-war scenes of mountain and seaside resorts, he treats many of the conventions, no less than the sites, of American landscape painting with low-threshold cheek.

Not that Homer couldn't be serious, especially when prodded by exposure to places outside the New York–Boston urban axis of his livelihood. Around 1875 Homer visited Virginia, not a casual undertaking in the bitterness of Reconstruction. Later, in the summer of 1880, at the seaside in Gloucester, Massachusetts, he produced scores of watercolours which expanded his already strong handling of outdoor light, as did a sojourn on the North Sea coast of England in 1881–2. Most important, in 1883 Homer left New York City for Prout's Neck, Maine.

Having summered on the spit with his family since 1875, the artist now dug in for all the coast's formidable seasons, allowing himself plenty of opportunities for other outdoor experiences in the sun of the Bahamas and Florida, and the briskness of the Adirondacks. Although

all of his landscapes are acclaimed, Homer's importance for future generations of artists lay in his Prout's Neck seascapes of the 1890s and later. In these, what critics had previously seen as defects of style—that is, lack of finish in surface and absence of refinement in touch—were now admired as 'independence' and a 'savage disregard of formula' by such as Charles Caffin, for whom Homer's originality of vision indicated the artist's 'personal strength'.[28] Savage is certainly an adjective that comes to mind viewing epic paintings like *Eastern Point* [**92**]. In this painting, Homer's glimpse of primordialism—facilitated by his near-perfect meshings of palette, light, and mood—underscores what is constant in nature: its terrible might and its obliviousness to man.

Structuring the latter part of the century as a contrast between the intense individuality of Winslow Homer and the conformism of painters who succumbed to the siren voice of foreign influence is a shibboleth of American landscape history now losing strength. What is more, dividing into opposing camps artists who 'unselfconsciously accepted [Europe] as the cultural fountainhead out of which America's own culture should emerge' at the end of the century and those 'who retained a commitment to the American tradition and to … naturalism' does no favours for a painter of Homer's calibre.[29] Singling him out as the culmination or acme of nineteenth-century American landscape does not render him full justice either. Indeed, in terms of intellectual and psychological complexity, to say nothing of style,

Homer's art probably should not be confined to 'summing up', since in essence he starts something that falls outside the limits of this book. With these drawbacks in mind, it must be admitted that it is also impossible *not* to close a chapter on landscape painting with a discussion of Homer's work in that he, more than any other landscapist except Cole, engages current scholarship—and for reasons at odds with most earlier understandings of the work of American art.

Homer's contemporaries used words like 'virile' and 'rough' in describing the 'out-door type ... descendants of Leatherstocking' in his Adirondack settings.[30] By a process that was not without contributions from the painter himself, what Homer painted and what he was as a man were elided. In the sense that whatever power resided in Homer's landscapes tended to ratify power itself as masculine, the painter's public persona, that of the taciturn bachelor–sportsman, endowed not only his 'hardy' depictions of mountains but also his powerful views of the ocean with a ruggedness that masked other qualities—selectivity, for instance, and sensitivity. By the early twentieth century, assessments of Homer's art as both masculine and, as Royal Cortissoz opined, somehow natural ('almost artless ... unmistakably free')[31] were commonplace. Nowadays, such characterizations, especially regarding Homer's masculinity, are being dismantled.

Sarah Burns, for example, resituates Homer, or rather perceptions of Homer's art, within another very masculine world: big business, and, indirectly, Darwinian models of natural selection that authorized certain kinds of capitalist business practices. A painting like *Eastern Point* might thus be read as one that displaced commerce's 'precariousness and uncertainty, [its] unpredictable and often disastrous fluctuation' on to nature.[32] In this view, Homer on Prout's Neck, his work wrought from and by the daunting yet painter-controlled

elements, could be compared in 'masculinity' to emperors of commerce, a view sharpened by emphasizing Prout's Neck as a developing 'cottage community' in which Homer and especially his brothers were financially involved. Bearing down on this understanding of Homer's landscape does not lessen his accomplishment; on the contrary, his standing among those interested in American art has never been higher.

The American West

Few places on this planet are ignorant of the American West. Cowboy, cowgirl, stagecoach, shoot-out, pony-express, and dozens of other vivid word pictures come as easily to lips speaking Hindi as English, and globally popular art has made it happen. Television and comics owe their stock western imagery to movies, which, in turn, often found their source in fiction like Owen Wister's paradigmatic tale of cowboy life, *The Virginian*, 1902. Wister himself acknowledged certain western art from the turn of the century, grimly stereotyped stuff, as inspiration. In the nineteenth century, arguably, there's a western art prior to the clichés, one more embryonic, that introduced ideas about what the west looked like, who lived there, who wanted to live there, how to use it, how to see it.

Initially, the history of western art generated rather bland narratives, their gist being that the grandeur of the west and the patriotism of certain artists intersected at a point somewhere in the Rocky Mountains. Scholarship heated up in the late twentieth century when art historians began to establish distinctions amongst individual artists. Some went on to allege that western art—popular or 'fine', early or late—fuelled policies of expansion or rationalized its consequences. Running to the core of the work art does, debates on the nature of western art, and this claim in particular, do not arise from academic squabbling but from unresolved issues that touch all Americans to some degree. This is because the history of westward expansion cannot be considered without recognition of its correlate: the death, dispersal, or attempted 'deracination' of the west's native inhabitants. Withal, the concept of Manifest Destiny that underwrote expansion as an ineluctable, providentially ordered right of 'Euramericans' to occupy the continent coast to coast, was—and still is—taken seriously by many people. As Alan Trachtenberg observed when a polemical 1991 exhibition of art of the American West raised the ire rather than the consciousness of a US Senator, 'Along with the landing of Columbus, Plymouth Rock and Thanksgiving, the Battle of the Alamo and the "War between the States" [Manifest Destiny is] one of the foundation myths of American nationalism.'[1]

This chapter looks at some key examples of western art, here

Detail of 106

construed as images of land as well as native and settling peoples, with

the idea of breaching the insularity that has led to widespread insistence on a western realism so extreme as to be labelled 'transparent'. It probes the business of imaging the west and the interrelationships of painting and photography. I take issue with notions of a pristine west containing an indigenous people suspended in time. While settling the lands beyond the Appalachian Mountains required an international cast—immigrants from Europe and Mexico, from Asia and the South Pacific—these peoples flooded western territories that already existed in what William Cronon calls 'a metropolitan orbit'. The heterogeneous aboriginal peoples were deeply enmeshed in trade and inter-cultural exchange and their land was continually altering.[2] Finally, what 'West' *means* changes with settlement, a rolling frontier line moving from Virginia to California, and beyond. A huge number of American paintings, photographs, engravings, chromolithographs, and book illustrations catch something of this vibrancy and complexity before they (and it) hardened into myth.

The cosmopolitanism of the production and reception of western art itself also requires emphasis. That is, whatever American-ness was invested in or applied to the west as idea, the circuit of that idea's existence was always between the west, the east coast, and certain European capitals, notably Paris, London, and Berlin. This circuit was neither sporadic nor incidental.[3] What comes into play in studying western art—issues of race, hierarchies of power, fantasies of the Other—is complicated by Europe's participation in imagining and settling the west.

Of the handful of artists associated with early expeditions west, two made the trip with European patrons, and a third not only published his work first in Europe but had his greatest successes showing his paintings there. In addition, artist–ethnographers, those men who recorded the faces and customs of, especially, the Plains tribes, were among those who fostered or countered conceptions of New World inhabitants as 'noble savages', a term in literary use by the seventeenth century propagating a myth of an uncorrupted wilderness paradise and its inhabitants. One should also keep in mind that the exploitation of the west was fortified by confidence in the *virtue* of Manifest Destiny as a policy and a concept ordaining the triumph of civilization over savagery, a notion that had (sometimes under its alias, 'civilizing mission') quite a good run in Europe's African and Asian colonies. By century's end, transatlantic fascination with the American West was commonplace: German readers snapped up adventure stories set there by novelist Karl May and British tourists purchased made-to-order Yosemite landscapes as expensive souvenirs.[4]

A note: twin demons of convenience and convention encourage the retention of certain monolithic terms. Readers should accept that 'west' stands in for diverse western regions—desert south-west,

forested north-west, mountains, plains, amber waves of grain—and characterizes, more or less, the entirety but not the specifics of 'west'. Also, I assume that the terms 'Native American' and 'Indian' used interchangeably, as in real life, carry no disrespect.

Moving west

Painted in San Francisco by the German-American William Hahn, *Yosemite Valley from Glacier Point* [**93**] superficially has much in common with Homer's depiction of visitors to the White Mountains [**91**]. Both portray the fixed travel patterns of a certain class: refined figures transported by staid hired horses to a summit in an area well known for natural splendour. Homer's tourists, skimpily realized as though the mist blots out their substance, hold a commanding position in relation to the size of the landscape, but inclement weather leaves them very little to see. In contrast, everything in Yosemite, from the gleaming hide of a chestnut horse to the snow-capped mountains, stands available to sight, ours and Hahn's tourists, through the instrumentality of a clean light that offers up details just this side of fussiness. Miles away, a waterfall sets a scale calculated to reveal the immensity of the canyon stretching to the horizon and limitlessly to either side.

While Homer mocks conventions of tourism, Hahn supplies the picture-postcard effect of a stupendous geological formation reduced to sight-bite. That's one reason why Homer's image is compelling whereas Hahn's canvas seems a bit simplistic. Still, *Yosemite* offers other food for thought. A pair of indifferent guides in rough brown clothes and high riding boots insert a note of class differentiation rare in western art, which usually goes to some lengths to assert social homogeneity. The woman peering through opera glasses brings to mind binocular-wielding visitors to Church's studio looking at his painting of Niagara Falls, forcing representation and original to exchange and re-exchange pictorial value. One other point about the tourists: since the party includes a child as well as women, Hahn's painting is reassuring about the safety and comfort of family travel to the extraordinary site, adding to the domestication of a region that earlier painters had peopled with sometimes violent white adventurers.

While Niagara appeared very early in reports describing North America, Yosemite only came to the attention of Euramericans in 1833 through the explorations of a group sent out to locate the Pacific by Captain Benjamin Bonneville's commercial and scientific expedition. Thereafter stunned visitors eagerly publicized this naturally awesome region through widely disseminated prints and photographs. President Lincoln was persuaded in 1864 to give the young state of California the Yosemite lands; Congress made them a National Park in 1890, endorsing the idea that the resources of the west included tourism aimed at appreciation of preserved natural beauty.

Something about the idea of the west—its distances perhaps, or its potential—merged into motion: going west, heading west, westward, westward bound (coined by American railroads), westering, and—more hectically—goldrush, landrush. Although cross-country travel was not commonplace, once the Golden Spike was driven into the tracks connecting the Union Pacific and the Central Pacific railroads in 1869, a transcontinental system allowed, said William Cullen Bryant in touting the Rockies as a rival to Switzerland, 'easy access to scenery of a most remarkable character'.[5] If not to be accomplished as blithely as all that, moving west encompassed pioneers in covered wagons and tourists in Pullman railcars in the span of a half-century. Romantically, moving west promised a destination free of convention and big enough to get lost in. 'Eastward I go only by force; but west-

ward I go free', Thoreau exulted in 'Walking' (*Atlantic Monthly*, 1862), adding that 'there are no towns or cities in it of enough consequence to disturb me'. Two decades later, when Theodore Roosevelt (1858–1919), mourning the death on the same day in 1884 of his mother and his first wife, escaped the east for two years in North Dakota, or when Thomas Eakins, fleeing censorious PAFA board members in 1887, restored his balance at a ranch very near Roosevelt's, that sensibility still prevailed, therapeutically.

Expeditions and explorations

Art of the American West has been characterized as expeditional (explorations of settled as well as uninhabited land) or exploitational (incorporating settlement as well as commercial development) or both,

since these aims are not mutually exclusive. Cronon, for instance, identifies as 'frankly promotional' the watercolours [**94**] John White (*c*.1585–93) made during what may have been the first exploration of the New World to be covered by an artist, the 1585 English adventure at Roanoke. Reproduced as wood engravings in naturalist Thomas Hariot's *A Briefe and True Report of the New Found Land of Virginia* (1590), White's pictures served to arouse interest in settling or investing in the New World. 'Stripped of the booster uses to which they were put', Cronon adds, White's images are properly seen as 'disinterested' edification. From another standpoint, not hard to figure out, expeditions are complicit in what can be seen as exploitation's project, imperialism, a topic that will re-appear below.[6]

Of the early expeditions west, the most famous—undertaken by Meriwether Lewis and William Clark in 1804 to map and inventory the Louisiana Purchase of the previous year—enrolled no artists in its varied band. Just as pictures from space, rather than satisfying curiosity, stimulate questions astronomers didn't know they had, descriptions of western terrain inflamed Europeans and Americans with an eagerness to know more about the region's startling geology as well as its timbered land, mineral deposits, wildlife, and—importantly—inhabitants. Visual accounts of three other ante-bellum expeditions, two led by Europeans, an adventurer and a scientist, and

94 John White

*Indians Fishing, c.*1585
Embellishing the region's abundance, White catalogues the implements and practices of the Algonquians, whose simple, even Edenic, life introduces the element of nobility into primitive existence. The native's body as the site of his nobility, an idea incipient here, is manifested usually in a more statuesque physique.

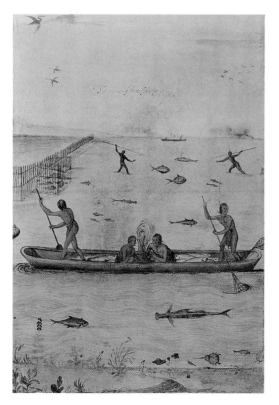

one the singular effort of an obsessed, erstwhile miniature painter from Philadelphia, sustained this ardour.

George Catlin at home and abroad

Immediately upon visiting tribes along the Mississippi River in 1832, George Catlin (1796–1872) forsook his modest career as a miniaturist and assiduously followed a plan both crazy and heroic:

I have designed to visit every tribe of Indians on the Continent, if my life should be spared; for the purpose of procuring portraits of distinguished Indians, of both sexes in each tribe, painted in their native costume; accompanied with pictures of their villages, domestic habits, games, mysteries, religious ceremonies, and so forth with anecdotes, traditions, and history of their respective nations.

He published a well-received account of his trip in London in 1841 (New York, 1842), pushing hard on the 'toilsome' aspect of his labour in regard to the perils of travel and the monumental scope of his endeavour. He exhibited in the United States whenever and wherever he saw an opportunity. Finally, he transplanted his Indian Gallery, consisting of almost 600 paintings as well as artefacts and some Native Americans themselves, to France and England in 1839, remaining abroad nearly three decades.

In England, Catlin and his entourage went on the road, part stage show, part museum, all hoopla. Queen Victoria invited him to show his curiosities and, in Paris, Louis-Philippe ordered a hall in the Louvre set aside for his personal viewing [**95**]. In Paris as in London, Catlin's ensemble generated wonder, acclaim, intense excitement; then, its novelty waning, came a shabby afterlife as a sensation whose season had passed. Brian Dippie movingly writes:

95 George Catlin

'Louis-Philippe's Party Inspects Catlin's Gallery in the Louvre …', from *Catlin's Notes of Eight Years' Travels … in Europe*, 1848

Catlin's art provided the French king with an opportunity to recall his own expedition among Cherokees, Choctaws, and Chickasaws in the late 1790s.

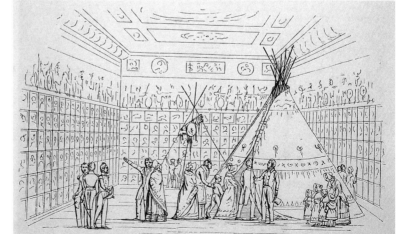

96 George Catlin

Four Bears, Second Chief, in Full Dress (Mandan), 1832–4
The Mandan, who lived in the region around the upper Missouri, were devastated by a smallpox epidemic only a few years after Catlin portrayed them.

[Catlin] had won international fame as the painter–historian of the native American, and he had been driven from the United States by indifference, from France by revolution, and from England by the threat of debtor's prison. Through it all he had struggled to make a living from his Indian paintings, while dreaming of the fortune awaiting him could he but persuade the United States government to buy his works entire.[7]

He couldn't.

Karl Bodmer and Maximilian zu Weid

Although the west is a big place, the small number of Euramericans passing through it on prescribed routes at this early point all eventually met up. Swiss artist Karl Bodmer (1809–93) first met Catlin out west, then again in Paris. Though he dismissed him as a 'charlatan', Bodmer greeted Catlin's success abroad with pleasure, anticipating a broadened patronage that would reflect well on his own project. Bodmer had

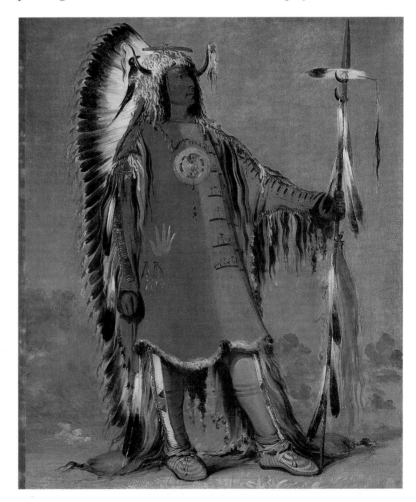

97 Karl Bodmer

Biróhkä (The Robe with the Beautiful Hair), Hidatsa Man, 1833–4

The legibility of every line defining facial feature, no less than robe ornamentations or head-dress construction, pins the figure to the paper as impassively as a naturalist pins a butterfly to a mounting board.

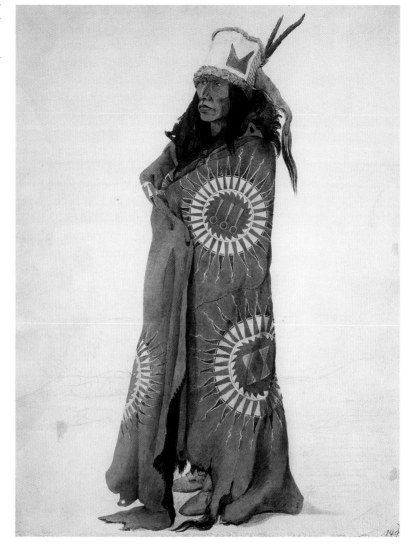

97 Karl Bodmer

Biróhkä (The Robe with the Beautiful Hair), Hidatsa Man, 1833–4

toured western territories in the company of Maximilian zu Weid, a German naturalist and aristocrat who took particular interest in the Americas. Maximilian's *Travels in the Interior of North America in the Years 1832 to 1834*, published in Germany in 1839 and in both English and French editions a few years later, used Bodmer's meticulous specimen drawings as well as his paintings of the Missouri River Valley and its inhabitants as illustrations for his scientific text.[8]

Not that Bodmer and Catlin painted alike. Catlin's portraits, like *Four Bears, Mandan Chief* [**96**], spend their energy on the trappings by which the artist wants to document the particulars of tribal or native identity. Despite this emphasis on the collective, an individual is created. For instance, in the Mandan bonnet, which signals Four Bears' status among his contemporaries, or the knife in his head-dress

and horizontal feather on his lance, items of the chief's personal history, ethnography tells a personal story. (Elbridge Burbank's later ethnographic portraiture [25] occupies a related realm but wants to be more 'scientific'.) In comparison, Bodmer generally struck an aesthetic note, as in *Biróhkä, a Hidatsa*, a watercolour of 1833–4 [97]. His eye engaged more deeply than his mind, Bodmer paints with scrupulous, and striking, control of line and colour.

Alfred Jacob Miller

The German–Swiss pair saw Catlin's work in St Louis in 1833 and they also met Sir William Drummond Stewart, a Scots sportsman who later spent six months in 1837 on his own expedition. Stewart hired a memory-maker, Baltimore artist Alfred Jacob Miller (1810–74), to depict the life of mountain men and Native Americans, as well as the terrain along the Oregon Trail. Although Stewart planned to immure Miller's oil paintings in his Scottish castle, the artist first showed 18 of them at the Apollo Association in New York City in 1839. It proved to be a beach-head on a market that Miller never relinquished. Though he did not travel west again, Miller continued to use the raw material of his trip as the source of much of his art until he died. Unlike either Bodmer or Catlin, Miller frankly *painted*, discarding the pencil for the sweep of a brush and soft-pedalling detail in favour of general effect.

In *Trappers Saluting the Rocky Mountains* [98] he designed a view that, at first glance, looks like an eastern landscape. As the viewer's eye travels through the scene, however, from the unusually exultant figures on a

98 Alfred Jacob Miller

Trappers Saluting the Rocky Mountains, 1834

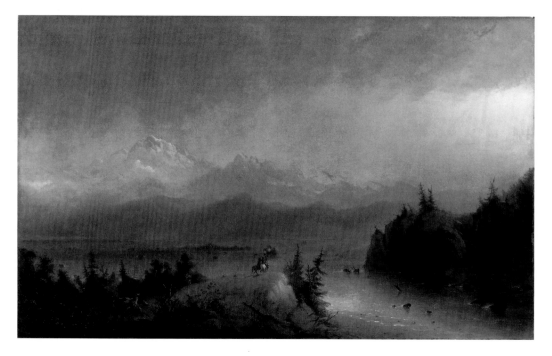

rocky promontory across the shining river and into the woods, revelation dawns. Those great white mounds in the distance, their contour erratic and their volume suddenly palpable, aren't clouds, but enormous mountains, their size alone putting them outside ordinary experience.

Scenery so nearly incredible demanded witness. The announcement of photography in 1839, and the later technical refinements that permitted its use on the trail, however arduously, could have obviated expedition artists' record-making role. That it did not is a tribute to the esteem in which they were held by scientific and cultural communities. Lured by curiosity, artists also travelled west in response to market considerations, which probably exerted equal or greater pull. During and especially after the Civil War, painters joined expeditions for the explicit purpose of making art for a ready-formed audience.[9]

Albert Bierstadt

Albert Bierstadt (1830–1902) sits, spider-like, at the centre of webbing that ties any discussion of expeditions west, the art market, and the role of photography in both enterprises. The painter, whose patrons were to include western industrialists, first travelled as far as the Wind River Mountains in the Nebraska territory in 1858 accompanying, though not officially, Captain Frederick Lander's survey. German-born and Massachusetts-raised, Bierstadt had journeyed to Düsseldorf in the mid-1850s to study with another German-American, Emanuel Leutze (1816–68); but Leutze sent the aspiring landscapist to train in the approved fashion, sketching *en plein air* in the Harz Mountains in Germany and the Alps in Switzerland. The latter proved memorable.

A recently located painting of Lake Lucerne demonstrates that, stylistically, Bierstadt would treat the Rockies as he had the Alps—emphasizing grandeur through scale.[10] In a letter published in *The Crayon* (1859), he maintained, 'The [Rocky] [M]ountains are very fine; as seen from the plains, they resemble very much the Bernese Alps, one of the finest ranges in Europe. ... They are of a granite formation, the same as the Swiss mountains.' Thanks to relentless railroad promotionals—'Why go to the Alps when you can see the same thing right here in the United States?', the ads enquired—not only the painter but his viewers as well were accustomed to thinking about western scenery in comparison with Europe. Still, although artists and viewers may have sought to validate the landscape potential of the Rockies by reference to the Alps as a known artistic quantity, in their American way the Rockies gained on the Alps and, by 1869, Samuel Bowles' *The Switzerland of America* asserted that western scenery surpassed Europe's most sublime offerings.

There was a difference between backpacking on alpine paths and journeying west, and Bierstadt made it known. Tuckerman, praising Bierstadt, commented that 'adventure is an element in American

artist-life which gives it singular zest and interest', an element, one recalls, introduced to 'artist-life' by Thomas Cole's account of his early experience in Ohio's forests (which were, in the 1820s, the 'west'). Following Cole not only in deed but word, Bierstadt promulgated a wilderness-wandering mythology for himself. He wrote letters for publication (or told interviewers) about life on the trail and its very real hardships, stories that impressed Tuckerman mightily. In addition, a companion, Fitz Hugh Ludlow, published entertaining and subtly informational articles about their exploits, not at all like the advertisements Theodore Winthrop penned about Frederic Church's travels, even if their net effect—celebrity and certification—was the same. One does wonder why Bierstadt, like Cole and Church, succeeded in parleying experience as authenticity whereas Catlin failed.

Aptitude, authenticity, authority—Bierstadt equipped himself well and when, in 1860, he started showing landscapes of the Rocky Mountains in Tenth Street Studio Building rooms decorated with artefacts of Indian culture, critics and lay viewers alike perceived him in terms of his (momentarily) more famous colleague: 'Mr Bierstadt's name is now associated with the Rocky Mountains as is that of Mr Church with the Andes.'[11] Mentored by Church, Bierstadt exhibited a single 'Great Painting', *The Rocky Mountains, Lander's Peak* [99]. On a vast canvas, about 8 x 10 feet, scenery of quite remarkable magnificence reveals itself in stages, from vignettes of Shoshone 'life and manners', embraced by shadow, to a middleground in which a waterfall's mightiness is dwarfed when the eye rises to the ever-receding, ever-grander mountains that reach, eventually, the clouds.

99 Albert Bierstadt

The Rocky Mountains, Lander's Peak, 1863

European viewers, like their American counterparts, looked at Bierstadt's scenes of the Rockies with eyes prepared by literature; the London *Morning Post* of 16 January 1868 called this painting 'Fenimore Cooper upon canvas!', though Cooper wrote largely about the northeast.

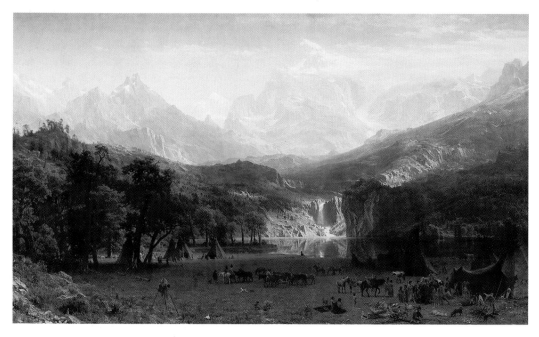

After its launch, Bierstadt sent the canvas on tour in the United States and Europe; in London it not only won Queen Victoria's verbal imprimatur but also sold to James McHenry, one of a number of British entrepreneurs who made money in the American West, railroads in his case. A chromolithograph published by a London gallery, a prospectus accompanying the American tour of the painting and inviting subscriptions for an engraving by the widely respected James Smillie, related stereographs, and wood engravings of his sketches for the painting in *Harper's Weekly* as early as 1859—all suggest that the late twentieth century hardly holds patent rights on the concept of spin-off [**100**].

Technological advances in printmaking expanded not only the artist's audience but his patronage, with art dealers coming in for their share of profits too. Amid the prosperity of post-war America, it seems only reasonable that the art world should share in the general well-being and on commodity-centred terms. Church and Bierstadt number among the best-known painters whose commercial instincts were acute, but they were exceptional only in the degree of their success.

Not all was roses. For one thing, the foreground multiplicity of the painting incited controversy: were the natives Bierstadt portrayed a distraction or testimony? The distinction outlined an aesthetic issue— that is, whether august land forms might be compromised by mundane staffage, meaning by this not the abstraction of a lone Indian symbolic of 'wilderness', as in Cole's *Kaaterskill Falls* [**75**], but figures whose every activity appears so factually loaded they seem to be planned for some future natural history diorama. Can a landscape convey the

sublime and information simultaneously? To put it another way, can the sublime be accurate?

For Bierstadt, unwillingly, the answer seemed to be 'no'. By the turn of the century, Bierstadt's bright star was all but extinguished. Paintings once hailed, though not unanimously, as worthy to hang alongside the canvases of English painters of the sublime, like Turner, were castigated for their failure to render the landscape adequately as *American*. Others were seen as over-focused on detail, too much like their photographic counterparts and unlike the aestheticized nature that painters like Inness were popularizing. In 1905, Samuel Isham's influential *History of American Painting* pronounced 'the huge canvases which made [Bierstadt's] reputation are but a sort of scene painting, superficial, exaggerated, filled with detail imperfectly understood. The leaves seem of painted tin, the rocks of pasteboard, the mountains themselves seem rather reminiscent of the Alps than possessing the actual characteristics of the Rockies.'[12] Currently, Bierstadt's paintings have recovered their critical lustre as a consequence of American art history's work of restoration in the late twentieth century.

Western migrations

Pioneers and 'progress'

Crass, rampant *will* to possess the land has no scarier visualization than a photograph [101] taken on 16 September 1893 as what appears to be bedlam on horseback surges by. It documents homesteaders loosed on Oklahoma territory in a land sale dividing 6 million acres among nearly 100,000 frenzied people within a few hours. Congress, which over the course of the 1830s had sent dozens of tribes from their native regions to large tracts of land around what is now Oklahoma, began buying much of this territory back from the Indians and selling it off between 1889 and 1893 in 'landrushes'. Speed wed with impetuosity gave birth to wonders. The town of Guthrie, Oklahoma, 'a city of 10,000 people, 500 houses and innumerable tents', one amazed claimant wrote, sprang up 'where twelve hours before was nothing but a broad expanse of prairie'.[13]

Landrushes are one kind of migration. If other kinds of settlement organized things better, or at least more patiently, they might nonetheless be depicted in masterful philosophical confusion: 'progress' as movement—wagons rolling across the plains—and as improvement— the civilizing ideal. In John Gast's *American Progress* [102], for example, the eponymous personification wafts her way, unravelling telegraph wire above ranks of miners, hunters, pioneers, farmers, railroads, towns. Terrified Indians and buffalo race off the canvas and out of 'civilization's' line-up. Composed for commercial use, Gast's illustration treats a would-be western population as a straight textbook demonstration of class uniformity.[14]

101 P.A. Miller/Thomas Croft?

'Racing into the Cherokee Outlet. Ten Seconds after the Gun', 16 September 1893

102 John Gast

American Progress, 1872

Almost triumphant in tone, pictorial images like this one represented immigrants as invincible, but prose accounts abound of sickly pioneers, yellow-faced and weak to the point of collapse from a variety of diseases brought on by insalubrious climates or the rigours of travel; geologist Clarence King, in *Mountaineering in the Sierra Nevada*, 1872, told of pioneers turned perpetual migrants, animal-like as a result of over-long exposure to the wilderness and innate shiftlessness.

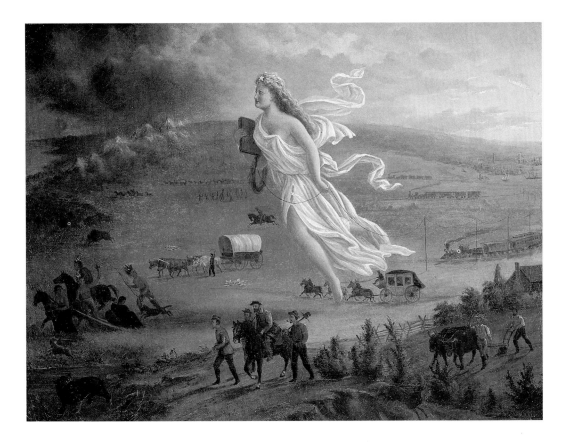

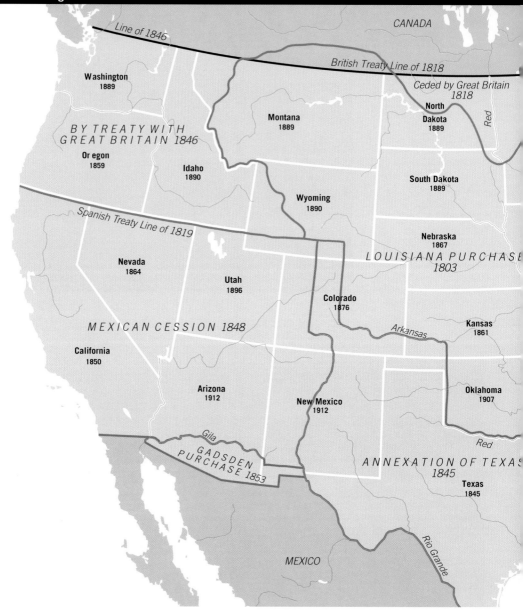

CANADA

Line of 1846

British Treaty Line of 1818

Washington
1889

Ceded by Great Britain
1818

North
Dakota
1889

Montana
1889

Red

BY TREATY WITH
GREAT BRITAIN 1846

Oregon
1859

Idaho
1890

South Dakota
1889

Wyoming
1890

Spanish Treaty Line of 1819

Nebraska
1867

LOUISIANA PURCHASE
1803

Nevada
1864

Utah
1896

Colorado
1876

Kansas
1861

MEXICAN CESSION 1848

Arkansas

California
1850

Arizona
1912

New Mexico
1912

Oklahoma
1907

Gila

GADSDEN
PURCHASE 1853

Red

ANNEXATION OF TEXAS
1845

Texas
1845

MEXICO

Rio Grande

Appeals to settle the west amplified Gast's point. Whisked from crowded eastern cities to spread out across the continent by 'grand lines of railroad ... revealing what our first Great Emigrant, Columbus, vainly sought to manifest in the gloom of earlier ages—that the shortest way to the Indies was via America', immigrants and metropolitan tourists followed map makers, prospectors, pioneers, and the labour gangs who built the railroads [**103**]. In *Where to Emigrate, and Why*, 1869, Frederick B. Goddard, chanting the mantra of a booming

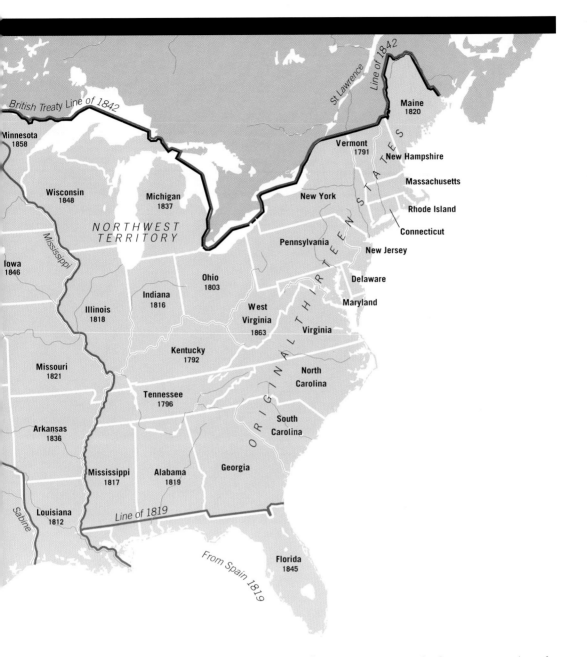

post-war United States ('more pig-iron smelted ... more steel made, more coal mined, more lumber sawed and hewed, more vessels built ... more houses constructed, more manufactories ... started, more cotton spun and woven, more petroleum collected, refined and exported than in any equal period in the history of the country'), offered 'all we have, and are, or may be, as a nation ... to share with the struggling millions of the earth', 600,000 of whom had arrived within the past two years.

Goddard's book was aimed at a European audience. The Chinese,

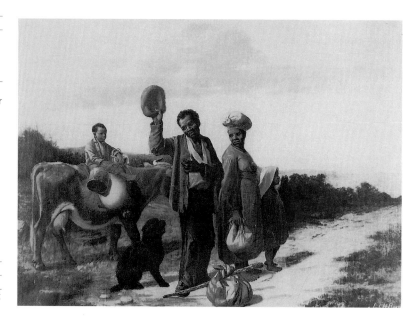

along with Irish immigrants the backbone of railroad labour gangs, were disinvited after 1882 by Act of Congress. Not explicitly forbidden, neither Mexicans nor mestizos were encouraged to settle the west. Black settlers, before the Civil War embodying the combustible issue of slavery in which the west was implicated deeply, fared little better. After Reconstruction—that is, after 1877—when federal troops left southern whites and their former slaves looking at each other through eyes filled with trepidation or hostility, many African–Americans chose to seek a living out west. Some, like the Exodusters (whose name was taken from the Old Testament book of Exodus which narrates the Jewish search for a promised land), migrated in groups, while others walked, rode, or travelled by steamboat. The former slaves and their animals in *Goodbye, Ole Virginia* [**104**] by James Henry Beard (1812–93) might be setting out for the west, given the ambivalent expressions with which they depart,

and if so, even this mediocre genre painting gains significance by adding to the list of those canvases in which the trope of locomotion differentiates and classifies an evolving western population.[15]

Native Americans

Seth Eastman (1808–75), an Army topographical draughtsman, painted *Indian Mode of Traveling* [**105**] with the implication that ancient migratory customs of nomadic tribes—how household items are packed, babies carried, horses ridden—carry valuable ethnographic information. Reinforcement of stereotyping lurks within this ethnography, for Indians migrating by walking or riding draught animals typified backwardness, the primitiveness that is the *sine qua non* of racial otherness.[16] One of several paintings Eastman executed for a multi-authored visual survey of North American Indians commissioned by Congress (and admired enough to have required at least one replica), *Indian Mode of Traveling* offers Eastman's somewhat opaque account of the wending route taking the Dakota from their land. Do they trudge with stately resignation to extinction, or are they merely changing camp? Did legislators passing though the Capitol's glossy marble halls, where one version of the painting hung, glimpse the Dakotas filing by and call to mind the tragic results of the Indian Removal Act of 1830, which killed more than 4,000 when 13,000 Cherokee walked the 'trail of tears' from the south-east to Oklahoma? Or did legislative minds begin to germinate what became the Dawes General Allotment Act?

While one arm of Indian control involved shuffling tribes out of the way of white settlement, like consigning superfluous pieces of furniture to the attic when the main living quarters fill up, other approaches like the Dawes Act assumed that Indians could never be white but that they could live like whites.[17] To continue to exist, they must needs dwell in communities organized like Euramerican communities, follow Euramerican behaviour patterns, especially where social mores were concerned, and so forth. The logic of assimilation comes from how 'savage' was construed when it was detached from 'noble': by identifying, sometimes with the help of ethnographic visual records, in what ways Native Americans did not live, think, act, as did the culture doing the identifying, that culture epitomizing the 'civilized' norm. In this context, Eastman's paintings of Native Americans, specimens vulnerably displayed to his eye, become vulnerable themselves, their 'science' enlisted to confirm bias, their 'art', to construct otherness.

By century's end paintings of slow-moving Indians made bold to confirm the consequences of backwardness. *Morning of a New Day* [**106**] by Henry Farny (1847–1916) puts the case squarely in the title and in the compositional design. Strung in a rag-tag line along the side of a mountain, Indians watch—or not—a train streak through a valley, its

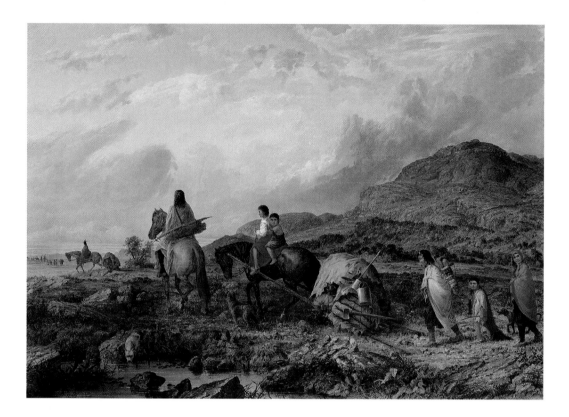

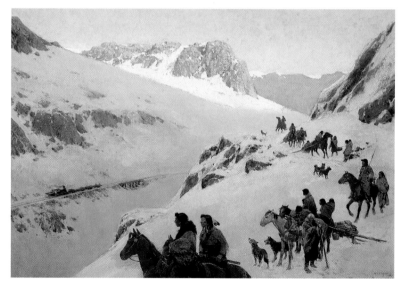

slickness and speed a contrast to the tired pace of horses dragging travois and the weighted steps of the elderly who, like the women, walk. Expanding the fateful narrative, Julie Schimmel comments, is the manner in which 'the Indians are pushed to the margin of the picture,

the two leading figures already cut off by the frame'.[18] It is probably no coincidence either that the season is winter, when Nature metaphorically dies.

Tourists

If locomotion provided a ready trope for making distinctions between various groups of people in the west, Hahn's tourists gazing upon the wonders of Yosemite and Farny's Indians staring dully into a chasm suggest that distinctions having to do with ownership are located in the trope of looking. Why looking and possession are linked can be explained in terms internal to the paintings themselves and the tradition of landscape viewing in which they appear. That is, the spectators in Hahn's composition belong to a privileged class, one that not only has the leisure and money to tour but also responds as consumer to the blandishments of entrepreneurs selling the west. Travel historian Lynne Withey points out that efforts to increase awareness of the western territories in eastern metropolitan centres offer 'a remarkable example of how scenic beauty, popular attitudes, transportation improvement, and clever promotion came together to transform a sparsely settled frontier into a mecca for tourists … Nearly 30,000 people traveled from Omaha to San Francisco in 1871, rising to 75,000 in 1875 and about 100,000 by the end of the century.'[19] In one sense, then, Hahn's travellers have bought the right to look at the west, and it is a transaction in which the painted tourists function on both sides of the deal. Farny's Indians read as dispossessed because the object of their gaze eludes them, leaves them behind, and because of the way the painting is presented to the viewer, the figures and the railroad operating as binaries, locking into a commonplace strategy of reductiveness.

Adventure-land

Although it would be difficult to place an exact date on it, at some point after the Civil War representations of the west veered toward entertainment, an entertainment usually dressed as edification. Tourism, along with dramatized performance of western history like Buffalo Bill Cody's Wild West, which turned everything from horseback riding to warfare into theatre, were magnified by a literature of the west as 'Adventure-land', the entire combination anticipating the Disney corporation by decades in packaging fantasy as reality.

The transatlantic circulation of western imagery and ideas now shifted impetus. The impact of an American-generated cowboy mythology registered abroad economically, for example in foreign (especially British) ownership of cattle ranches, and culturally, as in the wildly popular novels of Karl May. A confidence man from Saxony, May created German-speaking gunslingers like 'Old Shatterhand' in *Der Schatz im Silbersee* (1891), famous to this day.[20] In the United

107 Anon.

'Theodore Roosevelt in Buckskins', 1885

Of his trip to the Dakotas in 1884, Roosevelt remembered, 'It was still the Wild West in those days ... the West of ... Wister's stories and ... Remington's drawings.'

States, dime novels with cowboy protagonists interchangeable with May's simplistic characters flourished. On another level, books such as future President Theodore Roosevelt's 1885 *Hunting Trips of a Ranchman* made heroes of cowboys and derided as 'sentimental nonsense' the idea that native lands were 'taken', as Indians never had what he recognized as 'real ownership'. Corpulent, short-sighted and asthmatic, Roosevelt [107] admired 'sinewy, hardy, self-reliant ... daring, adventurous, uncomplaining, fearless' cowboys, who were, he confided, almost all native-born.[21] The archetype of the cowboy, historians agree, is found in Owen Wister's novel, *The Virginian* [108]. Who could disagree? Speaking little, packing a gun and unafraid to use it, poker-playing, and cougar-lithe, the Virginian, after all, drawls the immortal, 'When you call me that, smile.'

Wister dedicated his novel to his good friend Roosevelt, and both men formed close ties to Frederic Remington (1861–1909), a mostly self-taught illustrator, painter, and sculptor. Remington frequently translated 'cowboy' visually as a slight, weather-beaten, homely man of antic temperament, a durable image eventually superseded in the public mind by more glamorous cinematic cowboys. His paintings and sculptures encapsulated entire epics of the west in a single figure or a climatic moment, often aided by titles that told the tale, such as *The Last Stand* or *Fight for the Water Hole*.

108 Charles M. Russell (?)

Illustration from *The Virginian*, 1902

This line drawing from Owen Wister's *The Virginian* may be the work of cowboy painter Charles M. Russell, as the initials indicate, though he is not credited as illustrator.

109 Frederick Remington

Coming Through the Rye, c.1902

Television copied movies in casting a small, sometimes gimpy and grizzled coot— 'Gabby' or 'Pap' or 'Doc'—as sidekick to the muscular and wholesomely handsome cowboy hero; Remington's cowboys, sources for twentieth-century imagery, were frequently the coot type, whether young or old.

Remington's story-telling and a staged rehearsal of western history met up with interesting results when the commissioners for the 1904 Louisiana Purchase Centennial in St Louis persuaded him to display an enlargement (in a material called staff, which is a mixture of plaster and straw used for temporary expositions) of a four-horseman bronze group, *Coming Through the Rye* [**109**]. Since Remington mistakenly thought Robert Burns' poem of the same title referred to drinking rye whiskey, his four raucous cowboys exhibit a dazzling alcoholic abandon. The exposition labelled the piece variously 'Off the Trail' and 'Cowboys Shooting Up a Western Town', referring to the exuberant gunfire as a well-known release from the pressures of cattledrives. Michael Shapiro thinks that 'an association between these riders and the biblical Four Horsemen of the Apocalypse could not have been lost' on the artist.[22] Whatever the case, as a summary of a century of American westward expansion and its art, it would be hard to improve on Remington's sculpture at the Louisiana Purchase Exposition, either in irony or in celebration.[23]

Beyond California

Shortly after the census had announced the closing of the continental frontier, the German–American statesman Carl Schurz opposed a bid

to make Hawaii an American territory: 'a number of semicivilized natives crowded upon by a lot of adventurers ... among them Chinese and Japanese making up nearly one-fourth of the aggregate. ... No candid American would ever think of making a State of this Union out of such a group of islands with such a population as it has.' Such arguments had done little to stem commercial and strategic interest in the Sandwich Islands, as they were then known, for they had become important mainly as the investment of a small but powerful commercial group running sugar and fruit plantations, one Mr Dole among them. In 1893, in fear of Queen Liliuokalani's vocal nationalism, these businessmen overthrew Hawaii's indigenous government, installed themselves in office and declared a provisional republic which the American Government recognized even before loyalist Hawaiians capitulated. Five years later, Congress, in a land-happy mood as a result of the Spanish–American war in which they had 'acquired' Cuba, the Philippines, and Guam, agreed to annex the islands, and a government of non-Hawaiians ensured the hegemony of white businessmen there for some time to come.

Heir to this history, *The Lei-Maker* [**110**], by Theodore Wores (1859–1939), has been described as the islands' 'unofficial' national image. Wores, a Californian who studied painting in Munich, specialized in painting Californian landscape as well as genre scenes set in Japan and Hawaii. Light-drenched and colourful, Wores' paintings depicted a Pacific region in which native peoples were both picturesque and 'primitive' in comparison to the Anglo population. Unlike the Japanese and Chinese also working the plantations, native Polynesian peoples tended to be regarded by Euramerican writers and artists like Wores as children in paradise, innocent and enchanted, a state that caused them to be heavily missionized but that appears to have precluded the quasi-scientific documentation in painting that was accorded Native Americans.

Re-reading the west

The revisionist writings of 'new historians of the west', as they are popularly termed, challenge accepted views of settlement of the west, especially those put forth by scholars working in the long shadow cast by Frederick Jackson Turner. In 1893 Turner's 'Significance of the Frontier in American History' argued that qualities co-determinate with democracy, like individualism and an absence of strong class distinctions, had been enabled by frontier conditions, conditions which were, in the main, free of cosmopolitan eastern taint. Since Turner assumed that 'long before the pioneer farmer appeared on the scene, primitive Indian life had passed away', he did not understand the west as virginal. Still, in articulating an image of the west that located its purity in values of self-reliance and industry, its mission in

110 Theodore Wores

The Lei-Maker, 1901

The lei-maker wears a billowy
garment introduced by
Christian missionaries anxious
to cover the islanders'
nakedness.

the double transformation of chaos to control and European to American, and its democracy as the absence of urban/elite domination, Turner wrote the history Americans wanted to be theirs.

Actually, much revisionist thinking has been along lines originally sketched out by plain-spoken nineteenth-century observers: in conquering the west, the American Government participated in the destruction of a civilization for reasons motivated by gain. Helen Hunt Jackson's 1881 *A Century of Dishonor*, for example, censured government policies in the west. She later transmuted her claims to a novel, *Ramona*, 1884, in the fruitless hope of producing for the Indian cause a book that would do what *Uncle Tom's Cabin* did for the cause of abolition.[24]

In *The Legacy of Conquest*, 1987, regarded as an opening salvo of revisionisms currently proposed, Patricia Nelson Limerick highlighted the violence attendant on the settling of the west by thinking about land

value in terms of gain. 'Of all the persistent qualities in American history,' she writes, 'the values attached to property retain the most power', and in the drive for property, she concludes, lay 'the core of the Western adventure'.[25] Occasionally, reactions to revisionisms' new–old viewpoints echo Roosevelt—'sentimental nonsense'—though the adjective tends to be something sharper.

The west as America

In 1991, a National Museum of American Art exhibition of some 160 pieces of western art in a wide range of media saluted the idea of revision. William Truettner and his co-organizers called the show, cheekily, *The West as America*, modifying the title of a 1976 Bicentennial exhibition at the same institution, *America as Art*. In that show, Joshua Taylor, taking as he said a 'narrow' view, looked at 'ideas and attitudes about America [that] became inseparable from the country's art and, conversely, how in some instances art itself became an identifying mark of America'. In *The West as America*, Truettner claimed the exhibition as a space for interrogating art more than (but not instead of) experiencing it aesthetically: 'ideology … is the embracing factor of our investigation. … Ideologies, like myths, are based on a historical agenda that can be made to reveal itself. When viewed through a new perspective, images often yield this agenda—one taken for granted and therefore never acknowledged by nineteenth-century viewers.'[26]

Did art, the exhibition asked, assist in naturalizing the conquest of the west, in downplaying its market-driven impetus and in fostering notions of white superiority? Detractors cried foul, mostly on the grounds that revisionists have their history wrong, while others took the stance that, whatever the history, it's not the role of art, exhibitions, or tax-payer-funded institutions to meddle with 'political' issues.

It will not have escaped readers' notice that this chapter itself naturalizes the revisionist point of view. From this perspective, it offers a chronological narrative of highlights (and some dimmer moments) that emphasize transatlantic conditioning of makers and viewers in the doubling operation performed by art of the American West: how the most spectacular lands of the western territories could be seen as sublime and how Native Americans could be absorbed in humanity's scheme as noble savages. It also brings up nineteenth-century understandings of what western art could *do*: not only could painting 'accurately' render the terrain, it could show what natives are 'like'.

Consider Catlin's rationale for his life-work:

I have … contemplated the noble races of red men who are now spread over these trackless forests and boundless prairies, melting away at the approach of civilization. Their rights invaded, their morals corrupted, their lands wrested from them, their customs changed, and therefore lost to the world; and they at

last sunk into the earth, and the ploughshare turning the sod over their graves, and I have flown to their rescue—not of their lives or their race (for they are *'doomed'* and must perish), but to the rescue of their looks and their modes. … phoenix-like, they … may live again upon canvas.

Catlin's art creates its subject in order to 'preserve' but not to save it. Categorizing a people and their knowledge, collecting and reproducing as information how they 'look', or behave, or believe, becomes a project of controlling. In this sense, it could be said that Catlin colludes, unwittingly, with governmental and private agencies whose purpose, to possess the land, requires Native American subjugation.

Americans were not unique in their effort to promote art as a means for knowing what natives are 'like', since concurrent representations of Asian-Indians in British art and North Africans in French art make similar claims. Herein lies a peculiarity of the art history of the American West: it is revised but not theorized. It still lacks concentrated analysis theorized from perspectives of imperialism, which is, like 'western art', a monolithic term that does not refer to a uniform operation but does adequate service in accounting for certain systems of political, economic, and social control. When Edward Said wrote *Orientalism* in 1978, he helped to focus attention on the work imperialism does culturally, especially in creating its subjects and dominating seemingly non-political discourse. Said also commented on the reluctance of cultural historians to probe imperialism as a cultural condition of making and seeing. Analysis of the construction of the Indian Other, of the Other's colonized body and appropriated culture, is well under way. Perhaps post-colonial understandings will help de-victimize Native Americans in the contemporary narrative, opening to scrutiny a welter of conflict, complicity, and resistance that restores agency to the 'Othered' in the art of the American West.[27]

7 Memory and Myth: Commemorative Art

Detail of memorial to Robert Gould Shaw, 1894–96 (plaster model). See also 116.

Two amateur photographs, taken almost a hundred years apart. The earlier [111] portrays the Virginia grave of Confederate General 'Stonewall' Jackson in the 1860s, a time when burial practices encouraged commemoration of the dead in bucolic settings designed to leaven grief with nature's soothing. These women respond to the invitation to mourn pastorally by kneeling on the ground and yearning over the tombstones. Garden cemeteries like this one played a special role during the Civil War, helping survivors repress the horrors of makeshift battlefield cemeteries where skeletons clad in blue or grey sometimes poked out of shallow graves, disturbed by soldiers gathering to fight yet again.

The later photograph [112] depicts Italian-American businessmen participating in a Columbus Day ceremony in Baltimore. Their 1950s-style dark suits place the date well after 1934, when 12 October became a national holiday and a notably Italian-American event. Like Poles, Jews, the Irish, and Norwegians, among many others, Italians established an aggregate body in nineteenth-century America by means of a common mental image of 'homeland' shaped and validated by commemorative acts. Arriving in the United States at an ever-accelerating rate that threatened to overwhelm native-born Americans, immigrants frequently learned the power of ethnicity through commemorative acts and art.

112 Anon.

'Columbus Day Parade in Baltimore', 1950s

Dark-haired men squint at the camera, while two of their number pretend to be engaged in the act of placing a wreath on an eroded marble statue of Christopher Columbus, raised in 1892. Grainy and poorly focused, the photograph nonetheless adds to the rite's commemorative effectiveness.

Although both photographs were made in the south, geography as well as time separates them. Virginia, birthplace of General Robert E. Lee and Confederacy President Jefferson Davis and home to Richmond, the Confederacy's capital city, exemplified the secessionist, parochially minded south during the Civil War. The border state of Maryland, whose capital, Baltimore, hugs the periphery of a constellation of east-coast cities with strongly international populations, identifies with both north and south. However local, the activity taking place in each photograph embraced national affairs. As the century progressed, American women increasingly assumed the role of inculcating moral behaviour and preserving domestic and public memories, a role that was strengthened while soldiers fought and died. Like other newcomers, Baltimore's Italian-American men enact a ritual staking out a social role for ethnic memory.

I use both photographs as stimulants to thinking about how the past is conceptualized in nineteenth-century American art. Honouring or shaping a memory in form (cemeteries, statues, photographs) and in act (mourning, parading, writing a book) commemorates. Commemorative art usually possesses a public dimension, and one of the things it does publicly is to inscribe important local and national myths on memory: founders and saviours are honoured, values asserted and preserved, cultural patterns shared. Contested memory

can be massaged into resolution by commemorative art, or disappear if
ignored. Commemorations can be spontaneous but not self-directive;
that is, they do not occur as something inherent to an event, process, or
personality but are the product of human agency.

Memory and the body

The matters touched on in these photographs, the event of the Civil
War and the process of immigration, test the very limits of commemo-
ration, so overpowering are they in their subject and scope. My reasons
for considering the two events together has to do with the manner in
which the commemorative art pertinent to each helps to account for the
conditions by which certain testimonies of memory have been
constructed in the United States. Because the questions this chapter
addresses are general, the aim is to probe rather than resolve. I focus on
the body, and not incidentally. Commemorative sculpture can be
considered to have originated at least in part in the desire to make a
surrogate body, to replace one lost through death perhaps, or to
emblematize an individual who also represents a group (the single
figure ideally expressing the group's desired unity and wholeness).

Crassly put, the Civil War destroyed bodies, killing more people than
any other conflict in American history to date. It maimed thousands
more. National cemeteries were introduced, drawing on the recent
popularity of garden cemeteries in an attempt to thwart the body's loss of
consequence in war by marking land as memorial. But this war perverted
the very idea of cemetery, strewing the earth with heaps of mangled
bodies. The way in which dead soldiers were remembered impinges on
the history of sepulchral sculpture and burial practices, as religion's
monopoly was gradually being given over to private enterprise. Non-
white bodies, like those of African-Americans who died in the war or
who were manhandled by enforcers of the Fugitive Slave Act of 1850,
received little and ambiguous commemorative notice. White women
promoted memorials for others, but were rarely themselves commemo-
rated for public acts.[1]

Immigration added bodies, late in the century in numbers so many
times over the five million who arrived between 1815 and 1860 that in
some nativist circles new immigrant bodies were looked upon as
superfluities and even, in extreme cases, as expendable. Culturally, the
immigrant body rarely arrives in a condition acceptable to xeno-
phobes whose means of attaching difference to aliens include
imputations of disease and moral decay. The financial panics of the
1870s and 1890s depressed the job market, contributing to class and
ethnic animosity directed towards new arrivals. The immigrants, in
turn, sometimes tried to cling to the lowest rungs of the economic
ladder by shoving off the African-American. To create a physical and
political space for themselves, immigrants massed as one body,

reading newspapers in their own language and monopolizing certain trades. Commemoratively, they multiplied the body in pageants and parades and represented it as monumental through sculpture.

Memories of war

It very soon became obvious that death and decay would be inescapable for vast numbers of people during the Civil War. More than 600,000 soldiers died, and the wounded were uncountable. Walt Whitman's inchoate cry upon encountering makeshift hospitals after an 1863 battle at Chancellorsville, 'O heavens, what scene is this? ... these butchers' shambles? ... the groans and screams—the odor of blood. ... slaughter-house!', gives only an inkling of the horror everywhere to be seen, smelled, heard. In part the mortality level was attributable to developments in weapons technology that outraced advances in medicine and transportation. Even military strategy had not kept pace. Despite the newly increased destructive capacity of cannons and guns, armies faced off as they had in earlier wars and so obliterated themselves [113]. At Spotsylvania in 1864, General Horace Porter recalled, 'Rank after rank was riddled by shot and shell and bayonet thrusts, and finally sank, a mass of torn and mutilated corpses.'[2]

Sometimes, if an event holds too much pain, commemorations cannot handle it all. Abraham Lincoln (1809–65) knew the enormity of an event like the July 1863 Battle of Gettysburg warranted simplicity: 'We can not dedicate—we can not consecrate—we can not hallow—this ground. The brave men, living and dead ... have consecrated it, far above our poor power to add or detract', he said in dedicating a portion

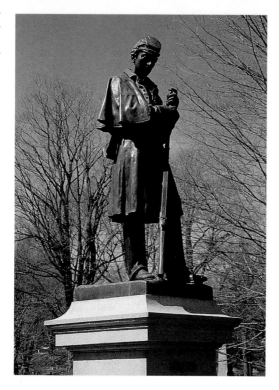

of the battlefield as a national cemetery. No ordinary graveyard was imagined, then, but a killing field of a divided country converted into a national, undivided, burial space in order to claim a collective memory. Two memory practices attempt to create the collectivity: one draws on the unifying emotions of patriotism; the second enlists the sentiments attached to the idea of the garden cemetery.

Garden cemeteries

Burial grounds had moved from churchyards to new garden cemeteries not long before the war. In Europe, church interments had begun to decline in the late eighteenth century, when burial laws were instituted

to relieve overcrowded and insanitary churchyards and to eliminate mass (pauper) graves. Cemetery owners acquired land with a rural, garden-like appearance, usually on the outskirts of town, and they encouraged lavish individual grave ornamentation, appealing to newly prosperous classes wishing to emulate aristocratic privilege in death as in life [114]. The garden cemetery movement spread to the United States with the 1831 opening of Mount Auburn, in Cambridge, Massachusetts. Thereafter the garden cemeteries' enduring popularity was sustained by the patronage of middle-class European immigrants familiar with such cemeteries, and kept intact by working-class immigrants like the Italian groundsmen and stoneworkers employed at Cleveland's Lake View Cemetery (established 1869), who were founders of the city's 'Little Italy' right next door.[3]

As national cemeteries allied with garden cemeteries by emphasizing an opportunity for contemplation in a rustic setting, so garden cemeteries added Civil War memorials [115]. Offered as a collective sign of those whose bodily remains lay nearby or were buried far from home, many of the memorials looked the same, whether in the north or south: a single white soldier, of whole and uninjured body, soberly reflecting on his experience and that of his comrades.[4] 'So far were the two sides from representing the ideas of their cause in plastic form,' Kirk Savage observes, 'that their monuments became indistinguishable, except in the inscription and (if they could afford it) in the arcane details of the uniform.'[5] When publicly sited—on a town square, say— these same monuments commemorated all soldiers who fought, not just those who died.

Selective memories

Although monuments raised throughout Europe and its colonies in the nineteenth century have been exhaustively studied for their aesthetic significance as well as the ideological work they performed— promoting imperialism, legitimating new regimes or consolidating old ones, even subverting class or religious hegemonies—American Civil War monuments were not accorded a similarly double-barrelled scrutiny.[6] However, as a result of the intensified scholarly and public attention paid to American art since the blossoming of the field in the 1960s, along with recurrent cycles of 'Civil War fever', a few monuments have now been examined as objects of both aesthetic and cultural significance. Analyses of 'standing soldier' monuments compellingly argue for the manner in which these statues, by presenting the figure uninjured and ignoring military men of other races, help to reconfirm a white masculinity destabilized by the war.[7] Among the most visible of Civil War commemorations by site, Augustus Saint-Gaudens' (1848–1907) 1896 *Robert Shaw Memorial* [116] and Thomas Ball's (1819–1911) *Emancipation Group*, 1876 [117], do acknowledge the

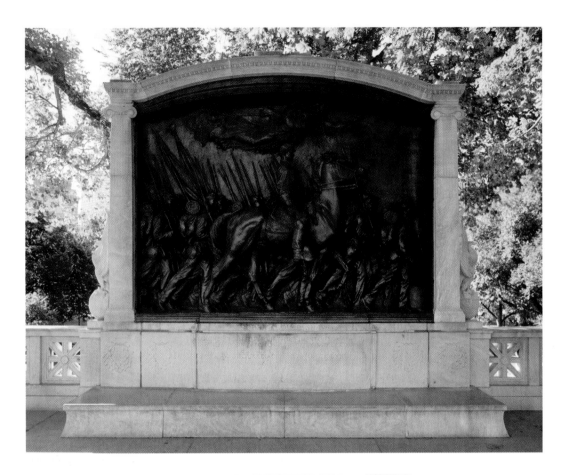

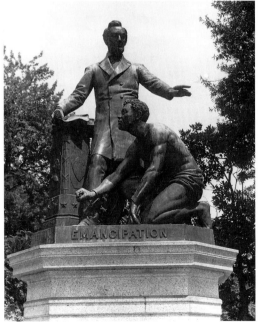

African–American as a factor in the Civil War, but reading the racial relations they inscribe has not, I think, been a clear-cut matter.

Augustus Saint-Gaudens and the Shaw Memorial

In 1863, when Massachusetts raised an all-black volunteer regiment, the 54th Infantry, abolitionist governor John Andrew asked the well-to-do, activist parents of Robert Gould Shaw if their son would serve as the unit's colonel. Since all of the unit's ranking officers were to be white, Andrews sought them from a class and a political stance whose credentials would aid the enterprise. A few months after accepting the appointment, Shaw fell at Fort Wagner, South Carolina, as did immense numbers of his men.[8] Stripping off his uniform, Confederate soldiers threw Shaw's corpse into a mass grave atop the bodies of his men; his parents refused to have his body moved.[9] A subscription group initially led by New England abolitionists such as poet Henry Wadsworth Longfellow (1807–82) and Sen. Charles Sumner raised $16,000 for a monument to Shaw, a commission offered to Saint-Gaudens in 1884; 12 years later the monument was installed across from the State House in Boston.

Using a portrait for Shaw's likeness, Saint-Gaudens hired men he found on the street as models for the soldiers. Shaw's figure itself, central and tense, possesses no muscular power to compare with the piston-like haunches of the men and the horse, and his self-contained carriage risks negligibility against the importunate rhythm driving the soldiers. Above the men, a personification of Fame floats like an afterthought, squeezed into a space that does not seem to have been planned with her in mind and banally modelled in relation to the energetic treatment of the men.

What is the relationship of the black troops, the relief's most striking feature, to the memory offered up by the monument? 'Background' for the white subject in a war fought over issues in which black bodies counted primarily as economic and political factors? Not until the 1982 rededication of the memorial were the names of black soldiers added to the inscription. To recall contributions of black soldiers to a war in which they played a substantial part? The strength of the physical portrayal of the soldiers, and the solemnity of the moment which so convincingly dominates their expressions, argues this position. Even Shaw can be drawn into this reading, by a militarily contradictory assertion that he does not 'lead the march or guide the narrative', a declaration which tempts Kirk Savage to conclude that the Shaw memorial was 'the closest the country came to erecting a national tribute to the black soldier and the black cause'.[10]

Thomas Ball and the Emancipation Group

While no one today denies the contribution of over 200,000 black

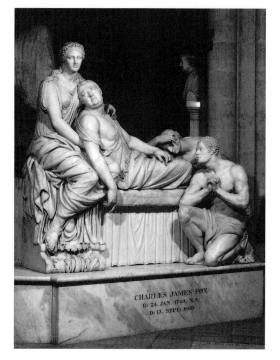

CHARLES JAMES FOX
B: 24. JAN. 1749, N.S.
D: 13. SEPT. 1806

soldiers to the Union effort, on that score the Shaw monument remains ambiguous (at the very least) commemoratively. Regarding the manumission of more than four million slaves, questions of commemoration were less ambiguous than fraught: what should a monument to emancipation remind viewers *of*? Which viewers? To be sure, many African-Americans harboured no doubts concerning the desirability of remembering this event in a public forum. Monies eventually amounting to more than $20,000 collected from black donors were awarded in 1873 by the Western Sanitary Commission (a predecessor of the Red Cross, whose members were all white) to a Boston sculptor living in Florence, Thomas Ball. The *Freedmen's Memorial Monument* was unveiled in 1876 in the nation's capital.

Shortly after the Civil War, Ball had modelled in clay a small-scale ensemble of Lincoln together with an unshackled Liberty. This combination perhaps carried over to Ball's attempt to use realism to convey an abstraction, the idea of freedom, in the monument. Unsurprisingly, viewers interpreted the monument literally. Some white audiences tended to see the monument with the black man foremost, 'an agent in his own deliverance ... exerting his own strength, with strained muscles, in breaking the chain which had bound him'. Others explained the way the two figures are juxtaposed as 'Lincoln bidding a Negro, with broken chains at his wrists, to rise', a reading many viewers today accept, with consequent regret or anger that black participation in slavery's end is obscured. What comes to mind in

regard to Ball's visual conceptualization of Emancipation is a sculpture he would not necessarily have known, Richard Westmacott's (1775–1856) 1810–23 monument to Charles James Fox in Westminster Abbey [**118**]. Westmacott surely appropriated the pose of the kneeling black man in his relief from early British anti-slavery literature, which used a shackled kneeling man with clasped hands to implore, 'Am I not a man and a brother?' Employing this abolitionist motif to ostensibly celebrate release, both memorials acknowledge the threat that a freed black man presents to a white society, allowing the pose to keep him servile and undermine his masculinity.[11]

At the unveiling ceremony of the *Freedmen's Memorial Monument to Abraham Lincoln*, to give it the full—and illuminating—title, Frederick Douglass (1817?–95) deprecated Lincoln's association with emancipation, pointing to the late president's motive in freeing the slaves as a policy of war rather than as an overridingly moral imperative. Douglass' objections went unheeded. A replica ordered by Boston subscribers in 1877 became sentimentally known in that city as *Emancipation Group*, a title with reverberations so massive the name of the Washington original was altered. In contrast to the predominant tenor of its nineteenth-century reception, modern analyses of the sculpture tend to indict it, and its white audience, for a painfully impoverished understanding of manumission.[12]

In recent years, the Shaw Monument and *Emancipation Group* have been read within a historical position—with which, perhaps unconsciously, American art history aligns itself—that claims the war was 'about' slavery and so 'about' race. An opposing view among historians holds that slavery may be at the heart of the war but its motive was an attempt to preserve the Union from secessionism, and its consequences were limited to that cause. In the sense that after 1865, as many historians note, the 'United States' took a singular verb of being, replacing the earlier plural usage, the Civil War decided something about how the country was going to be defined as a nation, at least among its white citizens.

The Civil War did not resolve the anomalous social and political condition of blacks; it did not reduce racism or dismantle the practices of white supremacy; it did not lessen sectional rivalries. (The same could be said for the later Indian Wars and the subsequent condition of Native Americans.) One may even claim that the bloody imprint of the Civil War stained most of the century, during the war in multitudinous deaths, and afterwards by an onset of vigilante-style violence and renewed if sometimes disguised conflict.

Winslow Homer and the Civil War
To translate negatives so profound into art relied on careful negotiation of the webbing that connects, and ultimately constitutes, memory's

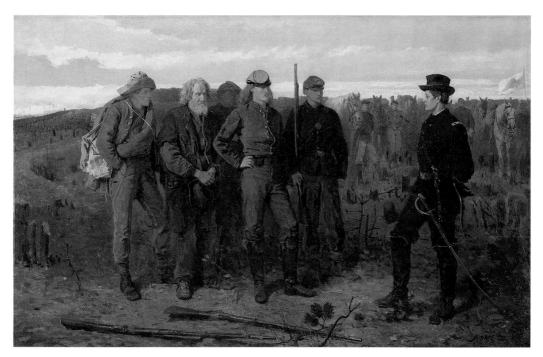

realm.[13] The most interesting Civil War art betrays the spiritual and
psychological uneasiness gripping those who knew, or intuited, that
the monsters loosed by battle would not easily be recontained.
Whether as viscerally wrenching photographs of the dead or as
comforting periodical illustrations of families reunited with loved
ones, pictorializations of the Civil War helped viewers imagine, if not
comprehend, that horrific event. Painting lent itself less well to this
effort, and not at all to rendering war's pressing topicality. Yet the Civil
War produced a major painter: Winslow Homer. Trained as a lithogra-
pher and working as an illustrator for mass-publication journals in
Boston and New York, Homer began working in oils while on assign-
ment as an artist–reporter supplying war imagery for *Harper's Weekly*
magazine. As the title of a first painting, *Defiance: Inviting a Shot* [**87**],
indicates, he sometimes portrayed a serious, indeed lethal, side of
combat. Other paintings mute war's terror by dwelling on the banality
of camp life: cooking, playing horseshoes, hanging around. *Prisoners
from the Front* [**119**], one of his greatest works, engages both aspects.

General Francis Barlow stands opposite three Confederate soldiers
and their dummy-faced guards. The prisoners sum up the south's
desperation—all of its men were needed for the fight, unlike the north
which allowed men to buy out of the draft, and these three men repre-
sent popular northern stereotypes of the south's mongrel force. The
lantern jaw and hunched posture of the fellow on the left suggest a
young volunteer out of the hills; the elderly man, hat in hands and with
a worried scowl upon his face, reveals how deeply the south has dug

into its reserves; and the bravado stance, flowing hair, and fine-boned face of the rebel closest to General Barlow invoke whatever might be aristocratic about plantation owners. Barlow looks pensively at the southerners, who by turns uncertainly or arrogantly stare back, and in the pregnant silence of this exchange is compressed everything unsayable that a war brings to mind.

Homer went to Paris in 1867 for the opening of the Universal Exposition, where *Prisoners* and another of his canvases, *The Bright Side* [**120**], represented United States painting in the Fine Arts pavilion. From Homer's friend, critic Eugene Benson, to present-day art historian Hugh Honour, the consensus view of *The Bright Side*, a scene of black teamsters sunning themselves, is that it evidences the painter's high seriousness concerning racial matters during the Civil War. They reason that African-Americans not only are compositionally dominant in the painting but also unalloyed visually by whites—features remarkable in combination (though not unique) in the portrayal of black figures by a white artist—and that, moreover, Homer does not condescend to his subjects, which is exceptional. Countering such a reading would be the loaded, or coded, racist overtones of the painting, especially the antic appearance of the pipe-smoking head jutting out from the tent, which recalls Homer's use of comic negroes in his illustrations, as well as the stereotype-fulfilling image of lounging, lazing blacks.

The New York *Evening Post* (28 April 1866) decided that, hung together, *Prisoners from the Front* and *The Bright Side* 'would make a comprehensive epitome of the leading facts of our war', meaning thereby to ascribe the war's causes to issues of race and sectionalism. In summing up yet transcending stereotype, the paintings have in

120 Winslow Homer
The Bright Side, 1865

common an equivocality that, if it does not also 'epitomize' the war, addresses the confusion of feelings and motives embedded in the idea of war, particularly a 'civil' one.

Preserving a past

Among commemoration's multifarious work, the task of providing an avenue for drawing or challenging boundaries of national identity took on an urgency in the fluid conditions of a century marked by immigration and expansion. Visual arts were employed to mediate reciprocity between national identities and national ideologies, while architecture and cultural rituals helped to generate ideas of community. For immigrants, all of these means were employed in constructing an idea of the homeland, tangibly (a monument, an architectural style, a prescribed residential quarter) and intangibly (the retention of language and customs). For white people born in the United States, one usable past offered itself as the equivalent of a homeland: the colonial era and its denouement, the War of Independence. Many of the colonial architecture preservation projects were initiated and carried out by women, though monitored and paid for by men. Figurative commemorative art raised by immigrant groups, in contrast, commended its subject to public memory not as historical artefact but as a corporeal art-object and, in ceremonies attending its installation and usage, as a site of potential public veneration. Since they were in no wise the traditional authorizing agencies of commemorations, groups of women and groups of immigrants constituted socially peripheral elements and hence promoted counter-histories, counter-memories.

The Mount Vernon Ladies' Association
During the war, women, 'denied masculine means of political expression … everywhere turned to public, symbolic ways of demonstrating

their nationalism', writes Jeanie Attie.[14] Thus, in addition to preservation causes, scores of volunteer organizations, including the Sanitary Commission, were run exclusively or in part by women, and women led many commemorative efforts from the grand to the simple (like tending General Jackson's grave). They could deflect any criticism that such public activities were unsuitable to the modesty required of their sex by emphasizing not only their experience as family managers but their concern to bring moral uplift into the public sphere.

Beginning in the decade before the Civil War, the colonial revival encouraged romanticization as well as veneration of a myth of national generation. At the heart of the myth stood its stalwart protagonist, General George Washington, first President of the United States. Well placed in war's aftermath to produce a seemingly non-ideological and totalizing history that all sides might buy into, preservationists like the Mount Vernon Ladies' Association memorialized a narrative of homogeneity and comfort at Washington's estate in Virginia [121]. They based their history on 'authentic' domestic objects, removed by more than years from the uncertain, disorderly present. If not precisely a counter-history, theirs was certainly a counter-intuitive one.

A Virginian, Ann Pamela Cunningham, founded the Mount Vernon Ladies' Association in 1853 to raise money for the restoration of Washington's deteriorating house and lands, which the former president's descendant wanted to sell. By 1858 the association had purchased the estate and received a charter from the state of Virginia. During and after the war, the Mount Vernon Ladies' Association reconstructed the house as a means to connect the 'perfect' American with domestic order and comfort. At the same time, they deliberately planted a vision of an early American past that respected the regional as integral to, rather than apart from, the national.

121 Winslow Homer

Mount Vernon, 1861

This watercolour would be among Homer's earliest, drawn as Washington's house and estate were being brought to public attention by the Mount Vernon Ladies' Association. In style it is tentative but arresting: tiny black figures tumbling out of a Mount Vernon side door look almost like specks on the watercolour paper.

Washington Crossing the Delaware

Few Americans today realize the democratic symbolic value Washington possessed internationally during this time. As painted by his eighteenth-century contemporaries Gilbert Stuart, Charles Willson Peale, and John Trumbull, among others, and immortalized in stone by Europeans like Antonio Canova, Jean-Antoine Houdon, and Francis Chantrey, Washington's face and form assumed for American audiences the lineaments by which he is still recognized: a large and unmarked brow, remarkably clear and slightly hooded eyes, a long firm jawline and a torso with plenty of bulk but no superfluities. Though various artists perceived him as dashing (Trumbull) or homely (Peale), all endowed him with an unruffled air—approachable but dignified. In Europe, Washington's name was better known than his face until Emanuel Leutze's *Washington Crossing the Delaware* [**122**] appeared at mid-century. Two canvases of this famous image existed initially (the one which ended up in Bremen was destroyed during World War II). Leutze envisioned a moment during the War of Independence when Washington daringly transported his troops across the wintry Delaware River from Pennsylvania to New Jersey, on 26 December 1776 surprising and capturing the enemy in Trenton. In Germany, the poet Ferdinand Freiligrath had alluded to Washington with imagery that characterized revolution—he was involved in the 1848 upheavals—as a ship bound for America and manned by freedom lovers. Since Leutze's sympathies as a '48er' were renowned in Düsseldorf, where he painted both canvases, his colleagues there sang of 'the mighty Delaware' traversed by Washington as a river flowing

122 Emanuel Leutze

Washington Crossing the Delaware, 1851

One of the few works in American art history that deserves the label 'icon', the painting was created in Düsseldorf by a German–American active in that city's artistic and political community.

123 Paul Fjeld

Colonel Hans Christian Heg,
1925

The popularity of the 'standing soldier'-type monument did not diminish over the years and was even adapted by immigrant groups, as this example for the Wisconsin State Capitol by a Norwegian artist demonstrates.

'between America and here'. An icon of patriotism in the United States, *Washington Crossing* spoke to European liberals of every stripe, especially those hoping to force out monarchies and install democratic forms of government.

Immigrants and the creation of 'homelands'

Born a German, raised in America, Leutze spent all but the final years of his career in Düsseldorf; his painting spoke not just to Americans about their history but to European revolutionaries too. The past preserved in the United States may not be exclusively 'American' in other ways. For example, immigration historians used to believe that aliens wanted to shed their foreign skin—whatever made them stereotypically ethnic—in order to change their nationality as soon as possible. Nowadays that notion carries little credibility, and migration studies concentrate on the ways 'homelands' are invented and utilized to discover a common past experienced or desired. Mental constructions that are possible only at a distance, concepts of 'homeland' foster solidarity and paradoxically enable accommodation to transplantation more readily than the ethnically weakening project of assimilation. Generally, it is assumed that civic acts, such as sponsoring commemorative sculpture, help immigrants move from marginality to salience in American social and political life. Looking at it from another angle, one sees that immigrants and the art they sponsor provide each other with meaning in regard to the homeland as much as in relation to the new land.

For instance, a statue of a soldier [**123**], honouring Colonel Hans Christian Heg, Norwegian-born leader of an entirely Scandinavian Wisconsin Union regiment, was raised in 1925 in front of the Wisconsin State Capitol and erected at the same time in Norway. A subscription committee headed by Det Norske Selskab af Amerika, promised 'every American with Norse blood in his veins will delight to take part in raising the necessary amount' to erect *both* statues. The subscription committee intended not only to commemorate Heg, who fell in 1863 at the Battle of Chickamauga, but also to respond to recent conditions in Norway, where a newly muscular nationalism emerged at the beginning of the twentieth century as Norway shrugged off Swedish domination; fashioning a public memory for a heroic native son who had died more than half a century earlier thereby claimed a national Norwegian identity in the United States for Norwegian-Americans. On these terms the unveiling ceremony in Madison, which featured the Norwegian national anthem as well as the flag of the 15th Wisconsin, a combination of Norwegian and American colours supporting an inscription reading, ambiguously, 'For Gud og Vårt Land', for God and 'our' country, makes sense.[15]

Columbus remembered: as founder

The wreath bearers photographed at the foot of Baltimore's statue of Columbus were the successful heirs of a nineteenth-century project to reclaim Columbus as an Italian and to give immigrants from the region a unified homeland. It took some doing, as most Americans, by a process of reasoning that transposed 'finding' North America to 'founding' the United States, counted Columbus as a compatriot.

John Vanderlyn

During the 1830s, Congress commissioned four murals to accompany the four paintings by Trumbull already in the Capitol (see Chapter 1). While the choice of subjects for these new paintings was made on regional grounds as much as anything else, John Vanderlyn's *Landing of Columbus on the Island of Guanahani, West Indies*, completed in 1847 [**124**], and Robert Weir's *Embarkation of the Pilgrims at Delft Haven, Holland, 22 July 1620*, completed in 1843, were installed in the Capitol rotunda as the first two events in an American history sequence culminating in Washington's presidency.[16] Vanderlyn (1775–1852) produced what might be called the definitive 'Landing' iconography on two counts. First the painting possesses not a little religious weight, lending gravity and wonder to this extraordinary event. Second, and related to the first, the painting lifts Columbus right out of the historically mundane and so seals his American destiny.

Behaving acrimoniously or gratefully, according to temperament, Columbus' sailors provide a counterpoint to his calm at the centre. He gives thanks to God, spotlit face turned to heaven, while in his left hand, the royal standard proclaims European possession of the land. In his right hand he holds the sword that will make it so. Although there were no religious on this, the first of Columbus's four voyages,

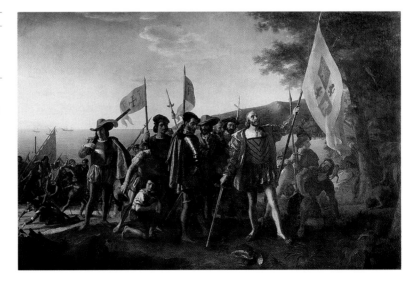

124 John Vanderlyn

Landing of Columbus on the Island of Guanahani, West Indies, October 12, 1492, 1839–47

In depicting the disembarkation of Columbus and his men in the New World with religious overtones, Vanderlyn produced a 'Landing' iconography that has proved indelible.

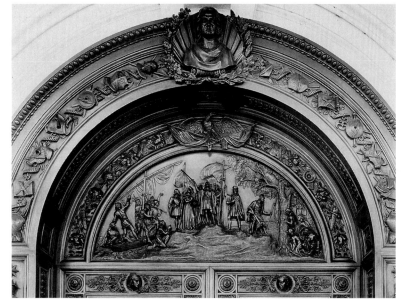

Vanderlyn includes someone (a priest?) holding a crucifix and he places a light-filled aureole around Columbus' head, confirming what the double action of the praying–possessing Columbus signals: the Discoverer is also Deliverer. For the Native Americans that Vanderlyn pictured lurking in the forest, the message was clear.

Randolph Rogers

Randolph Rogers (1825–92) was a self-taught sculptor until a well-disposed patron sent him to Italy to train. To fashion doors for the rotunda entrance of the Capitol, he proposed 'the subject to be the life of Columbus ... illustrated by ... alto[bas]-reliefs, which will contain in all about one hundred and fifty figures, besides twelve portrait statuettes and twelve heads of the distinguished contemporaries of Columbus, together with suitable ornamental work'. His plan approved in 1858, Rogers set to work modelling each relief in clay. Installed first on the Capitol interior, they were moved to the main entrance in 1871. The lunette portrays the Landing, pinnacle of Columbus's life as set forth by Rogers [**125**]. As in Vanderlyn's mural, Columbus takes centre stage both by compositional placement and in relation to his companions, who cluster around him (or even kneel before him) like courtiers. Like Vanderlyn also, Rogers imagines the Indians, whom Columbus himself described as graciously welcoming, as woodland creatures, cowering and insignificant.[17]

The Columbian Exposition

To celebrate the quattrocentennial of the United States—if counting starts in 1492—a World's Fair, the 'Columbian Exposition', was orga-

Detail of 128

As early as 1792, the New York 'Columbian Order' had toasted 'Christopher Columbus, the discoverer of this New World!' During the first quarter of the following century, he leapt from explorer to ancestor, aided by writers and artists who incoherently celebrated the nation's genesis by entangling Columbus' fifteenth-century voyage with other beginning points, like the first presidency or, especially, the Pilgrims' voyage in the seventeenth century. Structuring American history to begin in 1492 and naming Columbus as a forefather with credentials very like those of the Pilgrims (he set sail in order to seek 'bright freedom', proclaimed a 1792 ode) became fixed by mid-century. This narrative resulted in an attractively cohesive, lengthy, and heroic American history, to which the prominence of Columbian subjects in the United States Capitol's artistic embellishments granted an official imprimatur. At the Capitol, Columbus appeared in a cornice frieze, a relief, two frescoes, a colossal sculpture, and all eight panels and the lunette of a bronze double door, as well as in the lead-off rotunda mural.

nized by Chicago's civic and business leaders. Delayed a year by a nationwide financial depression and by urban social problems of an intensity unmatched in the preceding decades, the fair opened to huge success in 1893. The iconography of Columbus' Landing reached the zenith of its visibility on the fair grounds, in commercialization of his image in advertisements and souvenirs and in large-scale monuments and architectural ornamentation made by sculptors organized by Saint-Gaudens. From a small commemorative medal picturing the Landing, designed by Saint-Gaudens himself, to a triumphal arch surmounted by Columbus as Apollo composed by Saint-Gaudens' friend Daniel Chester French (1850–1931), the fair's official Columbus never varied in his role as founder–discover. The epitome, by size and ramification, was made by a student of Saint-Gaudens, Mary Lawrence (dates unknown), who produced a colossal statue of Columbus, arms uplifted and face tilted heavenward in a standard 'Landing' typology, greeting visitors at the east entrance to the fair as though welcoming them to the fruits of his discovery [**126**].

Columbus remembered: as Italian

The immigrant Italian alternative typology of Columbus appeared in commemorative art raised at century's end in more than a score of cities scattered across the country. These monuments uniformly eschewed association with Vanderlynian-type 'Landing' scenes.[18] Instead, statues of Columbus given to their communities by Italian-Americans employ the same attributes that the Baltimore statue boasts—anchor, globe, and/or map—signifying Columbus' role as a mariner. All are single figures. With rare exceptions, all are produced by Italian sculptors and take an Italian monument to Columbus in Genoa as their model. Of

126 Mary Lawrence Tonetti

Christopher Columbus, 1893 (destroyed)

Made of an impermanent material called staff, as were most of the Fair's sculptures, the colossal statue accidentally burned some years later.

127 Gaetano Russo

Christopher Columbus, 1892

By virtue of its site (59th Street at the foot of Central Park, now called Columbus Circle) and size (77 feet), Russo's work stands as the most conspicuous of Italian-American Columbus commemorations.

this group, which numbers more than a dozen, a monument by Gaetano Russo (dates unknown) in New York is easily the grandest, incorporating, in addition to pedestal reliefs of the departure and landing, a *columna rostrata*, or naval triumphal column, a personification of Genius, an eagle, and emblems of the United States and Italy [**127**].

The Italian-American press, and in particular Carlo Barsotti, editor of *Il Progresso Italo-Americano*, were key to the monument's inspiration, form, and completion. Barsotti started a subscription fund through his newspaper, which raised $20,000, monies that paid only for the marble. Having arranged a design competition in Italy, Barsotti managed to talk the winner, Russo, into donating his services, and the Italian Government into transporting the finished piece on a warship. As a delegate of the Italian-American community to New York's quattrocentennial committee, Barsotti charmed that organization into adopting the project as one of its own and received the premier site near Central Park. After the statue was unveiled, however, much of the New York establishment openly sneered, the *New York Times*, for example, referring to 'the swarthy sons of the sunny south' and their 'lightly clothed' women and children 'wander[ing]' at the statue's base, which the newspaper called 'a bit of marble'.[19]

Despite such denigrations, Italians in America persistently commemorated Columbus in statuary and succeeded in (re-) Italianizing the 'founder' by making him a mariner from the 'homeland'. While Italians today remain devoted to their province, before 1870—when a unified Italy came into being—there was even more

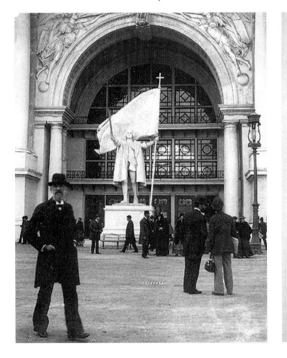

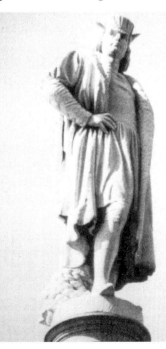

128 Five-dollar bill

US Treasury, series E, 1914
Merged legends of origin
showed up throughout the
century, in everything from
educational materials to folk
art, reaching their widest
audience in 1914 when the
Treasury issued a five-dollar
bill that showcased vignettes
of both landings—the
Pilgrims' in Massachusetts
(*right*) and Columbus' on a
Caribbean island (*left*).

cause for regionalist sentiment. That these regionally divided immigrants marshalled sufficient cohesion to form subscription committees for commissioning public monuments may be credited to their retention of language, religion, and customs in the United States. In large cities like New York, Italian-language newspapers helped persuade regionalized immigrants that they shared an ethnic identity as Italians and that one of the uses of this identity could be securing space, social and political, on very crowded ground.

Though politically divided, all regions in Italy shared an important folkway: religious processions in which a saint's three-dimensional image was the performance's object. These processions gave authority and inspiration to Italians parading to the foot of their very distinctive Columbus statues, processions that took place well before a Columbus Day holiday was legislated.[20] In this rite, a public link between Italians and Columbus was forged; the body that is the monument, then, acquired meaning through the bodies that accorded it homage.

Commemorative art's two great functions, recalling what is past and creating a memory for it, do not preclude historical contradictions; it helps make them possible, and worthwhile, in a country as large, as diverse, as persistently contentious yet tenaciously unified as the United States.

Notes

Introduction

1. Twain took exception to Paul Bourget, *Outre-Mer, Impressions of America*, 1895; see *Mark Twain at his Best*, ed. Charles Neider (New York, 1986), p. 297.

2. I hasten to dispel any sense that 'new' art history means 'better-than-old' art history. For example, much of American art history traditionally has been concerned with both high and low, or fine and popular, art, a fluidity that takes its cue from the porous nature of American art and life, and which any Americanist ignores at her/his risk. I take 'new art histories' from Bill Readings' 'New Art History', delivered at a 1994 conference: The New Art History—Revisited, Musée d'Art Contemporain de Montréal.

3. Linda Nochlin, *'Women, Art, and Power' and Other Essays* (New York, 1988), p. 176.

Chapter 1

1. Correspondence excerpted in John W. McCoubrey, *American Art 1700–1960: Sources and Documents* (Englewood Cliffs, NJ, 1965), pp. 10–18.

2. To avoid confusion, it's worth noting immediately that European academic precepts moved from inception to conception—that is, the sequence of learning led from drawing the model to executing a multi-figure painting.

3. Lois Marie Fink and Joshua Taylor, *Academy, The Academic Tradition in American Art* (Washington, DC, 1975), p. 12.

4. Alan Wallach—in 'Long-term Visions, Short-term Failures: Art Institutions in the United States, 1800–1860', in *Art in Bourgeois Society 1790–1850*, ed. Andrew Hemingway and William Vaughn (Cambridge, 1997), p. 297—explains that American elites were 'too weak and divided to co-operate in the creation of national cultural institutions'.

5. Carrie Rebora, 'History Painting at the American Academy of the Fine Arts', in *Redefining American History Painting*, ed. Patricia M. Burnham and Lucretia Hoover

Giese (Cambridge, 1995), p. 231.

6. Paul J. Staiti, *Samuel F.B. Morse* (Cambridge, 1989), pp. 158ff.

7. History painting was the means whereby many European academies, especially the one in London, supported nationalism; see, among others, Barbara Groseclose, 'Death, Glory, Empire: Art', in *Orientalism Transposed, the Impact of the Colonies on British Culture*, ed. Julie F. Codell and Dianne Sachko Macleod (Aldershot, 1998), pp. 189–201, and Dennis Montagna, 'Benjamin West's *The Death of General Wolfe:* A Nationalist Narrative', *American Art Journal* 13, 2 (1981), pp. 72–88.

8. See Barbara J. Mitnick, 'The History of History Painting', in *Picturing History, American Painting 1790–1930*, ed. William S. Ayres (New York, 1993), p. 31.

9. For West, see Montagna, 'Benjamin West's *The Death of General Wolfe*'; and Ann Uhry Abrams, *The Valiant Hero, Benjamin West and Grand-Style History Painting* (Washington, DC, 1985).

10. See Dorinda Evans, *Benjamin West and His American Students* (Washington, 1980).

11. Excerpted in McCoubrey, *American Art*, pp. 40–43. The six paintings are: *Death of General Warren*, 1786; *Death of General Montgomery in the Attack on Quebec, 31 December 1775*, 1786; *Capture of the Hessians at Trenton, 26 December 1776*, 1786–c. 1828; *Death of General Mercer at the Battle of Princeton, 3 January 1777*, 1787 (completed 1831); *Surrender of Lord Cornwallis at Yorktown, 19 October 1781*, 1787–c.1828; and *The Declaration of Independence, 4 July 1776*, 1787–1819.

12. Irma B. Jaffe, *John Trumbull: Patriot–Artist of the American Revolution* (Boston, 1975), p. 117. The four paintings for the Capitol rotunda were two military and two civil scenes: *The Surrender of General Burgoyne at Saratoga, 16 October 1777; The Surrender of Lord Cornwallis at Yorktown, 19 October 1781; The Resignation of General Washington, 23*

December, 1783; and *Declaration*.

13. P. Burnham, 'John Trumbull, Historian, The Case of the Battle of Bunker's Hill', in Burnham and Hoover Giese, *Redefining American History Painting*, p. 51.

14. Letter dated 3 October 1878 in *An American Art Student in Paris, The Letters of Kenyon Cox 1877–1882*, ed. H. Wayne Morgan (Kent and London, 1986), p. 139.

15. *Ibid.*, p. 142; see also H. Wayne Morgan, *Kenyon Cox, 1856–1919, A Life in American Art* (Kent and London, 1994), pp. 92–7. For Chalfant, see Marc Simpson *et al.*, *The Rockefeller Collection of American Art at the Fine Arts Museums of San Francisco* (New York, 1994), pp. 245–48.

16. In an attempt to redress enrolment depletion after the establishment of the ASL, the NAD, whose faith in the value of drawing from casts never faltered, followed up on its life classes for men with similar classes for women. Art schools in the US were far more progressive in this respect than European academies, though no one has asked whether the latter might have been influenced to rethink their policies by American precedent. Women were not admitted to anatomy lectures in the US. See Fink and Taylor, *Academy*, pp. 61–2.

17. See Randall C. Griffin, *Thomas Anshutz: Artist and Teacher* (Huntington, New York, 1994), pp. 48–9.

18. Joy Kasson, *Marble Queens and Captives* (New Haven and London, 1990), pp. 49–51.

19. J.G. Cawelti, *Apostles of the Self-Made Man: Changing Concepts of Success in America* (Chicago, 1965), pp. 39ff.

20. In the 1840s, many daguerreotypists also introduced their new technology by travelling from town to town; the market for photography soon enabled these itinerants to establish permanent studios.

21. For an example of the latter, see the travel diary of James Guild, an unsuccessful itinerant in New York State in the 1830s; see McCoubrey, *American Art*, pp. 28–32.

22. William Dunlap, *History of The Rise and Progress of the Arts of Design in the United States* (New York, 1969), Vol. 2, Pt 2, p. 354.

23. For example, those compiled by Dunlap and Tuckerman (as below).

24. Henry Tuckerman, *Book of the Artists, American Artist-Life* (New York, 1867), p. 601.

25. Nathaniel Hawthorne, *French and Italian Notebooks*, ed. Thomas Woodson (Columbus, 1980), p. 158 (dated April, 1858).

26. Chase is sometimes credited with the introduction of Impressionism to the United States. See H. Barbara Weinberg *et al.*, *American Impressionism and Realism: The Painting of Modern Life, 1885–1915* (New York, 1994), p. 22. The Ten first exhibited together in 1898 in New York; the group included Impressionists Childe Hassam (1859–1935) and John Twatchman (1853–1902).

27. Quoted in *Master Paintings from the Butler Institute of American Art*, ed. Irene Sweetkind (New York, 1991), p. 168.

28. Sarah Burns, *Inventing the Modern Artist: Art and Culture in Gilded Age America* (New Haven and London, 1996), pp. 19ff and pp. 79ff.

Chapter 2

1. Copley excerpted in John W. McCoubrey, *American Art 1700–1960* (Englewood Cliffs, NJ, 1965), p. 18; Stuart quoted in Neil Harris, *The Artist in American Society: the Formative Years 1790–1860* (New York, 1966), p. 66.

2. Stuart, as quoted in Harris, *The Artist in American Society*, p. 58; Paul J. Staiti, in *John Singleton Copley in America* (New York, 1995), p. 33.

3. When daguerreotypes suffused the portrait market in the 1840s and 1850s, photographers went to great lengths to insist that the camera should be used not merely as a physical record but as an index of character as well. See Graham Clarke, *The Photograph* (Oxford, 1997), pp. 101–5.

4. Elizabeth Mankin Kornhauser, '"Staring Likenesses": Portraiture in Rural New England, 1800–1850', in *Meet Your Neighbors: New England Portraits, Painters and Society 1790–1850* (Old Sturbridge Village, MA, 1992), p. 29.

5. William Dunlap, *History of the Rise and Progress of the Arts of Design in the United States* (New York, 1969), p. 289.

6. Nathaniel Hawthorne, *French and Italian Notebooks*, ed. Thomas Woodson (Columbus, 1980), p. 320.

7. I am thinking of the portrait reliefs of Augustus Saint-Gaudens (1848–1907), Daniel Chester French (1850–1931), and Olin Levi Warner (1844–96), all of whom studied in Paris; see Wayne Craven, *Sculpture in America* (New York, 1968), pp. 372–418.

8. Bruce Weber of Berry-Hill Gallery has determined the location of the setting.

9. Theodore E. Stebbins, Jr *et al.*, *A New World: Masterpieces of American Painting 1760–1910* (Boston, 1983), p. 201.

10. Richard Bushman, *The Refinement of America: Persons, Houses, Cities* (New York, 1992).

11. William Gerdts, 'Natural Aristocrats in a Democracy: 1810–1870', in *American Portraiture in the Grand Manner: 1720–1920* (Los Angeles, 1981), p. 35.

12. Susan Danly, *Facing the Past: Nineteenth-Century Portraits from the Pennsylvania Academy of the Fine Arts* (New York, 1992) p. 32.

13. Catharine Beecher, *Truth Stranger than Fiction* (1850; Boston, 1859), p. 23.

14. Alan Trachtenberg, *The Incorporation of America, Culture and Society in the Gilded Age* (New York, 1982), pp. 144–7.

15. In Gerda Lerner, 'The Lady and the Mill Girl …', in *Our American Sisters: Women in American Life and Thought*, ed. Jean Friedman and William Shade (Boston, 1973), p. 90. Also in the same collection, see Barbara Welter, 'The Cult of True Womanhood: 1820–1860', pp. 96–123.

16. William Inness Homer, 'Sketch for the *Gross Clinic*', in *Thomas Eakins*, ed. J. Wilmerding (Washington, DC, 1993), p. 80, and Elizabeth Johns, '*The Gross Clinic* or *Portrait of Dr Gross*', in *Thomas Eakins, the Heroism of Modern Life* (Princeton, 1983), pp. 46–81.

17. In a paper given in May, 1998, at Kenyon College. Michael Fried, *Realism, Writing, and Disfiguration: On Thomas Eakins and Stephen Crane* (Chicago, 1987), brings up this idea in different terms.

18. H. Barbara Weinberg, '*Artist's Wife and his Setter Dog*', in *Thomas Eakins*, ed. Wilmerding, p. 106.

19. Kathleen Spies, 'Figuring the Neurasthenic: Thomas Eakins, Nervous Illness, and Gender in Victorian America', *Nineteenth Century Studies* 12 (1998), pp. 85–109.

20. Elizabeth Johns, '*Maud Cook*', in *Thomas Eakins*, ed. Wilmerding, p. 124.

21. Nicolai Cikovsky, Jr, '*Archbishop Diomede Falconio*', in *Thomas Eakins*, p. 174, on sourness; and quoting Lloyd Goodrich, *Thomas Eakins*, Vol. 2 (Cambridge, MASS, 1982), p. 188, on meditation.

Chapter 3

1. Raymond Williams, *Culture and Society 1780–1950* (London, 1959), p. xiv.

2. Richard Jenkyns, 'Cards of Identity', *New York Review of Books*, 23 April, 1998, p. 52.

3. My usage follows Raymond Williams in *Keywords: A Vocabulary of Culture and Society* (New York, 1976), pp. 82–7.

4. For the consequences of this and other assumptions about the inhabitants of the New World, see Tzvetan Todorov, *The Conquest of America: the Question of the Other*, trans. Richard Howard (New York, 1984).

5. Imperial Roman sculpture included dark-skinned subjects of the Emperor, kneeling before him or, in one instance, squashed beneath his horse's hoof. The substitution of condition for place in what otherwise might be *genius loci* has an important place in the art of empires: see Barbara Groseclose, *British Sculpture and the Company Raj: Church Monuments and Public Statuary in Madras, Calcutta and Bombay to 1858* (London and Newark, 1995).

6. For a truly dizzying spin through the names an allegorical image might acquire, see the letters of Hiram Powers with regard to the sculpture eventually known as 'America', in Vivien Green Fryd, 'Hiram Powers's *America*: "Triumphant as Liberty and in Unity"', *The American Art Journal* XVIII, No. 2 (1986), pp. 55–75.

7. For the commissioning history and Meigs' correspondence, see Vivien Green Fryd, *Art and Empire, the Politics of Ethnicity in the United States Capitol, 1815–1860* (New Haven and London, 1992), pp. 185–200.

8. A Native American man sometimes signified the 'new world', especially in contrast to the old.

9. For a history, see Alton Ketchum, *Uncle Sam: the Man and the Legend* (New York, 1959). Uncle Sam is also a nickname for the government itself.

10. J. A. Leo Lemay, 'The American Origins of Yankee Doodle', in *William and Mary Quarterly* 33 (1976), pp. 435–66. See Joshua C. Taylor, 'The American Cousin', in *America as Art* (Washington, DC, 1976), pp. 39–94, and Francis Hodge, *Yankee Theatre: The Image of America on the Stage, 1825–1850* (Austin, TX, 1964). There is no agreement in linguistic circles on the origin of the word 'Yankee'.

11. Elizabeth Johns, 'An Image of Pure Yankeeism', in *American Genre Painting* (New Haven and London, 1991), pp. 24–59.

12. See Robert Wiebe, 'The Barbarians', in *Self-Rule, A Cultural History of Democracy* (Chicago and London, 1995), pp. 41–60.

13. Whitman, 'Leaves of Grass', in *The Poetry and Prose of Walt Whitman* (New York, 1949), p. 488.

14. Wiebe, *Self-Rule*, p. 1.

15. Hermann Warner Williams, *Mirror to the American Past* (Greenwich, CT, 1973) and James Thomas Flexner, *That Wilder Image* (Boston, 1962). See, contra, John Barrell, *The*

Dark Side of the Landscape: the Rural Poor in English Painting, 1730–1840 (Cambridge, 1980); T.J. Clark, *Image of the People: Gustave Courbet and the 1848 Revolution* (London and New York, 1973); Linda Nochlin and Sarah Faunce, *Courbet Reconsidered* (Brooklyn, 1988). (By referring to these books serially, I do not mean to conflate their very different approaches.)

16. Patricia Hills, 'Images of Rural America, the Works of Eastman Johnson, Winslow Homer and Their Contemporaries', in *The Rural Vision: France and America in the Nineteenth Century*, ed. Hollister Sturges (Joslyn, MO, 1987), pp. 14–15, discusses newspapers as 'pictorial visualization' of 'individualism nurtured by participatory democracy'; and see Bryan J. Wolf, 'All the World's a Code …' *Art Journal* 44 (1984), pp. 328–37, for an analysis of the newspaper's roles in the circulation of information (and how this process informs the content and composition of painting), accompanied by close attention to transitions in commercial journalism.

17. Mrs Frances Trollope, *Domestic Manners of the Americans*, ed. Donald Smalley (1832; New York, 1949), p. 226.

18. Quoted in Thomas C. Leonard, *News for All* (New York and Oxford, 1995), p. 10.

19. Benedict Anderson, *Imagined Communities, Reflections on the Origin and Spread of Nationalism* (1983; London, 1991), pp. 35–36.

20. Wolf, '*All the World's a Code …*', makes this observation apropos *War News*, p. 332; see also Johns, *American Genre Painting*, particularly pp. 121–2.

21. *Bulletin of the American Art-Union* (1 April 1851), as quoted by Patricia Hills in 'Picturing Progress in an Age of Expansion', in *The West as America, Reinterpreting Images of the Frontier, 1820–1920* (Washington, DC, 1991), p. 107.

22. Johns, *American Genre Painting*, p. 220.

23. Thomas C. Leonard, *News for All*, p. 102; see also Laura Coyle, 'The Best Index of American Life, Newspapers in the Artist's Work', in *William Harnett*, ed. D. Bolger, M. Simpson, and J. Wilmerding (New York, 1992), pp. 223–9.

24. Anderson, *Imagined Communities*, p. 73.

25. Nicolai Cikovsky and Franklin Kelly, *Winslow Homer* (New Haven and London, 1996), p. 96.

26. See Janet Duitsman Cornelius, *When I Can Read My Title Clear: Literacy, Slavery, and Religion in the Antebellum South* (Columbia, SC, 1991).

27. Taylor, *America as Art*, p. 44.

Chapter 4

1. *Of Time and Place, American Figurative Art from the Corcoran Gallery* (Washington, 1981), catalogue entry by Edward Nygren and Andrea C. Wei, p. 61.

2. Martha Banta, *Imaging American Women: Idea and Ideals in Cultural History* (New York, 1987), p. xxvii.

3. Ann Uhry Abrams and Anne Cannon Palumbo, *Goddess, Guardian and Grand Old Gal* (Atlanta, 1986), p. 15.

4. Angela Miller, 'Review of *Pastoral Inventions: Rural Life in Nineteenth-Century American Art and Culture*', *Winterthur Portfolio* 29, No. 4 (1989), p. 280.

5. See especially Sarah Burns, *Pastoral Inventions: Rural Life in Nineteenth-Century American Art and Culture* (Philadelphia, 1989), pp. 258–96.

6. James Gilbert, *Work Without Salvation: America's Intellectuals and Industrial Alienation 1880–1910* (Baltimore, 1977), p. vii, quoted in Melissa Dabakis, *Visualizing Labor in American Sculpture: Monuments, Manliness and the Work Ethic 1880–1935* (Cambridge, 1999), p. 219, n. 6, and Herbert G. Gutman, *Work, Culture, and Society in Industrializing America* (New York, 1976), p. 3.

7. Melissa Dabakis, *Visualizing Labor*, p. 22.

8. Nygren, *Of Time and Place*, p. 38.

9. Randall C. Griffin, 'Thomas Anshutz's *Ironworkers' Noontime*: Remythologizing the Industrial Worker', *Smithsonian Studies in American Art* 4 (1990), p. 138.

10. Michael O'Malley, 'Time, Nature and the Good Citizen', *Keeping Watch, A History of American Time* (Washington, 1996), pp. 1–54.

11. Thoreau quoted in O'Malley, 'Time, Nature …', p. 67; on railroads, p. 140.

12. Martin A. Berger, 'Painting Victorian Manhood', in Helen A. Cooper *et al.*, *Thomas Eakins, the Rowing Pictures*, (New Haven and London, 1996), p. 116.

13. 'The River Paintings', in Michael Edward Shapiro *et al.*, *George Caleb Bingham* (New York, 1990), p. 151.

14. Berger, 'Painting Victorian Manhood', p. 120. See also Elizabeth Johns, '*Max Schmitt in a Single Scull* or *The Champion Single Scull*', in *Thomas Eakins, the Heroism of Modern Life* (Princeton, 1983), pp. 19–45.

15. The mistaken description is in *New York Evening Telegram*, 20 April 1872, quoted in Nicolai Cikovsky and Franklin Kelly, *Winslow Homer* (New Haven and London, 1996), p. 92. Bryan J. Wolf, 'The Labor of Seeing:

Pragmaticism, Ideology, and Gender in Winslow Homer's *The Morning Bell*', *Prospects* 17 (1992): 273–319. N. Cikovsky, Jr, 'Winslow Homer's (So-Called) *Morning Bell*', *American Art Journal* XXIX (1998), pp. 5–17, convincingly argues for the title *The Old Mill*, and in the same essay explains that the money earned by country girls in the new textile mills was very often spent on fashionable 'city' clothes (p. 8).

16. O'Malley, 'Time, Nature …', p. 52, and see Catharine Beecher and Harriet Beecher Stowe, *The American Woman's Home* (New York, 1869).

17. Ann Douglas, *The Feminization of America* (New York, 1977), p. 10.

18. Quoted in Christine Stansell, *City of Women, Sex and Class in New York, 1789–1860* (New York, 1986), p. 159.

19. Kathy Peiss, 'Leisure and Labor', in *The Making of Urban America*, ed. Raymond A. Mohl (Wilmington, DE, 1988), p. 139.

20. Elizabeth L. O'Leary, *At Beck and Call: the Representation of Domestic Servants in Nineteenth-Century American Painting* (Washington, 1996), p. 49.

21. The term 'print capitalism' is Benedict Anderson's in *Imagined Communities, Reflections on the Origin and Spread of Nationalism* (1983; London 1991).

22. For an account of child labour far more dire, see Wilma King, *Stolen Childhood, Slave Youth in Nineteenth-Century America* (Bloomington, 1995).

23. Bruce Chambers, *The World of David Gilmour Blythe, 1815–1865* (Washington, DC, 1980), p. 38, quotes a vitriolic attack on these targets; jottings from Blythe's notebook in caption in Chambers, p. 39.

24. Dabakis, *Visualizing Labor*, p. 53.

Chapter 5

1. As laid out in Edward Nygren and Bruce Robertson, *Views and Visions: American Landscape before 1830* (Washington, DC, 1986).

2. As a discipline, art history itself could not be called widespread in the United States until the post-World War II years; see Udo Kultermann, *The History of Art History* (New York, 1993).

3. James Jackson Jarves, *The Art-Idea*, ed. Benjamin Rowland, Jr (Cambridge, MA, 1960), p. 189.

4. Kynaston McShine (ed.), *The Natural Paradise: Painting in America, 1800–1950* (New York, 1976).

5. Three prominent examples: Bryan Jay Wolf, *Romantic Re-Vision: Culture and Consciousness in Nineteenth-Century American Painting and Literature* (Chicago, 1982), introduces a Lacanian perspective; Alan Wallach, 'Making a Picture of the View from Mount Holyoke', *American Iconology*, ed. David C. Miller (New Haven and London, 1993), pp. 80–91, works out of Foucault; Kenneth Haltman, 'Antipastoralism in Early Winslow Homer', *Art Bulletin* LXXX, No. 1 (1998), pp. 93–112, utilizes the insights of phenomenology.

6. I do not consider, for lack of space, Cole's Italian scenes, but these should not be overlooked.

7. Ellwood C. Perry, III, 'Thomas Cole's Early Career: 1818–1829', in Nygren and Robertson, *Views and Visions*, p. 162; Alan Wallach, 'Thomas Cole, Landscape and the Course of American Empire', in *Thomas Cole: Landscape into History* (Washington, 1994), p. 23–4, places the 'discovery' of Cole's painting in art-historical context.

8. Wall should not be considered a straw man; see Kenneth Myers, *The Catskills: Painters, Writers, and Tourists in the Mountains, 1820–1895* (Yonkers, 1987), pp. 47–9.

9. David C. Miller, 'Introduction', *American Iconology*, p. 6.

10. William Cronon, *Uncommon Ground: Toward Reinventing Nature* (New York, 1995), p. 25.

11. Barbara Novak, 'Thomas Cole: The Dilemma of the Real and the Ideal', *Painting in the Nineteenth Century* (New York, 1969), pp. 61–79.

12. This is too complicated an idea to do justice to here: see Kenneth John Myers, 'On the Cultural Construction of Landscape Experience: Contact to 1830', in Miller, *American Iconology*, pp. 58–79, and Angela Miller, 'Landscape Taste as an Indicator of Class Identity in Antebellum America', in *Art in Bourgeois Society, 1790–1850*, ed. Andrew Hemingway and William Vaughn (Cambridge, 1997) pp. 340–61.

13. I am indebted to an unpublished (1997) paper by Nora C. Kilbane, 'Beyond *Kindred Spirits*'.

14. Quoted in John Durand, *The Life and Times of A.B. Durand* (New York, 1844), p. 213.

15. Barbara Novak, 'On Defining Luminism', in *American Light: The Luminist Movement, 1850–75*, ed. John Wilmerding (Washington, 1980), p. 29.

16. *Ibid.*, p. 25.

17. David C. Miller, 'The Iconology of Wrecked or Stranded Boats in Mid to Late Nineteenth-Century American Culture', in *American Iconology*, pp. 186–208.

18. Church scholars all take note of 1859, the year *Heart of the Andes* was exhibited, Humboldt died, and Darwin published *Origin of the Species*; see Stephen Jay Gould, 'Church, Humboldt, and Darwin: The Tension and Harmony of Art and Science', in Franklin Kelly, *Frederic Edwin Church* (Washington, 1990), pp. 96ff.

19. Sarmiento y Fausta, *Travels in the United States in 1847*, trans. Michael Aaron Rockland (Princeton, 1970), p. 225.

20. Katherine Emma Manthorne, *Tropical Renaissance: North American Artists Exploring Latin America 1839–1879* (Washington and London, 1989).

21. Quoted in Kelly, *Frederic Edwin Church*, p. 12.

22. Charles Dickens, *American Notes for General Circulation* (1842; London, 1972), p. 237.

23. Nicolai Cikovsky, Jr, '"Ravages of the Axe": the Meaning of the Tree Stump in Nineteenth-century American Art', *Art Bulletin* 61, 4 (1979), pp. 611–26, is the *summa* of interpretation of this motif.

24. Leo Marx, *The Machine in the Garden: Technology and the Pastoral Ideal in America*, (New York, 1964), p. 203–4.

25. 'Paragraphs from the Studio of a Recluse, 1905', in John W. McCoubrey, *American Art 1700–1960* (Englewood Cliffs, NJ, 1965), pp. 187–8; Kandinsky quoted in *Encyclopedia of Aesthetics*, Vol. 3, ed. Michael Kelly (Oxford, 1998), p. 23.

26. Samuel Isham, *History of American Painting* (New York, 1905), p. 457.

27. Wanda Corn, *Color of Mood: American Tonalism, 1880–1910* (San Francisco, 1972) remains a high point in this regard.

28. Charles Caffin, *American Masters of Painting* (London, 1903), pp. 71–80.

29. Wayne Craven, *American Art, History and Culture* (New York, 1994), p. 330.

30. Boston *Daily Evening Transcript*, 23 December 1892, quoted in Nicolai Cikovsky and Franklin Kelly, *Winslow Homer* (New Haven and London, 1996), p. 260.

31. In Isham, *History of American Painting*, supplemental chapters by Royal Cortissoz (1905; New York, 1927), p. 568.

32. Sarah Burns, *Inventing the Modern Artist: Art and Culture in Gilded Age America* (New Haven and London, 1996), p. 193.

Chapter 6

1. Alan Trachtenberg, 'Contesting the West', *Art in America*, Vol. 79, 9 (1991), p. 118. It is said that John L. O'Sullivan, editor of the *United States Magazine and Democratic Review*, coined the term, in 1845 telling Americans theirs was a 'manifest destiny to overspread the continent'.

2. William Cronon, 'Telling Tales on Canvas', in Jules Prown, *et al.*, *Discovered Lands, Invented Pasts: Transforming Visions of the American West* (New Haven and London, 1992), p. 62 and see also p. 56.

3. Not at issue here is belief in the frontier as 'the line of most rapid and effective Americanization', a thesis promulgated by Frederick Jackson Turner, *The Frontier in American History* (New York, 1920), pp. 3–4.

4. For example, an English immigrant living in California, Thomas Hill (1829–1908), specialized in custom landscapes for British clients who requested motifs like 'early morning' or 'sunset, with Indians'; see *Master Paintings from the Butler Institute of American Art*, ed. Irene Sweetkind (New York, 1991) p. 59.

5. William Cullen Bryant, *Picturesque America*, 1874, quoted in Alan Trachtenberg, *The Incorporation of America: Culture and Society in the Gilded Age* (New York, 1982), pp. 18–19.

6. Cronon, 'Telling Tales', pp. 44–5.

7. Brian Dippie, *Catlin and his Contemporaries: the Politics of Patronage* (Lincoln and London, 1990), p. 97.

8. *Ibid.*, p. 367.

9. William H. Goetzmann, *Exploration and Empire, the Explorer and the Scientist in the Winning of the American West* (New York, 1971), p. xiii, sets out three states of western exploration: (1) from Lewis and Clark to 1845, an era of 'international competition for the West'; (2) at mid-century, a 'westering' fulfilment of Manifest Destiny; and (3) after 1860, a period of 'Great Surveys'. For photography and the west, see Elizabeth Lindquist-Cock, *The Influence of Photography on American Landscape painting, 1839–1880* (New York, 1977) and Eugene Ostroff, *Western Views and Eastern Visions* (Washington, 1981).

10. See Nancy K. Anderson and Linda S. Ferber, *Albert Bierstadt Art and Enterprise* (New York, 1990), esp. pp. 130–31. Also Anderson, '"Curious Historical Artistic Data": Art History and Western American Art', in Prown *et al.*, *Discovered Lands, Invented Pasts*, pp. 1–36, esp. p. 24.

11. From *Round Table*, 27 February 1864, as quoted in Anderson and Ferber, *Albert Bierstadt*, p. 194.

12. Samuel Isham, *History of American Painting* (New York, 1905), p. 252.

13. Hamilton S. Wicks, *Cosmopolitan*, 22 April 1889, excerpted in *Eyewitness to America*, ed.

David Colbert (New York, 1997), p. 292.

14. Henry Nash Smith, *The Virgin Land: The American West as Symbol and Myth* (Cambridge, MA, 1950), observed, 'The myth of the garden as it had matured ... interpreted the whole vast West as an essentially homogeneous society in which class stratification was of minor importance', pp. 137–8.

15. See Gail Husch, '*Poor White Folks* and *Western Squatters*, James Henry Beard's Images of Emigration', *American Art* 7, 3 (1993), pp. 15–40. For exodusters, see Nell Irvin Painter, *Exodusters: Black Migration to Kansas after Reconstruction* (New York, 1976).

16. In reference to the women in the painting, see Katherine M. Weist, 'Beasts of Burden and Menial Slaves: Nineteenth-century Observations of Plains Indian Women', in *The Hidden Half: Studies of Plains Indian Women* (Washington, DC, 1983).

17. Exacerbating US Government interference, inter-tribal warfare, in which aggressive tribes commandeered lands from weaker groups, contributed to the population shifts.

18. Julie Schimmel, 'Inventing "the Indian"' in *The West as America: Reinterpreting Images of the Frontier, 1820–1920* (Washington, DC, 1991), ed. William H. Truettner, p. 172.

19. Lynne Withey, *Grand Tours and Cook's Tours* (New York, 1997), pp. 299–300.

20. Howard Lamar, 'An Overview of Westward Expansion', in Truettner, *The West as America*, pp. 19–20. Despite his continued popularity in German-speaking lands (for his romances of the Middle East as well as his cowboy stories), little has been written in English on May, who died in 1912.

21. Theodore Roosevelt, *Hunting Trips of a Ranchman* (1885), p. 11–12. Roosevelt also led the fight to protect public land in the west, creating some 194,000,000 acres of National Parks. See G. Edward White, *The Eastern Establishment and the Western Experience: the West of Frederic Remington, Theodore Roosevelt, and Owen Wister* (New Haven and London, 1968), Chapter 8: 'Technocracy and Arcadia: Conservation Under Roosevelt'.

22. See Peggy and Harold Samuels, *Frederic Remington* (Austin, 1985), pp. 327–8, and Michael Shapiro and Peter H. Hassrick, *Frederic Remington, the Masterworks* (St Louis Museum of Art, 1988), p. 206.

23. Robert W. Rydell, *All the World's a Fair: Visions of Empire at American International Expositions, 1876–1916* (Chicago, 1984), p. 157: 'The directors of the Saint Louis fair turned this portrait of the world into an anthropologically validated racial landscape that made ... continued overseas economic expansion seem as much a part of the manifest destiny of the nation as the Louisiana Purchase itself.'

24. See J. Grey Sweeney, 'Racism, Nationalism, and Nostalgia in Cowboy Art', *Oxford Art Journal* 15, 1 (1992), p. 79, n. 3.

25. Patricia Nelson Limerick, *Legacy of Conquest* (New York, 1987), pp. 56 and 77.

26. Lois Marie Fink and Joshua Taylor, *The Academic Tradition in American Art* (Washington, DC, 1975), p. xi, and Truettner, *The West as America*, p. 40. See also Bryan J. Wolf, 'How the West Was Hung, Or, When I Hear the Word "Culture" I Take Out My Checkbook', *American Quarterly* 44, 3 (1992), pp. 418–38. For another experience see Sweeney, 'Racism, Nationalism ...', pp. 67–80.

27. See Amy Kaplan, 'Left Alone with America: the Absence of Empire in the Study of American Culture', in *Cultures of United States Imperialism*, ed. Amy Kaplan and Donald E. Pease (Durham, 1993), pp. 3–21. An exemplary post-colonial perspective is Frances K. Pohl, 'Old World, New World: the Encounter of Cultures on the American Frontier', in Stephen F. Eisenman, *Nineteenth Century Art: A Critical History* (London, 1994), pp. 144–62. Feminist projects have raised issues provocative for art historians; see Helen Carr, 'Woman/Indian: "The American" and his Others', in *Europe and its Others*, Vol. 2, Proceedings of the Essex Conference on the Sociology of Literature, July 1984, pp. 46–60, and Susan Prendergast Schoelwer, 'The Absent Other: Women in the Land and Art of Mountain Men', in Prown *et al.*, *Discovered Lands, Invented Pasts*, pp. 135ff and esp. p. 203. To mention the bearing analyses of western art informed by these two theories might exert does not preclude other theoretical potentialities.

Chapter 7

1. See Edward D.C. Campbell and Kym S. Rice (eds), *A Woman's War: Southern Women, Civil War and the Confederacy* (Richmond, 1996).

2. Walt Whitman, *Specimen Days* (New York, 1949), pp. 616–17; Porter quoted in Geoffrey C. Ward *et al.*, *The Civil War: An Illustrated History* (New York, 1990), p. 291.

3. Stanley French, 'The Cemetery as Cultural Institution: the Establishment of Mount Auburn and the "Rural Cemetery" Movement', in *Death in America*, ed. David

Stannard (Philadelphia, 1975), p. 77 observes that: '... Mount Auburn was open to anyone who wished to purchase a lot ... it was a nonprofit organization in which the proceeds from plot sales would be spent exclusively in maintenance and improvements'.

4. Wayne Craven, *Sculpture in America from the Colonial Period to the Present* (Newark and New York, 1984), p. 235, notes the prevalence of these figures also on town squares and crossroads throughout the north-east. In the midwest, in comparison, the single soldier frequently receives elaboration in the form of narrative pedestal reliefs.

5. Kirk Savage, 'The Politics of Memory: Black Emancipation and the Civil War Monument', in *Commemorations: the Politics of National Identity*, ed. John R. Gillis (Princeton, 1994), p. 129.

6. See, among others, Albert Boime, *Hollow Icons: The Politics of Sculpture in Nineteenth-Century France* (Kent and London, 1987); P. Fusco and H. W. Janson (eds), *The Romantics to Rodin* (Los Angeles County Museum of Art, 1980); Barbara Groseclose, *British Sculpture and the Company Raj: Church Monuments and Public Statuary in Madras, Calcutta and Bombay to 1858* (London and Newark, 1995).

7. See Kirk Savage, 'Common Soldiers', in *Standing Soldiers, Kneeling Slaves* (Princeton, 1997), pp. 162ff.

8. Albert Boime, *The Art of Exclusion: Representing Blacks in the Nineteenth Century* (Washington, DC, 1990), contains an account of the regiment's history, pp. 199–203.

9. 'We can imagine no holier place than that in which he is ... nor wish him better company. ...' Quoted in Ward *et al.*, *Civil War*, p. 248.

10. Savage, *Standing Soldiers*, p. 136; Boime, *Art of Exclusion*, concludes, pp. 201–11, that the sculptor 'succeeded in establishing a visual "color-line" that guarded white supremacy'.

11. See Savage, 'Freedom's Memorial', in *Standing Soldiers*, pp. 89ff. See also Craven, *Sculpture in America*, pp. 219–28.

12. Especially Boime, *Art of Exclusion*, pp. 171–2.

13. The French historian Pierre Nora and his collaborators have excavated what Nora calls 'realms of memory', identifying spheres from which the French nation collectively was made and was made collective (see Bibliographic Essay). The fulcrum for Nora's project is the French Revolution. American culture has yet to be the subject of a similar operation, though one can imagine that if it were, the Civil War would take the place of the French Revolution.

14. Jeanie Attie, 'War Work and the Crisis of Domesticity in the North', *Divided Houses: Gender and the Civil War*, ed. Catherine Clinton and Nina Silber (New York, 1992), p. 254; also see Steven Conn, 'Rescuing the Homestead of the Nation: the Mount Vernon Ladies' Association and the Preservation of Mount Vernon', *Nineteenth Century Studies* II (1997), pp. 71–94.

15. I am grateful to Kristin A. Risley for sharing her unpublished paper, 'Man, Monument, and Myth: the Making of Hans Christian Heg', 1998.

16. See Vivien Green Fryd, *Art and Empire: The Politics of Ethnicity in the U.S. Capitol, 1815–1860* (New Haven, 1992), pp. 42–61; Sally Webster, 'Writing History/Painting History', in *Critical Issues in Public Art: Content, Context, and Controversy* (New York, 1992), pp. 33–43 and Barbara Groseclose, 'American Genesis: The Landing of Christopher Columbus', in *American Icons, Transatlantic Perspectives on Eighteenth and Nineteenth Century Art*, ed. Thomas Gaehtgens and Heinz Ickstadt (Getty Center, 1992), pp. 11–34. I am not concerned here with Pilgrims; their role in mythologies of origin is treated in Ann Uhry Abrams, *The Pilgrims and Pocahantas: Rival Myths of American Origin* (Boulder, Colorado, 1999).

17. '...They came swimming to the ships' launches ... and brought us parrots and cotton thread in balls and ... many other things. ... they gave of what they had very willingly', Columbus wrote. See *The 'Diario' of Christopher Columbus's First Voyage to America, 1492–1493*, trans. Oliver Dunn and James E. Kelley, Jr (Norman, 1989), p. 65.

18. I count at least 14, ranging from Detroit to Providence. In contrast, statues raised to Columbus at the turn of the century by non-Italians number around six.

19. Quoted in Michele Bogart, *Public Sculpture and the Civic Ideal* (Chicago, 1989), p. 334, n. 37.

20. John Williams, 'Italian Regionalism and Pan-Italian Traditions', in *Folklife Center News* XI, 3 (1989), p. 11.

Historical events	Visual arts
1775	
1775 American War of Independence begins	
1776 Declaration of Independence	
1782 Hector St-John de Crêvecoeur, *Letters from an American Farmer*	
1783 Treaty of Paris, ending war	
	1786 John Trumbull, *Death of General Warren at the Battle of Bunker' Hill*
1788 US Constitution ratified	
1789 George Washington elected first US President (serves until 1797)	
1800	
1800 Washington, District of Columbia, becomes capital	
1803 Louisiana Purchase extends US borders	
1804–6 Lewis and Clark expedition to map Louisiana Purchase	1805/6 Pennsylvania Academy of the Fine Arts founded in Philadelphia
1812–14 War with Great Britain	
1818 Northern boundary of US established at 49th Parallel	
1819 Florida purchased from Spain	
	1821 Sarah Miriam Peale, *Anna Smyth*
1825	
1825 Erie Canal opens	
1826 James Fenimore Cooper, *Last of the Mohicans*	1826 National Academy of Design established in New York City
1828 Andrew Jackson elected 7th President (serves 1829–37); introduction of universal manhood suffrage; Daniel Webster, *An American Dictionary of the English Language*; Washington Irving, *Life of Columbus*	
1830 Jackson signs Indian Removal Act into law; first wagon trains cross Rocky Mountains	
1832 Mrs Frances Trollope, *Domestic Manners of the Americans*	
1834 George Bancroft, *History of the United States* (1834–76)	1834 William Dunlap, *Rise and Progress of the Arts of Design in the United States*; Longacre and Herring's National Portrait Gallery of Distinguished Americans (1834–6)
1835	
1835 De Tocqueville, *Democracy in America* (Vol. 2 published in 1840)	1835 Hiram Powers, *Andrew Jackson*; William Sidney Mount, *Bargaining for a Horse*
1836 Battle of the Alamo; Lone Star Republic founded (1836–45); Ralph Waldo Emerson, *Nature*	1836 Thomas Cole, *The Oxbow* and *Course of Empire*
1837 Financial panic, US and Great Britain; Ralph Waldo Emerson, *The American Scholar*	
1838 Underground Railroad established; 4,000 die in forced move westward on Cherokee 'Trail of Tears'	
1839 Daguerreotype introduced in US by Samuel F.B. Morse	1839 American Art Union begins as Apollo Association (closed 1852)
1840 Transcendentalist publication, *The Dial*, begins	
1842 Charles Dickens, *American Notes for General Circulation*	
1843 John Ruskin, *Modern Painters*	1843 Hiram Powers, *The Greek Slave*
1844	
1844 Samuel F.B. Morse demonstrates telegraph to Congress: 'What hath God wrought!'	1844 George Catlin, *Letters and Notes on the Manners, Customs, and Conditions of the North American Indians, Written during Eight Years' Travel (1832–39) Amongst the Wildest Tribes of Indians in North America* (two volumes)

	Historical events	Visual arts
1845	1845 Texas annexed; Irish potato famine begins, increasing immigration to US; Margaret Fuller, *Woman in the Nineteenth Century*	
	1846 Mexican–American War (1846–48); Oregon acquired; Smithsonian Institution founded	
	1848 Gold discovered in California; Chinese immigration begins; first women's rights convention, Seneca Falls, NY	1848 Richard Caton Woodville, *War News from Mexico*
		1849 Asher B. Durand, *Kindred Spirits*
1850		1850 William Sidney Mount, *California News*
	1851 Herman Melville, *Moby Dick*; potato famine drives more than 200,000 from Ireland to US	1851 George Caleb Bingham, *County Election*; Emanuel Leutze, *Washington Crossing the Delaware*
	1852 Harriet Beecher Stowe, *Uncle Tom's Cabin*; Alexander von Humboldt, *Personal Narrative of Travels to the Equinoctial Regions of America* (English trans.)	
	1854 Henry David Thoreau, *Walden*	
1855	1855 Walt Whitman, 'Leaves of Grass'; Henry Wadsworth Longfellow, *Hiawatha*	1855 *The Crayon: A Journal devoted to the Graphic Arts and the Literature Related to Them* (to 1861)
		1856 Lilly Martin Spencer, *Kiss Me and You'll Kiss the 'Lasses*
	1857 Dred Scott decision in Supreme Court upholds slavery; financial panic; first Otis elevator operated	1857 Frederic Church, *Niagara Falls*
	1858 First transatlantic cable; Colonel Frederick Lander's overland expedition to Rockies	1858 Frank Blackwell Mayer, *Independence*
	1859 John Brown's failed raid on Harper's Ferry, VA, to incite slave revolt	1859 Frederic Church, *Heart of the Andes*
1860	1860 Abraham Lincoln elected 16th President (serves 1861–5); Nathaniel Hawthorne, *Marble Faun*; South Carolina secedes	
	1861 Mississippi, Florida, Alabama, Georgia, Louisiana, Texas, Virginia, Tennessee, Arkansas, and North Carolina secede; Jefferson Davis elected President of the Confederate States of America; attack on Fort Sumter launches Civil War (1861–5)	
	1862 Homestead Act offers settlers land in the west	
	1863 Lincoln, *Gettysburg Address*; Emancipation Proclamation in effect	1863 Thomas Crawford, *Armed Freedom* installed at US Capitol; Eastman Johnson, *The Newspaper Reader*; Albert Bierstadt, *Rocky Mountains, Lander's Peak*
1865	1865 Robert E. Lee surrenders to Ulysses S. Grant, ending Civil War; Lincoln assassinated; 13th Amendment abolishes slavery	1865 Harriet Hosmer, *Sleeping Faun*
		1866 Winslow Homer, *Prisoners from the Front*
	1867 Reconstruction Act passed; Alaska purchased	
	1869 Union Pacific Railroad (transcontinental) completed; American Women's Suffrage Association founded; Matthew Brady, *National Photographic Collection of War Views*; Louisa May Alcott, *Little Women*	

	Historical event	Visual arts
1870	1870 15th Amendment prevents voting discrimination by race, colour, or previous condition of servitude 1871 Chicago fire 1872 Yellowstone National Park, Wyoming (first National Park) 1873 Financial panic in US and Europe; Mark Twain and Charles Dudley Warner, *The Gilded Age* 1876 Centennial Exposition, Philadelphia; Battle of Little Bighorn kills General Armstrong Custer and his entire force; Henry James, *Roderick Hudson*; Alexander Graham Bell demonstrates telephone 1877 Reconstruction ended; Edison invents phonograph; strikes sweep railroad and coal industries	1870–9 Metropolitan Museum of Art, Philadelphia Museum of Art, and Chicago Art Institute open 1875 Thomas Eakins, *Gross Clinic* 1876 Thomas Ball, *Emancipation Group*; Winslow Homer, *Cotton Pickers*; Edward Bannister awarded bronze medal at Centennial Exposition for *Under the Oaks*, a landscape 1877 Society of American Artists founded; Winslow Homer, *Sunday Morning in Virginia* 1878 Horace Bonham, *Nearing the Issue at the Cockpit*
1880	1879 Thomas A. Edison invents light bulb 1880 Henry Adams, *Democracy* 1882 Knights of Columbus founded; Walt Whitman, *Specimen Days*; Chinese Exclusion Act 1883 Supreme Court voids Civil Rights Act of 1875 1884 Mark Twain, *Huckleberry Finn*	1880 Thomas Anshutz, *Ironworkers' Noontime* 1882 John Singer Sargent, *Daughters of Edward D. Boit*
1885	1886 Haymarket Riot; Geronimo captured in last major US–Indian War; Coca-Cola goes on sale 1889 Oklahoma landrush; Theodore Roosevelt, *Winning of the West* (1889–96)	1885 Thomas Eakins, *The Artist's Wife and Setter Dog* 1886 Statue of Liberty unveiled in New York; William Michael Harnett, *New York News*
1890	1890 Jacob Riis, *How the Other Half Lives*; Sherman Anti-Trust Act; William Dean Howells, *Hazard of New Fortunes*; Wounded Knee massacre of Sioux by US Cavalry; game of basketball invented 1892 Strike of steelworkers at Homestead, PA; Ellis Island becomes immigrant station 1893 Chicago World's Columbian Exposition; Frederick Jackson Turner, 'Significance of the Frontier in American History' 1895 Stephen Crane, *Red Badge of Courage* 1896 US Supreme Court upholds 'separate but equal' doctrine of segregation; Edison introduces moving pictures to US	1890 Thomas Hovenden, *Breaking Home Ties* 1891 George Inness, *Early Autumn, Montclair* 1892 Gaetano Russo, *Christopher Columbus* unveiled in New York 1896 Augustus Saint-Gaudens, *Shaw Memorial* unveiled in Boston
1898	1898 Spanish–American War; US annexes Hawaii	

Further Reading

General works

Among the many excellent surveys of or including nineteenth-century American art that the reader is urged to consult, Milton Brown's *American Art to 1900: Painting, Sculpture, Architecture* (New York, 1977), now sadly out of print, provides the most comprehensive coverage; portions of his text were condensed in Brown *et al.*, *American Art: Painting, Sculpture, Architecture, Decorative Arts, Photography* (New York, 1979), a volume that treats the entire span of all the arts in the United States. Barbara Novak, *American Painting in the Nineteenth Century: Realism, Idealism, and the American Experience* (1969; New York, 1974) remains a standard text, joined recently by David Lubin, *Picturing a Nation: Art and Social Change in Nineteenth Century America* (New Haven, 1994). Specialized books include (but are not limited to) Sharon F. Patton, *African-American Art* (Oxford, 1998); Sally M. Promey, *Spiritual Spectacles: Vision and Image in Mid-Nineteenth-Century Shakerism* (Bloomington, 1993); Eleanor Tufts, *American Women Artists, 1830–1930* (Washington, DC, 1987); and John Michel Vlach, *Plain Painters: Making Sense of American Folk Art* (Washington, 1998). William H. Gerdts' *Art Across America: Two Centuries of Regional Painting 1710–1920*, 3 vols (New York, Paris, 1998) uncovers a wealth of regional information.

Matthew Baigell, *A Concise History of American Painting and Sculpture* (New York, 1984); Wayne Craven, *American Art: History and Culture* (New York, 1994); Robert Hughes, *American Visions: The Epic History of Art in America* (New York, 1997); Daniel Mendelowitz, *A History of American Art* (New York, 1970); Joshua C. Taylor, *America As Art* (Washington, DC, 1976); and John Wilmerding, *American Art* (Baltimore, 1976) are all broad recent histories with good sections on the nineteenth century. Earlier surveys of interest include: Virgil Barker, *American Painting: History and Interpretation* (New York, 1950); James Thomas Flexner, *That Wilder Image: The Paintings of America's Native School from Thomas Cole to Winslow Homer* (Boston, 1962); Sadakichi Hartmann, *A History of American Art* (1902; New York, 1934); Suzanne LaFollette, *Art In America* (New York, 1929); Oliver Larkin, *Art and Life in America* (1949; New York, 1960), and Edgar P. Richardson, *Painting in America: the Story of 450 Years* (New York, 1968). Bryan J. Wolf, *Romantic Re-Vision: Culture and Consciousness in Nineteenth-Century American Painting and Literature* (Chicago, 1982), while neither a survey nor general, is the progenitor of theory (not as content, though he is relied upon by many, but as praxis) for the field. Finally, two histories of chiefly European art parcel out a small but well-written portion of their survey to nineteenth-century American artists and art: Stephen R. Eisenman *et al.*, *Nineteenth-century Art: A Critical Interpretation* (London, 1994) and Robert Rosenblum and H.W. Janson, *19th-Century Art* (New York, 1984); in the former the 'American' chapters are written by Frances Pohl and Linda Nochlin.

For histories of sculpture, which have ever been scant but worthy, consult Wayne Craven, *Sculpture in America from the Colonial Period to the Present* (Newark and New York, 1984), which builds on the pioneering work of Lorado Taft, *The History of American Sculpture* (1917; New York and London, 1930) and Albert TenEyck Gardner, *Yankee Stonecutters: The First American School of Sculpture, 1800–1850* (New York, 1944); William H. Gerdts, *American Neoclassical Sculpture: the Marble Resurrection* (New York, 1973); Carol Ockman, *Nineteenth-Century American Women Neoclassical Sculptors* (Poughkeepsie, NY, 1972); and Charlotte S. Rubenstein, *American Women Sculptors* (Boston, 1990). *Two Hundred Years of Sculpture in America* (New York, 1976), the catalogue of a Whitney Museum of American Art exhibition, contains informative essays, as does Joy Kasson, *Marble Queens and Captives: Women in Nineteenth-Century American*

Sculpture (New Haven, 1990).

A real boon to students have been recent collections of essays that follow a topical approach, among them: Mary Ann Calo (ed.), *Critical Issues in American Art: A Book of Readings* (Boulder, CO, 1998); Marianne Doezema and Elizabeth Milroy (eds), *Reading American Art* (New Haven and London, 1998); Thomas Gaehtgens and Heinz Ickstadt (eds), *American Icons: Transatlantic Perspectives on Eighteenth- and Nineteenth-Century American Art* (Santa Monica, CA, 1992); David C. Miller (ed.), *American Iconology: New Approaches to Nineteenth-Century Art and Literature* (New Haven, 1993); and Harriet F. Senie and Sally Webster (eds), *Critical Issues in Public Art: Content, Context, and Controversy* (New York, 1992). (In what follows and in the Notes section of this book, I refer only to the original essays in these collections; previously published articles are cited by initial journal publication.)

A couple of thoughtful and illuminating essays about the discipline have served it well: Wanda Corn, 'Coming of Age: Historical Scholarship in American Art', *Art Bulletin* 70, No. 2 (1988), pp. 188–207, and Elizabeth Johns, 'Scholarship in American Art: Its History and Recent Developments', *American Studies International* XXII (1984), pp. 3–40, and 'Histories of American Art: The Changing Quest', *Art Journal* XLIV (1984), pp. 313–14. In addition to these historiographies—which offer excellent bibliographies—encyclopaedias and dictionaries of American artists and art are available in most general and research libraries. Readers may also readily consult other documentary materials, among them William Gerdts and James Yarnall, *The National Museum of American Art's Index to American Art Exhibition Catalogues: From the Beginning through the 1876 Centennial Year*, 6 vols (Boston, 1986); George C. Groce and David Wallace, *The New York Historical Society's Dictionary of Artists in America* (New Haven and London, 1957); John W. McCoubrey, *American Art 1700–1960: Sources and Documents* (Englewood Cliffs, 1965); and an online index to nineteenth-century American art periodicals, http://www.rlg.org, as well as an online index to painting and sculpture, http://www.siris.si.edu.

Finally, my personal choices for literary and historical guides to the period are Malcolm Bradbury, *Dangerous Pilgrimages: Transatlantic Mythologies and the Novel* (London, 1995) and Howard Zinn, *A People's History of the United States* (New York, 1980).

Chapter 1
Key texts
These include: Patricia Burnham and Lucretia Hoover Giese (eds), *Redefining American History Painting* (Cambridge, 1995); Lois Marie Fink and Joshua C. Taylor, *Academy, the Academic Tradition in American Art* (Washington, DC, 1975); Neil Harris, *The Artist in American Society: the Formative Years 1790–1860* (New York, 1966); and Lillian B. Miller, *Patrons and Patriotism: The Encouragement of the Fine Arts in the United States 1790–1860* (Chicago and London, 1966).

Academies and casts
Mary Bartlett Cowdrey, *American Academy of Fine Arts and American Art-Union*, 2 vols with introduction and history by Theodore Sizer (New York, 1953) and *National Academy of Design Exhibition Record, 1826–1860*, 2 vols (New York, 1943); Carl Goldstein, *Teaching Art: Academies and Schools from Vasari to Albers* (Cambridge, 1996); Christine Huber Jones, *The Pennsylvania Academy and its Women 1850–1920* (Philadelphia, 1974); Pennsylvania Academy of the Fine Arts, *In This Academy: The Pennsylvania Academy of the Fine Arts, 1805–1976* (Philadelphia, 1976); Donald R. Thayer, 'Early Anatomy Instruction at the National Academy: the Tradition Behind It', *American Art Journal* VIII (1976), pp. 38–51; Alan Wallach, 'The American Cast Museum: An Episode in the History of the International Definition of Art', in *Exhibiting Contradictions: Essays on the Art Museum in the United States* (Amherst, 1998); and H. Barbara Weinberg, *The American Pupils of Jean-Léon Gérôme* (Fort Worth, TX, 1984).

History painting/painters and related subjects
Ann Uhry Abrams, *The Valiant Hero: Benjamin West and Grand-Style History Painting* (Washington, 1985); William S. Ayres (ed.), *Picturing History: American Painting 1770–1930* (New York, 1993); Patricia Burnham, 'John Trumbull, Historian[;] The Case of the *Battle of Bunker's Hill*', in Burnham and Hoover Giese, *Redefining American History Painting*; William H. Gerdts and Mark Thistlethwaite, *Grand Illusions: History Painting in America* (Fort Worth, TX, 1988); Barbara Groseclose, 'Death, Glory: Art', in *Orientalism Transposed*, ed. Julia Codell and Dianne Sachko Macleod, (Aldershot, 1998), pp. 189–201; Irma B. Jaffe, *John Trumbull: Patriot–Artist of the American Revolution* (Boston, 1975); Paul J. Staiti,

Samuel F. B. Morse (Cambridge, 1989); William H. Truettner, 'The Art of History: American Exploration and Discovery Scenes, 1840–1860', *American Art Journal* XIV, No. 1 (1982), pp. 4–31. Of the many articles on Benjamin West, all of them informative, I would single out Dennis Montagna, 'Benjamin West's *The Death of General Wolfe*: A Nationalist Narrative', *American Art Journal* XIII, No. 2 (1981), pp. 72–88.

Institutions, art organizations, and collecting and the market
Jennifer A. Martin Bienenstock, 'The Formation and Early Years of the Society of American Artists, 1877–1884', PhD dissertation, City University of New York, 1983; David R. Brigham, *Public Culture in the Early Republic: Peale's Museum and its Audience* (Washington and London, 1995); Jay Cantor, 'Prints and the American Art-Union', in *Prints in and of America to 1850*, ed. John D. Morse (Charlottesville, VA, 1970); Ella M. Foshay *et al.*, *Mr Luman Reed's Picture Gallery: a Pioneer Collection of American Art* (New York, 1990); Maybelle Mann, *The American Art-Union* (Otisville, NY, 1977); Kathleen D. McCarthy, *Lady Bountiful Revisited: Women, Philanthropy, and Patronage* (New Brunswick, NJ, 1990); Daniel J. Sherman and Irit Rogoff (eds), *Museum Culture: Histories, Discourses, Spectacles* (Minneapolis, 1994); Linda Hennfield Skalet, 'The Market for American Painting in New York: 1870–1915', PhD dissertation, The Johns Hopkins University, 1980; Carol Troyen, 'Retreat to Arcadia: American Landscape and the American Art-Union', *American Art Journal* XXIII, No. 1 (1991), pp. 21–37; William H. Truettner, 'William T. Evans, Collector of American Paintings', *American Art Journal* VIII, No. 2 (1971), pp. 50–79; H. Barbara Weinberg, 'Thomas B. Clarke: Foremost Patron of American Art from 1872 to 1899', *American Art Journal* III, No. 1 (1976), pp. 52–83; and Saul Zalesch, 'Competition and Conflict in the New York Art World, 1874–1879', *Winterthur Portfolio* 29, 2/3 (1994), pp. 103–20.

Paris
Annette Blaugrund, *Paris 1889: American Artists at the Universal Exposition* (New York, 1989); Lois Marie Fink, *American Art at the Nineteenth-Century Paris Salons* (Washington, DC, 1990); H. Wayne Morgan, *Kenyon Cox 1856–1919: A Life in American Art* (Kent, OH, 1994); and H. Barbara Weinberg, *The Lure of Paris: Nineteenth-Century American Painters*

and their French Teachers (New York, 1991).

Artist and model
Michael Hatt, '"Making a Man of Him": Masculinity and the Black Body in Mid-Nineteenth-Century American Sculpture', *Oxford Art Journal* 15, No. 1 (1992), pp. 21–35; Margaret Olin, 'Gaze', in *Critical Terms for Art History*, ed. Robert S. Nelson and Richard Shiff (Chicago and London, 1996), which has a useful list of suggested readings; and Dolly Sherwood, *Harriet Hosmer: American Sculptor, 1830–1908* (Columbia, MO, 1991).

Constructing the artist
Allentown Art Museum, *The Artist's Studio in American Painting 1840–1983* (Allentown, PA, 1983); Sarah Burns, *Inventing the Modern Artist: Art and Culture in Gilded Age America* (New Haven, 1998); John Cawelti, *Apostles of the Self-Made Man: Changing Concepts of Success in America* (Chicago, 1965); Carolyn Kinder Carr and George Gurney, *Revisiting the White City: American Art at the 1893 World's Fair* (Washington, DC, 1993).

To fill in some of the blanks for topics I have not treated in this chapter—especially, and crucially, the serious and fruitful dialogue on the subject of aesthetics in nineteenth-century America—see the following texts: Linda Jones Docherty, 'A Search for Identity: American Art Criticism and the Concept of the "Native School", 1876–1893', PhD dissertation, University of North Carolina at Chapel Hill, 1985; William H. Gerdts, 'The American 'Discourses': A Survey of Lectures and Writings on American Art, 1770–1858', *American Art Journal* XV, No. 3 (1983), pp. 61–79; James Jackson Jarves, *The Art-Idea*, ed. Benjamin Rowland, Jr (1864; Cambridge, MA. 1960); and Roger B. Stein, *John Ruskin and Aesthetic Thought in America, 1840–1900* (Cambridge, 1967). On a slightly different tack, Kathleen Pyne, *Art and the Higher Life: Painting and Evolutionary Thought in Late Nineteenth-Century America* (Austin, TX, 1996), is valuable. For Washington Allston, a pivotal early nineteenth-century painter whose art brought a spiritual dimension to the ongoing discussion of aesthetics in American art, see David Bjelajac, *Millennial Desire and the Apocalyptic Vision of Washington Allston* (Washington, DC, 1988).

Chapter 2
Key texts
These include: Neil Harris, *The Artist in*

American Society: the Formative Years 1790–1860 (New York, 1916). Portraiture has received some of its best treatment from museums, among the most useful in point of objects displayed or accompanying text: Susan Danly, *Facing the Past: Nineteenth-Century Portraits from the Collection of the Pennsylvania Academy of the Fine Arts* (New York, 1992); Elizabeth Mankin Kornhauser and David Jaffee, *Meet Your Neighbors: New England Portraits, Painters and Society 1790–1850* (Sturbridge, MA, 1992); *A Nineteenth-Century Gallery of Distinguished Americans*, catalogue by Robert G. Stewart (Washington, DC, 1969); and Michael Quick, Marvin Sadik, and William H. Gerdts, *American Portraiture in the Grand Manner, 1720–1920* (Los Angeles, 1981).

Refinement and domesticity, and its absence
Richard L. Bushman, *The Refinement of America: Persons, Houses, Cities* (New York, 1992); Elisabeth Donaghy Garrett, *At Home: The American Family 1750–1870* (New York, 1990); Karen Halttunen, *Confidence Men and Painted Ladies: A Study of Middle-Class Culture in America, 1830–1870* (New Haven and London, 1982); John F. Kasson, *Rudeness and Civility: Manners in Nineteenth-Century Urban America* (New York, 1990); and Margaretta Lovell, 'Reading Eighteenth-Century American Family Portraits; Social Images and Self-Images', *Winterthur Portfolio* 22 (1987), pp. 243–64.

Copley and Stuart
Jules David Prown, *John Singleton Copley*, 2 vols (Cambridge, MA, 1966); Carrie Rebora and Paul Staiti, *John Singleton Copley in America* (New York, 1995); Dorinda Evans, *The Genius of Gilbert Stuart* (Princeton, 1999).

Material culture and social history
Simon J. Bronner (ed.), *Consuming Visions: Accumulation and Display of Goods in America 1880–1920* (New York and London, 1989); Sarah Burns, 'The Price of Beauty: Art, Commerce, and the Late Nineteenth-Century American Studio Interior', in *American Iconology*, ed. David C. Miller (New Haven and London, 1993) pp. 209–38; Karin Calvert, *Children in the House: the Material Culture of Early Childhood, 1600–1900* (Boston, 1982); Katherine C. Grier, *Culture and Comfort: Parlor Making and Middle-Class Identity, 1850–1930* (Washington, DC, 1997); Lawrence Levine, *Highbrow/Lowbrow: The Emergence of Cultural Hierarchy in America*

(Cambridge, MA, 1988); Richard Ohmann, *Selling Culture: Magazines, Markets, and Class at the Turn of the Century* (London, 1996); Mary P. Ryan, *Cradle of the Middle Class: the Family in Oneida County, NY, 1790–1865* (Cambridge, 1981); Shirley Samuels (ed.), *The Culture of Sentiment: Race, Gender and Sentimentality in Nineteenth-Century America* (New York and Oxford, 1992); and Carroll Smith-Rosenberg, *Disorderly Conduct: Visions of Gender in Victorian America* (New York, 1985).

Construction of gender
Kathleen Adler and Marcia Pointon (eds), *The Body Imaged: the Human Form and Visual Culture Since the Renaissance* (New York and Cambridge, 1993); Martin A. Berger, 'Painting Victorian Manhood', in Helen A. Cooper *et al.*, *Thomas Eakins 'The Rowing Pictures'* (New Haven and London, 1996); and Mark C. Carnes and Clyde Griffen, *Meanings for Manhood: Constructions of Masculinity in Victorian America* (Chicago and London, 1990).

Individual artists
Burbank
M. Melissa Wolfe, 'The Influence of Ethnography on the Portraits of Elbridge Ayer Burbank', unpublished MA thesis, Ohio State University, 1992.

Eakins
The Eakins literature contains multitudinous specialized and general essays and books, including: Michael Fried, *Realism, Writing, Disfiguration: On Thomas Eakins and Stephen Crane* (Chicago, 1987); Kathleen A. Foster, *Thomas Eakins Rediscovered: Charles Bregler's Thomas Eakins Collection at the Pennsylvania Academy of the Fine Arts* (New Haven and London, 1997); Kathleen A. Foster and Cheryl Leibold, *Writing about Eakins: the Manuscripts in Charles Bregler's Thomas Eakins Collection* (Philadelphia, 1989); Lloyd Goodrich, *Thomas Eakins*, 2 vols (Cambridge, MA, 1982); William Inness Homer, *Thomas Eakins: His Life and Art* (New York, 1992); Elizabeth Johns, *Thomas Eakins: the Heroism of Modern Life* (Princeton, 1983); David Lubin, *Act of Portrayal: Eakins, Sargent, and James* (New Haven and London, 1985); Ellwood C. Parry III, 'The Thomas Eakins Portrait of Sue and Harry; or, When Did the Artist Change His Mind?', *Arts Magazine* 53, No. 9 (1979); and John Wilmerding (ed.), *Thomas Eakins* (Washington, DC, 1993).

Harding
Leah Lipton, *A Truthful Likeness: Chester Harding and his Portraiture* (Washington, DC, 1985).

Porter
Kornhauser and Jaffe, *Meet Your Neighbors*; and Jean Lipman, *Rufus Porter Rediscovered: Artist, Inventor, Journalist* (New York, 1980).

Powers
Vivien Green Fryd, 'Hiram Powers's *Greek Slave*, Emblem of Freedom', *American Art Journal* XIV, No. 3 (1982), pp. 31–9; 'Narratives of the Female Body: *The Greek Slave*', in Joy Kasson, *Marble Queens and Captives: Women in Nineteenth-century American Sculpture* (New Haven, 1990); and Richard P. Wunder, *Hiram Powers: Vermont Sculptor, 1805–1873* (Newark and London, 1991).

Sargent
Kathleen Adler, 'John Singer Sargent's Portraits of the Wertheimer Family', in *The Jew in the Text, Modernity and the Construction of Identity*, ed. Linda Nochlin and Tamar Garb (London, 1995); Trevor Fairbrother, *John Singer Sargent* (New York, 1994); Patricia Hills et al., *John Singer Sargent* (New York, 1986); and Richard Ormand, *John Singer Sargent: the Complete Paintings*, Vol. 1 (New Haven, 1997).

Ward
Lewis I. Sharp, *John Quincy Adams Ward: Dean of American Sculpture* (Newark, London, and Toronto, 1985).

Chapters 3 and 4

Key texts
These include: Benedict Anderson, *Imagined Communities: Reflections on the Origin and Spread of Nationalism* (1983; London, 1991); Homi K. Bhabha (ed.), *Nation and Narration* (London, 1990); Richard D. Brown, *The Strength of a People: The Idea of an Informed Citizenry in America, 1650–1870* (Chapel Hill and London, 1996); Mary P. Ryan, *Civic Wars, Democracy and Public Life in the American City in the Nineteenth Century* (Berkeley and Los Angeles, 1997); Charles Sellers, *The Market Revolution: Jacksonian America, 1815–1846* (New York, 1991); Robert Wiebe, *The Search for Order 1877–1920* (New York, 1967) and *Self-Rule: A Cultural History of American Democracy* (Chicago and London, 1995); and Raymond Williams, *Keywords: A Vocabulary of Culture and Society* (New York and Oxford, 1983) and *Culture and Society, 1780–1850* (London, 1959).

Key art histories
Sarah Burns, *Pastoral Inventions: Rural Life in Nineteenth-Century American Art and Culture* (Philadelphia, 1989); Melissa Dabakis, *Visualizing Labor in American Sculpture: Monuments, Manliness, and the Work Ethic 1880–1935* (Cambridge and New York, 1999); Patricia Hills, 'Images of Rural America, Genre Works of Eastman Johnson, Winslow Homer and their Contemporaries', in *The Rural Vision: France and America in the Nineteenth Century*, ed. Hollister Sturges, (Joslyn, MO, 1987) and *The Painters' America: Rural and Urban Life, 1810–1910* (New York, 1974); and Elizabeth Johns, *American Genre Painting: the Politics of Everyday Life* (New Haven, 1991).

Accounts of the United States by foreign writers
R. David Arkush and Leo O. Lee (eds), *Land without Ghosts: Chinese Impressions of America from the Mid-Nineteenth Century to the Present* (Berkeley and London, 1989); J. Hector St John de Crevecoeur, *Letters from an American Farmer* (1782; New York, 1982); Charles Dickens, *American Notes for General Circulation* (1842; London, 1972); Domingo Faustino Sarmiento, *Travels in the United States in 1847*, trans. Michael Aaron Rockland (Princeton, 1970); Alexis de Tocqueville, *Democracy in America*, trans. Henry Reeve (1835; New York, 1963); and Mrs Frances Trollope, *Domestic Manners of the Americans* (1832; New York and Oxford, 1984).

Personifications
Ann Uhry Abrams and Anne Cannon Palumbo, *Goddess, Guardian, and Grand Old Gal* (Atlanta, 1986); Martha Banta, *Imaging American Women: Idea and Ideals in Cultural History* (New York, 1987); Albert Boime, *The Unveiling of the National Icons: A Place for Patriotic Iconoclasms in a Nationalist Era* (Cambridge, 1998); E. McClung Fleming, 'The American Image as Indian Princess, 1765–1783', *Winterthur Portfolio* 2 (1965), pp. 65–81, and 'From Indian Princess to Greek Goddess: The American Image, 1783–1815', *Winterthur Portfolio* 3 (1967), pp. 37–66; Vivien Green Fryd, *Art and Empire: The Politics of Ethnicity in the U.S. Capitol, 1815–1860* (New Haven, 1992); Hugh Honour, *The European Vision Of America* (Cleveland, 1976); Alton Ketchum, *Uncle Sam: the Man and the Legend* (New York, 1959); Pierre Pravoyeur and June Hargrove, *Liberty: the French-American Statue in Art and History* (Philadelphia, 1986);

Bernard Reilly, *American Political Prints 1766–1876: A Catalogue of the Holdings* (Washington, DC, 1991); Judy Sund, 'Columbus and Columbia in Chicago, 1893: Man of Genius meets Generic Woman', *Art Bulletin* LXXV, No. 3 (1993), pp. 443–66; Marvin Trachtenberg, *The Statue of Liberty* (New York, 1986); and Marina Warner, *Monuments and Maidens: The Allegory of the Female Form* (New York, 1985).

Newspapers, readers/reading
Richard H. Brodhead, *Cultures of Letters: Scenes of Reading and Writing in Nineteenth-Century America* (Chicago and London, 1993); Ann Douglas, *The Feminization of American Culture* (New York, 1977); Lee Edwards, *Domestic Bliss: Family Life in American Painting, 1840–1910* (Yonkers, NY, 1986); Mary Kelly, 'Reading Women/Women Reading: The Making of Learned Women in Antebellum America', *Journal of American History* 83 (1996), pp. 401–24; and Thomas C. Leonard, *News for All: America's Coming-of-Age with the Press* (New York and Oxford, 1995).

Work
Abigail Booth Gerdts and Patricia Hills, *The Working American* (Washington, DC, 1979); Herbert Gutman, *Work, Culture and Society in Industrializing America* (New York, 1977); Gilda Lerner, 'The Lady and the Mill Girl: Changes in the Status of Women in the Age of Jackson, 1800–1840', *American Studies* 10, No. 1 (1969), pp. 5–15; Walter Licht, *Industrializing America: the Nineteenth-Century* (Baltimore and London, 1955); Raymond A. Mohl (ed.), *The Making of Urban America* (Wilmington, 1988); Elizabeth L. O'Leary, *At Beck and Call, the Representation of Domestic Servants in Nineteenth-Century American Painting* (Washington, 1996); Michael O'Malley, *Keeping Watch: A History of American Time* (Washington and London, 1990); Susan L. Porter (ed.), *Women of the Commonwealth: Work, Family and Social Change in Nineteenth-Century Massachusetts* (Amherst, 1996); Christine Stansell, *City of Women: Sex and Class in New York 1789–1860* (New York, 1986); Alan Trachtenberg *The Incorporation of America: Culture and Society in the Gilded Age* (New York, 1982); and Sean Wilentz, *Chants Democratic: New York City and the Rise of the American Working Class, 1788–1850* (New York and Oxford, 1984).

Individual artists

Anschutz
Randall C. Griffin, 'Thomas Anschutz's *The Ironworkers' Noontime*: Remythologizing the Industrial Worker', *Smithsonian Studies in American Art* 4, Nos 3–4 (1990), pp. 129–44.

Bannister
Juanita Marie Holland, *Life and Work of Edward Mitchell Bannister, 1828–1901* (New York, 1992).

Bingham
Barbara Groseclose, 'Painting, Politics, and George Caleb Bingham', *American Art Journal* 10 (1978), pp. 5–19 and 'The Missouri Artist as Historian', in Michael Edward Shapiro *et al.*, *George Caleb Bingham* (New York, 1990); Gail E. Husch, 'George Caleb Bingham's *The County Election*: Whig Tribute to the Will of the People', *American Art Journal* XIX, No. 4 (1987); Nancy Rash, *The Painting and Politics of George Caleb Bingham* (New Haven, 1991).

Blythe
Bruce Chambers, *The World of David Gilmour Blythe* (Washington, DC, 1980).

Hahn
Marjorie Dakin Arkelian, *William Hahn: Genre Painter 1829–1887* (Oakland, CA, 1976).

Harnett
Doreen Bolger, Marc Simpson, and John Wilmerding (eds), *William M. Harnett* (New York, 1992) and Alfred Frankenstein, *After the Hunt: William Harnett and Other American Still Life Painters 1870–1900* (Berkeley, 1969).

Homer
Like the literature on Eakins, analysis and interpretation of Homer's art has reached very large proportions; the best thing is to refer to Nicolai Cikovsky, Jr and Franklin Kelly, *Winslow Homer* (Washington, DC, 1995) for text, reproductions, and extensive bibliography. In addition, I would single out, in terms of the topics explored in this chapter: Marc Simpson *et al.*, *Winslow Homer: Paintings of the Civil War* (San Francisco, 1988); and Peter H. Wood and Karen C. C. Dalton, *Winslow Homer's Images of Blacks: The Civil War and Reconstruction Years* (Houston, 1988). In different veins, but crucial for new perspectives on Homer: Jules David Prown, 'Winslow Homer in His Art', *Smithsonian Studies in American Art* I (Spring, 1987), pp.

31–45 and Bryan J. Wolf, 'The Labor of Seeing: Pragmaticism, Ideology and Gender in Winslow Homer's *The Morning Bell*', *Prospects* 17 (1992), pp. 273–319.

Hovenden
Sarah Burns, 'The Country Boy Goes to the City: Thomas Hovenden's *Breaking Home Ties* in American Popular Culture', *American Art Journal* XX, No. 4 (1988), pp. 59–73.

Leutze
Barbara Groseclose, *Emanuel Leutze, 1816–1868: The Only King is Freedom* (Washington, DC, 1976).

Mount
See Johns, *American Genre Painting* as well as Alfred Frankenstein, *William Sidney Mount* (New York, 1975); Guy McElroy, *Facing History: The Black Image in American Art, 1710–1940* (San Francisco, 1990); and William T. Oedel and Todd S. Gernes, 'The Painter's Triumph; William Sidney Mount and the Formation of a Middle-Class Art', *Winterthur Portfolio* 23, 2/3 (1988), pp. 111–28.

Spencer
Robin Bolton-Smith and William H. Truettner, *Lilly Martin Spencer, 1822–1902: The Joys of Sentiment* (Washington, DC, 1973); in addition, Johns, *American Genre Painting*, and David Lubin, *Picturing a Nation: Art and Social Change in Nineteenth Century America* (New Haven, 1994), both contain very different but valuable chapters on Spencer.

Woodville
In addition to Johns, *American Genre Painting*, see Francis Grubar, *Richard Caton Woodville: An Early American Genre Painter* (Washington, DC, 1967) and Bryan J. Wolf, 'All the World's a Code: Art and Ideology in Nineteenth-Century American Painting', *Art Journal* 44 (1984), pp. 328–37.

Chapter 5
Key texts
Key texts that shape, or have shaped, current landscape history are as follows. Leo Marx, *The Machine in the Garden: Technology and the Pastoral Ideal in America* (New York, 1964); Barbara Novak, *American Painting of the Nineteenth Century: Realism, Idealism, and the American Experience* (New York, 1969) and *Nature and Culture: American Landscape and Painting: 1825–1875* (New York and Oxford, 1980); and, most recently, Angela Miller,

Empire of the Eye: Landscape Representation and American Cultural Politics, 1825–75 (Ithaca, 1993), as well as Albert Boime, *The Magisterial Gaze: Manifest Destiny and American Landscape Painting, c. 1830–1865* (Washington, DC, 1991); Dona Brown, *Inventing New England, Regional Tourism in the Nineteenth Century* (Washington, DC, 1995); Jay Cantor, *The Landscape of Change: Views of Rural New England 1790–1865* (Old Sturbridge Village, MA, 1976); John Davis, *The Landscape of Belief: Encountering the Holy Land in Nineteenth-Century American Art and Culture* (Princeton, 1996); Kenneth Myers, *The Catskills: Painters, Writers, and Tourists in the Mountains, 1820–1895* (Yonkers, 1988); Edward J. Nygren, with Bruce Robertson, *Views and Visions: American Landscape before 1830* (Washington, DC, 1986); and Roger Stein, *View and The Vision; Landscape Painting in Nineteenth-Century America* (Seattle, 1968).

American studies key texts include William Cronon (ed.), *Uncommon Ground, Toward Reinventing Nature* (New York, 1995); R.W.B. Lewis, *The American Adam: Innocence, Tragedy, and Tradition in the Nineteenth Century* (Chicago, 1955); Roderick Nash, *Wilderness and the American Mind* (New Haven, 1967); and Henry Nash Smith, *The Virgin Land: The American West as Symbol and Myth* (Cambridge, MA, 1950).

Individual artists, icons, and movements

Church
David Huntington, *Landscapes of Frederic Edwin Church* (New York, 1966); Franklin Kelly, *Frederic Edwin Church and the National Landscape* (Washington, DC, 1988); and Katherine Emma Manthorne, *Tropical Renaissance: North American Artists Exploring Latin America 1839–1879* (Washington, 1989).

Cole and the Hudson River School
Matthew Baigell and Allen Kaufman, 'Thomas Cole's "The Oxbow": A Critique of American Civilization', *Arts Magazine* 55, No. 5 (1981), pp. 136–9; John K. Howat *et al.*, *The World of the Hudson River School* (New York, 1987) includes a useful historiography by Kevin J. Avery, pp. 3–20; Angela Miller, 'Thomas Cole and Jacksonian America, *The Course of Empire* as Political Allegory', *Prospects* 14 (1990), pp. 65–92; and William H. Truettner and Alan Wallach *et al.*, *Thomas Cole: Landscape into History* (Washington, 1994).

Durand

David Lawall, *Asher B. Durand: A Documentary Catalogue* (New York, 1978).

Homer (as landscapist)

Philip C. Beam, *Winslow Homer at Prout's Neck* (Boston, 1966) and E. Bruce Robertson, *Reckoning with Homer, His Late Paintings and their Influence* (Cleveland, 1990).

Inness

Nicolai Cikovsky, Jr, *George Inness* (New York, 1971).

Luminism

The term is introduced in John I. H. Baur, 'American Luminism: A Neglected Aspect of the Realist Movement in Nineteenth-Century American Painting', *Perspectives USA* 9 (Autumn, 1954) and given its greatest elaboration in John Wilmerding *et al.*, *American Light: the Luminist Movement 1850–75* (Washington, DC, 1980).

Niagara

Jeremy Elwell Adamson: *Niagara, Two Centuries of Changing Attitudes* (Washington, DC, 1985) and Elizabeth McKinsey, *Niagara Falls: Icon of the American Sublime* (New York and Cambridge, 1985).

Ryder

Elizabeth Broun, *Albert Pinkham Ryder* (Washington, DC, 1989).

Chapter 6

Key texts

Key texts on western art and history are as follows. William Cronon, *Nature's Metropolis: Chicago and the Great West* (New York, 1991); Dawn Glanz, *How the West was Drawn: American Art and the Settling of the Frontier* (Ann Arbor, 1982); William H. Goetzmann and William N. Goetzmann, *The West of the Imagination* (New York, 1986); Clyde A. Milner II, Carol A. O'Connor, Martha A. Sandweiss (eds), *The Oxford History of the American West* (Oxford and New York, 1994); Jules Prown *et al.*, *Discovered Lands, Invented Pasts: Transforming Visions of the American West* (New Haven, 1992); Richard Slotkin, *Regeneration through Violence: the Mythology of the American Frontier, 1600–1860* (Middletown, CT, 1973); William H. Truettner (ed.), *The West as America: Reinterpreting Images of the Frontier, 1820–1920* (Washington, DC, 1991); Frederick Jackson Turner, *The Frontier in American History* (New York, 1920);

Ron Tyler *et al.*, *American Frontier Life: Early Western Painting and Prints* (New York, 1987). Books that helped fan the flames kindled by rethinkings of American western history: Patricia Nelson Limerick, *The Legacy of Conquest: the Unbroken Past of the American West* (New York, 1987) and Richard White, *'It's Your Misfortune and None of my Own': A New History of the American West* (Norman, OK, 1991). The website at http://sunsite.berkeley.edu/cal.heritage contains more than 30,000 images related to the history of the west and to California.

White attitudes towards Native Americans

In addition to Slotkin, *Regeneration through Violence*, Robert F. Berkhofer, Jr, *The White Man's Indian: Images from Columbus to the Present* (New York, 1978); Brian W. Dippie, *The Vanishing American: White Attitudes and U.S. Indian Policy* (Middletown, CT, 1982); Roy Harvey Pearce, *Savagism and Civilization: A Study of the Indian and the American Mind* (Baltimore, 1965); and Susan Schekel, *The Insistence of the Indian: Race and Nationalism in Nineteenth-Century Culture* (Princeton, 1998).

Individual artists

Bodmer

Robert J. Moore, *Native Americans: A Portrait: The Art and Travels of Charles Bird King, George Catlin, and Karl Bodmer* (New York, 1997).

Catlin

Brian W. Dippie, *Catlin and his Contemporaries: the Politics of Patronage* (Lincoln, NE, 1990); Kathryn S. Hight, '"Doomed to Perish": George Catlin's Depictions of the Mandan', *Art Journal* 49, No. 2 (1990), pp. 119–24; and William H. Truettner, *The Natural Man Observed: a Study of George Catlin's Indian Gallery* (Washington, DC, 1979).

Remington

Alexander Nemerov, *Frederic Remington and Turn-of-the-Century America* (New Haven, 1995); Peggy and Harold Samuels, *Frederic Remington* (Austin, TX, 1985); Michael Shapiro and Peter H. Hassrick, *Frederic Remington, the Masterworks* (St Louis, 1988); and G. Edward White, *The Eastern Establishment and the Western Experience: The West of Frederic Remington, Theodore Roosevelt, and Owen Wister* (Austin, TX, 1985).

Wores
William H. Gerdts, *Theodore Wores*
(1859–1939): Paintings from California to Japan
(New York, 1998).

Chapter 7

Key texts
These include: Albert Boime, *Art of Exclusion:*
Representing Blacks in the Nineteenth Century
(Washington, DC, 1990); Vivien Green Fryd,
Art and Empire: The Politics of Ethnicity in the
U.S. Capitol, 1815–1860; John R. Gillis (ed.),
Commemorations: the Politics of National
Identity (Princeton, NJ, 1994); Gary
Laderman, *The Sacred Remains: American*
Attitudes Toward Death, 1799–1883 (New
Haven and London, 1996); Pierre Nora,
'Between Memory and History: *Les Lieux de*
Mémoire, Representations 26 (Spring 1989), pp.
7–25; G. Kurt Piehler, *Remembering War the*
American Way (Washington and London,
1995); Kirk Savage, *Standing Soldiers, Kneeling*
Slaves: Race, War, and Monuments in
Nineteenth-Century America (Princeton, NJ,
1997); and David Stannard (ed.), *Death in*
America (Philadelphia, 1975).

The Civil War and Reconstruction
Edward Ayers, *The Promise of the New South*
(Oxford, 1992) [as heir to C. Vann Woodward,
Origins of the New South (Baton Rouge, 1951)];
Drew Gilpin Faust, *Mothers of Invention:*
Women of the Slaveholding South in the
American Civil War (New York, 1997); Foster
Gaines, *Ghosts of the Confederacy: Defeat, The*
Last Cause, and the Emergence of the New South
1865–1913 (New York, 1987); Leo Mazow,
Images of Annihilation: Ruins in Civil War
America (The Huntington Library, 1996);
Anne C. Rose, *Victorian America and the Civil*
War (Cambridge, 1992); Geoffrey C. Ward *et*
al., *The Civil War: An Illustrated History* (New
York, 1990). An online archival project, Valley
of the Shadow, can be found at: http://
jefferson.village.virginia.edu/vshadow2;
the American Civil War homepage,
http://sunsite.utk.edu/civil-war.web.html, has
links to most useful electronic files about the
war.

Immigration and ethnicity
Dale T. Knobel, *Paddy and the Republic:*
Ethnicity and Identity in Antebellum America
(Middletown, CT, 1986); Claudia L. Bushman,
America Discovers Columbus: How an Italian
Explorer Became an American Hero (Hanover
and London, 1992); John Higham, *Send These*
to Me: Immigrants in Urban America

(Baltimore and London, 1984, rev. edn) and
Strangers in the Land: Patterns of American
Nativism (1955; New Brunswick, 1988); Noel
Ignatiev, *How the Irish Became White* (New
York, 1995); Humbert S. Nelli, *From*
Immigrants to Ethnics: the Italian-Americans
(New York, 1971); April Schultz, *Ethnicity on*
Parade: Inventing the Norwegian-American
through Celebration (Amherst, 1994); Werner
Sollors, *Beyond Ethnicity: Consent and Descent*
in American Culture (New York, 1986); and
Ronald T. Takaki, *Iron Cages: Race and Culture*
in Nineteenth-Century America (New York,
1979).

Identity and memory
Among books probing the nature of identity
and memory and any connection between the
two are Pierre Nora's proposed 11-volume
project, with collaborators, on *Les Lieux de*
Mémoire, of which some is condensed in the
first volume of the English translation, *Realms*
of Memory: Rethinking the French Past, ed.
Lawrence D. Kritzman, trans. Arthur
Goldhammer (New York, 1996); as well as
John Bodner, *Remaking America: Public*
Memory, Commemoration, and Patriotism in the
Twentieth Century (Princeton, NJ, 1992);
Michael Kammen, *Mystic Chords of Memory:*
the Transformation of Tradition in American
Culture (New York, 1991); Donald Martin
Reynolds (ed.), '*Remove Not the Ancient*
Landmark': Public Monuments and Moral
Values (Amsterdam, 1996); and Mike Wallace,
Mickey Mouse History and other Essays on
American Memory (Philadelphia, 1996).

Individual artists

Ball
Michael Hatt, '"Making a Man of Him":
Masculinity and the Black Body in Mid-
Nineteenth-Century American Sculpture',
Oxford Art Journal 15 (1992), pp. 21–35 and
Freeman Murray, *Emancipation and the Freed*
in American Sculpture: A Study in Interpretation
(Washington, DC, 1916).

Homer
See bibliography for Chapters 3 and 4 (above).

Saint-Gaudens
John H. Dryfhout, *The Work of Augustus*
Saint-Gaudens (Hanover, NH, 1982); and Lois
Goldreich Marcus, 'The Shaw Memorial by
Augustus Saint-Gaudens: A History Painting
in Bronze', *Winterthur Portfolio* 14 (1979), pp.
1–23.

Vanderlyn

Barbara Groseclose, 'American Genesis, the Landing of Christopher Columbus', in *American Icons: Transatlantic Perspectives on Eighteenth- and Nineteenth-Century American Art*, ed. Thomas Gaehtgens and Heinz Ickstadt (Santa Monica, CA, 1992) and

Kenneth C. Lindsay, *The Works of John Vanderlyn: From Tammany to the Capitol* (Binghamton, NY, 1970).

Two features distinguish the history of American museums of art from those in other western countries: the relatively late date of their founding and an intellectual climate that initially considered institutions of fine art alongside, and in competition with, museums of natural science, archaeology, and other 'exhibitable' knowledges. Although two important American collections were in place before mid-century – Peale's Museum in Philadelphia, established in the late eighteenth century by the artist and polymath Charles Wilson Peale, and the Wadsworth Atheneum, in Hartford, Connecticut, which art patron Daniel Wadsworth helped to found in 1844 – major museums like the Metropolitan Museum of Art in New York City and the Museum of Fine Arts, Boston, were organized only in the 1870s. In that decade, too, William Corcoran converted his holdings into an eponymous public Gallery of Art in Washington, DC. The 1880s saw a band of fine arts museums springing up in what is now the midwest, some of which were tied to teaching academies: the Chicago Art Institute; the Cincinnati Museum of Art; the Detroit Institute of Art; and the Indianapolis Museum of Art.

In Peale's Museum, co-mingled displays of archaeology, geology, natural history, and portraiture were templates for later, institutionally separate, museum holdings in the major urban centres. Systematizing knowledge through the exhibition of artefacts, museums of natural history and other sciences gradually gave way to academic research functions; fine arts museums remained a repository for the analysis, preservation, and interpretation of painting and sculpture, as they are today.

Art Collection	Website
Addison Gallery of American Art, Phillips Academy, Andover, MA An excellent collection of American paintings, prints and works on paper from the Colonial period to the present. Includes a significant number of nineteenth-century works.	*www.andover.edu*
Amon Carter Museum, 3501 Camp Bowie Boulevard, Fort Worth, TX Begun in 1961 as a western collection with, mostly, Remingtons, the collection is now more varied.	*www.cartermuseum.org* Superb site with selected images, exhibition tours, library and archive links.
Art Institute of Chicago, Michigan Avenue at Adams Street, Chicago, IL The collection includes American painting, sculpture and decorative arts from the Colonial period to the present.	*www.artic.edu*
Brooklyn Museum, 188 Eastern Parkway, Brooklyn, NY The collection of American painting is considered one of the best in the United States. Among the nineteenth-century artists represented are Thomas Cole, Frederic Church, Albert Bierstadt, George Caleb Bingham, John Singer Sargent, George Inness, and Winslow Homer. The collection also includes American period rooms, sculpture, costumes, and decorative arts.	*www.brooklynart.org* Provides general information about the collections and features many nineteenth-century paintings.
Butler Institute of American Art, 524 Wick Avenue, Youngstown, OH A museum dedicated to American art with a good collection of nineteenth-century paintings.	*www.butlerart.com* Shows a large number of images with descriptions of the works.

Art Collection	**Website**
Cincinnati Art Museum, Eden Park, Cincinnati, OH A collection with significant examples of nineteenth- and twentieth-century American art.	www.cincinnatiartmuseum.com Provides an online tour of various collections, including nineteenth-century American art.
Cleveland Museum of Art, 11150 East Boulevard, Cleveland, OH An excellent collection with thorough range of American painting and decorative arts.	www.clemusart.com Shows selected works from the collection and provides a link to the Art Museum Image Consortium (AMICO).
Corcoran Gallery of Art, New York Avenue and Seventeenth Street NW, Washington, DC The collection includes American portraiture and landscape painting. Strong collection of Hudson River School landscapes, and significant paintings by Albert Bierstadt, John Kensett, and John Singer Sargent.	www.corcoran.org Provides information about the collection with selected images and accompanying text.
Detroit Institute of Arts, 5200 Woodward Avenue, Detroit, MI Excellent American collections of eighteenth, nineteenth-, and early twentieth-century American art.	www.dia.org Provides highly informative pages on the American art collection.
Fogg Museum of Harvard University, Quincy Street and Broadway, Cambridge, MA Strong collections in eighteenth- and nineteenth-century American painting and works on paper.	www.artmuseums.harvard.edu
Freer Gallery of Art, Smithsonian Institution, Washington, DC American holdings, including Homer and Sargent, enrich a renowned collection of Asian art.	www.si.edu/asia The website is tied to the Arthur M. Sackler Gallery of Asian Art and contains little on the Freer's American holdings.
Henry Francis du Pont Winterthur Museum, Winterthur, DE Collection of American arts from the Colonial period through to the mid-nineteenth century. A research centre in the American field.	www.winterthur.org Features, among other items, a period room tour.
Los Angeles County Museum of Art, 5905 Wilshire Boulevard, Los Angeles, CA Collection includes American paintings and sculptures from the Colonial period onwards, with an emphasis on late nineteenth- and early twentieth-century works.	www.lacma.org Offers selected works from the collection.
M.H. De Young Memorial Museum, Golden Gate Park, San Francisco, CA Collection of American art from Colonial times through to the mid-twentieth century. Includes painting and decorative arts.	www.thinker.org Shows selected images with descriptions of the works. Provides links to the other fine arts museums of San Francisco.
Metropolitan Museum of Art, Fifth Avenue and 82nd Street, New York, NY A vast American art collection. The nineteenth-century collection includes key works by George Caleb Bingham, Frederic Church, Thomas Cole, John Singer Sargent, Thomas Eakins, and Winslow Homer. Also features renowned examples of sculpture and decorative arts.	www.metmuseum.org Showcases an informative section on the American collection with images and descriptions of key works from nineteenth-century American art.

Art Collection	**Website**
Munson–Williams–Proctor Institute, 310 Genesee Street, Utica, NY Collection of eighteenth-, nineteenth-, and twentieth-century paintings, sculptures, drawings, and decorative arts, including the *Voyage of Life* series by Thomas Cole.	*www.mwpi.edu* Provides information about the various branches of the institute, including the art museum and libraries.
Museum of Fine Arts, 469 Huntington Avenue, Boston, MA Superlative American arts collections, including bequests of Mr and Mrs Maxim Karolik which feature nineteenth-century paintings.	*www.mfa.org* Provides an online tour of the collection. Shows selected works from the collection, including several nineteenth-century American paintings.
Museum of the City of New York, 1220 Fifth Avenue, New York, NY The collection includes landscape paintings by artists such as Asher B. Durand as well as genre paintings and a large collection of portraiture.	*www.mcny.org* Provides numerous images from the collection with commentary.
National Academy of Design, 12200 Fifth Avenue, New York, NY An extensive collection of nineteenth-century American painting, sculpture, and works on paper.	*www.nationalacademy.org*
National Gallery of Art, Sixth Street and Constitution Avenue, Washington, DC The collection is large and varied, and includes key American paintings.	*www.nga.gov* One of the first museums to produce a videodisc with over 1,600 images from its collection. Provides extensive texts and supporting information on the American collection. Online tours on selected artists, such as Sargent.
National Museum of American Art, Smithsonian Institution, Washington, DC A large collection of American art which includes painting, sculpture and works on paper. The painting section features key works by nineteenth-century artists.	*www.nmaa.si.edu* Shows images from the collection and provides valuable research resources.
National Portrait Gallery, F. Street at 8th, NW, Washington, DC The collection includes American portraits dating from the seventeenth century to the present in painting, sculpture, and miniatures.	*www.npg.si.edu* Provides a valuable collection and research records search.
New-York Historical Society, 2 Central Park West, New York, NY Extensive collection of American painting, sculpture, books, architectural drawings, and decorative arts.	*www.nyhistory. org*
New York State Historical Association, Farmer's Museum, and Village Crossroads, Cooperstown, NY American collections include fine, folk, decorative, and Native American works from the eighteenth and nineteenth centuries.	*www.nysha.org* Shows images with descriptions of the works and provides a link to the research library.
Palmer Museum of Art, Pennsylvania State University, University Park, PA Collection includes American art from 1799 to the present.	*www.psu.edu/dept/palmermuseum* Provides a chronological tour of 15 American works with historical and critical information.

Art Collection	Website
Pennsylvania Academy of the Fine Arts, Broad and Cherry Streets, Philadelphia, PA The United States' oldest art museum and school of fine arts. The collection includes outstanding examples of American painting and sculpture.	*www.pafa.org* Shows images from the collection and provides a link to the archives; a highly important research facility.
Philadelphia Museum of Art, Benjamin Franklin Parkway at 26th Street, Philadelphia, PA The American collections include a significant number of works by Thomas Eakins, Pennsylvania German art, and decorative arts.	*www.philamuseum.org* Provides general information about the collections and shows images from the American collections.
Toledo Museum of Art, Monroe Street and Scottwood Avenue, Toledo, OH Good collection of American arts, including glass.	*www.toledomuseum.org*
Virginia Museum of Fine Arts, Boulevard and Grove Avenue, Richmond, VA Collection includes examples from American painting, sculpture, and decorative arts.	*www.vmfa.state.va.us*
Wadsworth Atheneum, 25 Atheneum Square, Hartford, CT The American collection contains paintings, sculpture, and drawings dating from 1664. Excellent collection of Hudson River School landscape painting and eighteenth-century portraiture; also features nineteenth-century miniatures and neoclassical sculpture.	*www.wadsworthatheneum.org* Provides a selection of images and a link to the archives and the Auerbach Art Library.
William Rockhill Nelson Gallery of Art and Mary Atkins Museum of Fine Arts, 4525 Oak Street, Kansas City, MO The American collection includes good examples of nineteenth-century landscape painting and works by George Caleb Bingham, John Singer Sargent, and Winslow Homer.	*www.nelson-atkins.org* Provides general information about the American art collection with selected images.
Worcester Art Museum, 55 Salisbury Street, Worcester, MA The collection includes good range of eighteenth- and nineteenth-century American art.	*www.worcesterart.org*
Yale University Art Gallery, 1080 Chapel Street, New Haven, CT Strong in Colonial and nineteenth-century art, with major holdings of Trumbull, Eakins, and Homer.	*www.yale.edu/artgallery* Offers, among other things, an exhibitions page and a panoramic virtual tour.

Picture Credits

The publisher would like to thank the following individuals and institutions who have kindly given permission to reproduce the illustrations listed below.

1. Anon., *The Antique School,* (n.d.).
2. Zoffany, Johann, *The Academicians of the Royal Academy,* 1768. © The Royal Collection, Her Majesty Queen Elizabeth II. Reproduced courtesy of Royal Collection Enterprises Ltd. (305436)
3. Benjamin West, *The Death of General Wolfe,* 1770. Reproduced courtesy of the National Gallery of Canada, Ottawa. Transfer from the Canadian War Memorials, 1921. Gift of the 2nd Duke of Westminster, Eaton Hall, Cheshire, 1918. (8007)
4. John Trumbull, *The Death of General Warren at the Battle of Bunker's Hill, 17 June 1775,* 1786. Yale University Art Gallery. Reproduced courtesy of the Bridgeman Art Library.
5. John Trumbull, *The Declaration of Independence, 4 July 1776,* 1787–1819. 30.5 x 45.7 cm. Commissioned 1817, purchased 1819, placed 1826. Reproduced courtesy of the Architect of the Capitol. (70222)
6. John Trumbull, *Reclining Nude,* 1795. Reproduced courtesy of Yale University Art Gallery. Gift of the Associates in Fine Arts. (1938.273).
7. *Drawing from Life at the Royal Academy School at Somerset House,* Thomas Rowlandson, c.1798. Pen and ink, 14.6 x 21.6 cm. Reproduced courtesy of the Royal Academy of Arts, London. (w94.00812)
8. Kenyon Cox, study for *Science Instructing Industry* (female nude), 1898. Reproduced courtesy of the Metropolitan Museum of Art, Lathrop Fund, 1950. (50.101.1)
9. David Chalfant Jefferson, *Bouguereau's Atelier at the Académie Julian, Paris,* 1891. 28.6 x 36.8 cm. M.H. de Young Memorial Museum. Reproduced courtesy of the Fine Arts Museums of San Francisco, gift of Mr and Mrs John D. Rockefeller 3rd. (1979.7.26)
10. (*Left*) Thomas Eakins, 'Male nude sitting on modeling stand holding small sculpture of a horse', c.1885. Albumen print, 10.2 x 12.1 cm. (*Right*) Thomas Eakins, 'Male nude crouching in sunlit rectangle in Pennsylvania Academy studio', c.1885. Albumen print, 10.2 x 12.1 cm. Charles Bregler's Thomas Eakins Collection. Purchased with the partial support of the Pew Memorial Trust. Reproduced courtesy of the Pennsylvania Academy of the Fine Arts, Philadelphia. (1985.68.2.429)
11. Alice Barber (Stephens), *The Women's Life Class,* 1879. Oil on cardboard (grisaille), 30.5 x 35.6 cm. Reproduced courtesy of the Pennsylvania Academy of the Fine Arts, Philadelphia, gift of the artist. (1879.2)
12. Hiram Powers, *The Greek Slave,* orig. 1843. Engraving published in *Cosmopolitan Art Journal,* 2, December 1857. Photo courtesy of Joy Kasson.
13. Harriet Hosmer, *Sleeping Faun,* after 1865. Marble, 87.6 x 104.1 x 41.9 cm. © 1999 Museum of Fine Arts, Boston. Reproduced courtesy of Museum of Fine Arts, Boston, gift of Mrs Lucien Carr. (12.709)
14. Hellenistic, *Barberini Faun,* c.200–50 BCE. Photo, Hartwig Koppermannn. Reproduced courtesy of Staatliche Antikensammlungen und Glyptothek. (218.15A)
15. Charles Bird King, *The Itinerant Artist,* c.1825–30. Oil on canvas, 113.7 x 144.8 cm. © New York State Historical Association, Cooperstown, New York. Photo Richard Walker. Reproduced courtesy of New York State Historical Association, Cooperstown. (N.537.67)
16. Anon., 'Harriet Hosner's Studio in Rome, Visit of the Prince of Wales', *Harper's Weekly,* 7 May 1859. Photograph courtesy of Ohio State University Cartoon Research Library.
17. William Merritt Chase, *In the Studio,* c.1882. Oil on canvas, 71.4 x 101.8 cm. Reproduced courtesy of Brooklyn Museum of Art, Brooklyn, New York. Gift of Mrs Carll H. De Silver in memory of her husband.(13.50)
18. William Merritt Chase, *Tenth Street*

Studio, c.1881–1910. Oil on canvas, 119.1 × 167.6 cm. Reproduced courtesy of Carnegie Museum of Art, Pittsburgh. (17.22)

19. 'Artist's Reception at the Tenth Street Studios', 1869, Frank Leslie's *Illustrated Newspaper*, 29 January 1869. Courtesy of the Museum of the City of New York.

20. John Singleton Copley, *Mrs Thomas Gage*, 1771. Timken Museum, San Diego, California. Reproduced courtesy of The Bridgeman Art Gallery.

21. Rufus Porter, 'Correct likeness, taken with elegance and despatch by Rufus Porter'. Handbill, 1820–4. Reproduced courtesy of the American Antiquarian Society, Worcester, Massachusetts. (01609)

22. Chester Harding, *Amos Lawrence*, c.1845. Oil on canvas, 21.5 × 13.6 cm. © 1999 Board of Trustees, National Gallery of Art, Washington, DC. Photo, Richard Carfelli. Given in memory of the Rt. Rev. William Lawrence by his children. Reproduced courtesy of the National Gallery of Art, Washington, DC (1944.1.1.PA)

23. Hiram Powers, *General Andrew Jackson*, c.1835. Reproduced courtesy of the Metropolitan Museum of Art, Gift of Mrs Frances V. Nash, 1894. (94.14)

24. John Quincy Adams Ward, *William Hayes Fogg*, 1886. Marble, 76.2 cm. Union Theological Seminary, New York City. Photo Jerry L. Thomson.

25. Elbridge A. Burbank, *Chief Red Cloud, Sioux*, 1899. Oil on canvas, 23 × 33 cm. Pine Ridge. Ayer Collection. Reproduced courtesy of the Newberry Library, Illinois. (90-525)

26. Francois Joseph Bourgoin, *Family Group in New York Interior*, 1808. Oil on canvas, 76.2 × 106.7 cm. Private collection. Reproduced courtesy of Berry-Hill Galleries, Inc., New York. (c/9383)

27. Charles Wilson Peale, *Portrait of John and Elizabeth Lloyd Cadwalader and Their Daughter Anne*, 1772. Oil on canvas, 130.8 × 104.8 cm. Photo, Graydon Wood. Reproduced courtesy of Philadelphia Museum of Art. Purchased for the Cadwalader Collection with funds contributed by the Mabel Pew Myrin Trust and the gift of an anonymous donor. (19883.90.3)

28. Thomas Sully, *Lady with a Harp: Eliza Ridgely*, 1818. Oil on canvas, 21.45 × 14.25 cm. © 1999 Board of Trustees, National Gallery of Art, Washington. Reproduced courtesy of National Gallery of Art, Washington, DC, gift of Maude Monell Vetlesen. (1945.9.1.PA)

29. Gilbert Stuart, *Mrs George Plumstead*,

1800. Oil on canvas, 74.9 × 61.6 cm. Reproduced courtesy of the Pennsylvania Academy of the Fine Arts, Philadelphia, bequest of Helen Ross Scheetz. (1891.12.2)

30. Sarah Miriam Peale, *Anna Maria Smyth*, 1821. 91.2 × 69.9 cm. Reproduced courtesy of the Pennsylvania Academy of the Fine Arts, Philadelphia. Gift of Mrs John Frederick Lewis (the John Frederick Lewis Memorial Collection). (1933.10.67)

31. John Singer Sargent, *The Daughters of Edward Darley Boit*, 1882. Oil on canvas, 221.9 × 222.6 cm. Reproduced courtesy of Museum of Fine Arts, Boston. Gift of Mary Louisa Boit, Julia Overing Boit, Jane Hubbard Boit, and Florence D. Boit in memory of their father, Edward Darley Boit. (19.124)

32. Thomas Eakins, *Portrait of Dr Gross (The Gross Clinic)*, 1875. Oil on canvas, 116.7 × 256.4 cm. Jefferson Medical College of Jefferson College, Philadelphia. Reproduced courtesy of The Bridgeman Art Gallery.

33. Thomas Eakins, *The Artist's Wife and his Setter Dog*, c.1884–9. Oil on canvas, 76.2 × 58.4 cm. Photograph © 1993 the Metropolitan Museum of Art. Reproduced courtesy of the Metropolitan Museum of Art, Fletcher Fund, 1923. (23.139)

34. William Merritt Chase, *Portrait of Miss Dora Wheeler*, 1883.158. Oil on canvas, 7 × 165.8 cm. © 1997 the Cleveland Museum of Art. Gift of Mrs Boudinot Keith, in memory of Mr and Mrs J.H. Wade. (1921.1239)

35. Thomas Eakins, *Maud Cook*, 1895. Reproduced courtesy of Yale University Art Gallery. Bequest of Stephen Carlton Clark, B.A., 1903. (1961.18.18).

36. Thomas Eakins, *Archbishop Diomede Falconio*, 1905. Oil on canvas, 18.32 × 13.77 cm. ©1999 Board of Trustees, National Gallery of Art, Washington, DC. Reproduced courtesy of the National Gallery of Art, Washington, DC, gift of Stephen C. Clark. (1946.16.1.PA)

37. Ferdinando Gorges, 'Cannibal America', *America Painted to the Life*, 1659. Reproduced courtesy of the John Carter Brown Library at Brown University. (0468)

38. Augustin Dupré, Brigadier-General Daniel Morgan Medallion, 1789. © 1999 Smithsonian Institution, NNC, Douglas Mudd. Reproduced courtesy of the Smithsonian Institution, Washington, DC.

39. 'An Emblem of America'. Engraving, Adam Stanton House, Clinton, CT.

40. 'Columbia Mourns her Citizens Slain …', 1844. Lithograph. Reproduced courtesy of the Prints and Photographs Division of the Library of Congress, Washington, DC. (LC-

usz62-46533)

41. Thomas Crawford, *Freedom*, bronze cast by Clark Mills, 1863. Reproduced courtesy of the Architect of the Capitol, Washington, DC. (70106)

42. Anon., 'Uncle Sam's Pet Pups!', 1840. Woodcut and letterpress with watercolour. Reproduced courtesy of the Prints and Photographs Division of the Library of Congress, Washington, DC. (PC/US-A-1840-ESI.1)

43. William Sidney Mount, *Bargaining for a Horse*, 1835. Oil on canvas. Reproduced courtesy of the New-York Historical Society. (1858.59)

44. Frank Blackwell Mayer, *Independence (Squire Jack Porter)*, 1858. Oil on paperboard, 30.5 x 40.6 cm. Reproduced courtesy of National Museum of American Art, Smithsonian Institution, Washington, DC/Art Resource, New York. (1906.9.11)

45. 'Uncle Sam, An American Song', c.1858. Reproduced courtesy of the Performing Arts Division, Library of Congress, Washington, DC. (LC-USZ62-91849)

46. Eastman Johnson, *The Evening Newspaper*, 1863. Reproduced courtesy of Mead Art Museum, Amherst College. Gift of Herbert W. Plimpton, the Hollis Plimpton Memorial Collection. (1977.62)

47. Richard Caton Woodville, *War News from Mexico*, 1848. Oil on canvas, 68 x 62.9 cm. Reproduced courtesy of the Manoogian Foundation, on loan to the National Gallery of Art, Washington, DC.

48. William Sidney Mount, *California News*, 1850. Reproduced courtesy of Collection of The Museums at Stony Brook. Gift of Mr and Mrs Ward Melville, 1955.

49. William Michael Harnett, *New York Daily News*, 1888. Reproduced courtesy of The Metropolitan Museum of Art, Gift of Mr and Mrs William L. McKim, 1973. (1973.166.1)

50. Edmund White, *Thoughts of Liberia: Emancipation*, 1861. Oil on canvas. Reproduced courtesy of The New York Historical Society, on permanent loan from The New York Public Library. (5221)

51. Patrick Reason, *Frontispiece for The Liberty Bell*, published Boston, 1839. 'The Truth Shall Make You Free'. Engraving. Reproduced courtesy of the American Antiquarian Society, Worcester, MA. (01609).

52. Winslow Homer, *Sunday Morning in Virginia*, 1877. 64.1 x 101.6 cm. Photo, Ron Forth. Reproduced courtesy of Cincinnati Art Museum, John J. Emery Fund. (1924.247)

53. George Caleb Bingham, *The County Election*, 1851–2. Oil on canvas, 90 x 123.8 cm. Reproduced courtesy of The Saint Louis Art Museum, Missouri. (124.1944)

54. Horace Bonhan, *Nearing the Issue at the Cockpit*, 1878. Oil on canvas. Reproduced courtesy of the Corcoran Gallery of Art, Washington, DC. Museum purchase, Gallery Fund. (99.6)

55. Joseph Keppler, 'A Family Party', *Puck*, 1893. Photograph courtesy Ohio State University Cartoon Research Library.

56. Anon., *The Great Fear of the Period That Uncle Sam May Be Swallowed by Foreigners/The Problem Solved*, published San Francisco, 1876. Reproduced courtesy of the Prints and Photographs Division of the Library of Congress, Washington, DC. (LC.USZ62-22399)

57. Edward Moran, *Unveiling the Statue of Liberty*, 1886. Reproduced courtesy of Museum of the City of New York. (34.100.260)

58. Thomas Nast, 'Earn More than You Spend'. *Harper's Weekly*, 13 April 1878. Photograph courtesy Ohio State University Cartoon Research Library.

59. Frank Blackwell Mayer, *Leisure and Labor*, 1858. Oil on canvas. Reproduced courtesy of The Corcoran Gallery of Art, Washington, DC. Gift of William Wilson Corcoran. (69.95)

60. William Sidney Mount, *Farmers Nooning*, 1836. Reproduced courtesy of The Museums at Stony Brook, gift of Mr Frederick Sturges, Jr, 1954. (0.1.152)

61. Thomas Pollock Anshutz, *The Ironworkers' Noontime*, 1880. 43.2 x 60.6 cm. Reproduced courtesy of the Fine Arts Museums of San Francisco, gift of Mr and Mrs John D. Rockefeller 3rd. (1979.7.4)

62. Currier and Ives, *The Four Seasons of Life: Childhood, Youth, Middle Age, Old Age*. Reproduced courtesy of the Collections of the Prints and Photographs Division of the Library of Congress, Washington, DC. (LC.USZ-622: 2092/2094/2095/2093)

63. Thomas Hovenden, *Breaking Home Ties*, 1890. Reproduced courtesy of Philadelphia Museum of Art, gift of Ellen Harrison McMichael in memory of C. Emory McMichael. (42.60.1)

64. George Caleb Bingham, *Boatmen on the Missouri*, 1846. 63.5 x 76.8 cm. Reproduced courtesy of the Fine Arts Museums of San Francisco, Gift of Mr and Mrs John D. Rockefeller 3rd, 1979. (1979.7.15)

65. Thomas Eakins, *The Biglin Brothers Turning the Stake-Boat*, 1873. Oil on canvas, 101.3 x 151.4 cm. © 1999 the Cleveland

Museum of Art. Reproduced courtesy of the Cleveland Museum of Art, the Hinman B. Hurlbut Collection. (1984.27)

66. Winslow Homer, *The Morning Bell (The Old Mill)*, 1871. Oil on canvas, 61 x 97.2 cm. Reproduced courtesy of Yale University Art Gallery, bequest of Stephen Carlton Clark, B.A., 1903. (1961.18.26)

67. Lowell Mills, Timetable, 1851. Reproduced courtesy of the Baker Library, Harvard Business School.

68. Lily Martin Spencer, *Kiss Me and You'll Kiss the' Lasses*, 1856. Oil on canvas, 76.3 x 63.7 cm. Reproduced courtesy of the Brooklyn Museum of Art, A. Augustus Healy Fund. (70.26)

69. Platt Powell Ryder, *The Illustrated News, formerly Learning to Read, c.*1868. Oil on canvas, 43.2 x 35 x 3 cm. Reproduced courtesy of the Brooklyn Museum of Art, bequest of Mrs Caroline H. Polhemus. (06.36)

70. Winslow Homer, *The Cotton Pickers*, 1876. Oil on canvas, 61.0 x 97.1 cm. © 1997 Museum Associates, Los Angeles County Museum of Art. Reproduced courtesy of Los Angeles County Museum of Art. Acquisition made possible through museum trustees: Robert O. Anderson, R. Stanton Avery, B. Gerald Cantor, Justin Dart, Charles E. Ducommun, Mrs F. Daniel Frost, Julian Ganz, Jr, Dr Armand Hammer, Harry Lenart, Dr Franklin D. Murphy, Mrs Joan Palevsky, Richard Sherwood, Maynard J. Toll and Hal B. Wallis. (M.77.68)

71. Edward Mitchell Bannister, *Newspaper Boy*, 1869. Oil on canvas, 76. 2 x 63.5 cm. Reproduced courtesy of National Museum of American Art, Smithsonian Institution, Washington DC/Art Resource, New York. (S0030556)

72. William Hahn, *Union Square, New York City*, 1878. Oil on canvas, 25.5 x 40.5 cm. Reproduced courtesy of the Collection of The Hudson River Museum, gift of Miss Mary Colgate. (25.947)

73. David Gilmour Blythe, *A Match Seller, c.*1859. Reproduced courtesy of North Carolina Museum of Art, Raleigh. Purchased with funds from the State of North Carolina. (52.9.3)

74. Albert Weinert, The Haymarket Monument, 1893. Life-size bronze figure with 4.8m granite shaft. Forest Home Cemetery, Forest Park, Illinois. Reproduced courtesy of Melissa Dabakis, Kenyon College.

75. Thomas Cole, *Kaaterskill Falls*, 1826. Oil on canvas, 109.2 x 91.4 cm. Reproduced courtesy of The Warner Collection of Gulf

States Paper Corporation, Tuscaloosa, Alabama. (1991-0006)

76. William Guy Wall, *Cauterskill Falls on the Catskill Mountains, c.*1827. Reproduced courtesy of Honolulu Academy of Arts, Gift of The Mared Foundation, 1969. (3583.1)

77. Thomas Cole, *View from Mount Holyoke, Northampton, Massachusetts, After a Thunderstorm (The Oxbow)*. 1836. Oil on canvas, 130.84 x 193 cm. © 1995 the Metropolitan Museum of Art. Reproduced courtesy of the Metropolitan Museum of Art, gift of Mrs Russell Sage, 1908. (08.228)

78. Thomas Cole, *The Course of Empire; Savage State*, n.d.(1858.1), *The Arcadian or Pastoral State, c.*1836 (1858.2), *Consummation*, 1836 (1858.3), *Destruction, c.*1836 (1858.4), *Desolation, c.*1836 (1858.5). Oil on canvas. © Collection of the New-York Historical Society. Reproduced courtesy of The New-York Historical Society.

79. Asher B. Durand, *Kindred Spirits*, 1849. 116.8 x 91.4 cm. Reproduced courtesy of the Collection of the New York Public Library, Astor, Lenox and Tilden Foundations.

80. Asher B. Durand, *The American Wilderness*, 1864. Reproduced courtesy of the Cincinnati Art Museum, the Edwin and Virginia Irwin Memorial. (1968.261)

81. Kensett, John Frederick, *Lake George*, 1869. Oil on canvas, 112.1 x 168.6 cm. © 1992 the Metropolitan Museum of Art. Reproduced courtesy of the Metropolitan Museum of Art, Bequest of Maria DeWitt Jessup, 1915. (15.30.61)

82. Martin Johnson Heade, *Lake George*, 1862. Oil on canvas, 66 x 125.4 cm. © 1998 Museum of Fine Arts, Boston. Reproduced courtesy of Museum of Fine Arts, bequest of Maxim Karolik. (64.430)

83. Frederic Edwin Church, *Niagara*, 1857. Oil on canvas. Reproduced courtesy of the Collection of the Corcoran Gallery of Art, Washington, DC. Museum purchase, Gallery Fund. (76.15)

84. Frederic Edwin Church, *Niagara Falls from Goat Island, Winter*, 1856. Oil, traces of graphite on cardboard, 29.2 x 44.5 cm. Gift of Louis P. Church. Reproduced courtesy of Cooper-Hewitt Museum, Smithsonian Institution/Art Resource, New York. (000-1917-4-765A)

85. Frederic Church, *Heart of the Andes*, 1859. Stereograph, unidentified photographer. As exhibited at the Metropolitan Sanitary Fair, 1864. Reproduced courtesy of the New-York Historical Society. (61623)

86. Thomas Cole, *A View of the Mountain Pass*

Called the Notch of the White Mountains (Crawford's Notch), 1839. 101.6 x 156 cm. Reproduced courtesy of the National Gallery of Art, Washington, DC, Andrew W. Mellon Fund. (1967,.8.1.PA)

87. Winslow Homer, *Defiance; Inviting a Shot before Petersburg*, 1864. Oil on panel, 30.5 x 45.7 cm. © 1998 The Detroit Institute of Arts. Reproduced courtesy of Founders Society, Detroit Institute of Arts. Purchased with funds from Dexter M. Ferry, Jr. (51.66)

88. George Inness, *The Lackawanna Valley*, c.1855. Oil on canvas, 86 x 127.5 cm. © 1999 Board of Trustees, National Gallery of Art, Washington. Reproduced courtesy of the National Gallery of Art, Washington, gift of Mrs Huttleston Rogers. (1945.4.1.PA)

89. George Inness, *Early Autumn, Montclair*, 1891. Oil on canvas, 73.7 x 114.3 cm. Reproduced courtesy of the Delaware Art Museum. Gift of the Friends of Art and Special Purchase Fund, 1965 (65.1).

90. Albert Pinkham Ryder, *Toilers of the Sea*, c.1882. Reproduced courtesy of the Metropolitan Museum of Art, George A. Hearn Fund, 1915. (15.32)

91. Winslow Homer, *Mount Washington*, 1869. 41.3 x 61.6 cm. © 1999 The Art Institute of Chicago. All rights reserved. Reproduced courtesy of the Art Institute of Chicago, gift of Mrs Richard E. Danielson and Mrs Chauncey McCormick. (1951.313)

92. Winslow Homer, *Eastern Point*, 1900. © 1994 Clark Art Institute. Reproduced courtesy of Sterling and Francine Clark Art Institute, Williamstown, Massachusetts (E1068.4A)

93. William Hahn, *Yosemite Valley from Glacier Point*, 1874. Oil on canvas. Reproduced courtesy of California Historical Society, gift of Albert M. Bender. (x57.548.L.2)

94. John White, *Indians Fishing*, c.1585. Lithograph, 35.3 x 23.5 cm. Private collection. Courtesy of the Bridgeman Art Library.

95. George Catlin, 'Louis Phillippe's Party Inspects Catlin's Gallery in the Louvre ...', from *Catlin's Notes of Eight Years' Travels ... in Europe*, 1848.

96. George Catlin, *Four Bears, Second Chief, in Full Dress (Mandan)*, 1832–4. Oil on fabric, canvas mounted on aluminium, 73.7 x 61 cm. Reproduced courtesy of National Museum of American Art, Smithsonian Institution, Washington, DC/Art Resource New York. (1985.1.128)

97. Karl Bodmer, *Biróhkä (The Robe with the Beautiful Hair). Hidatsa Man*, 1833–4. 31.8 x 24.1 cm. Reproduced courtesy of the Joslyn Art Museum, Omaha, Nebraska, gift of the Enron Art Foundation. (JAM.1986.49.29)

98. Alfred Jacob Miller, *Trappers Saluting the Rocky Mountains*, 1834. Reproduced courtesy of Buffalo Bill Historical Centre, Cody, Wyoming, gift of the Coe Foundation. (10.70)

99. Albert Bierstadt, *The Rocky Mountains, Lander's Peak*, 1863. 186.7 x 306.7 cm. © 1985 the Metropolitan Museum of Art. Reproduced courtesy of the Metropolitan Museum of Art, Rogers Fund, 1907. (07.123)

100. Charles Bierstadt, *Our Party, Yosemite Valley, California* and *Mirror Lake, Yosemite Valley, California*. Stereographs. Private collection.

101. P.A. Miller/Thomas Croft, 'Race into the Cherokee Outlet. Ten Seconds after the gun, September 1893'. Photographic credit claimed by both P.A. Miller and Thomas Croft, both employed that day by William S. Prettyman, Arkansas City, Kansas. Reproduced courtesy of Archives & Manuscripts Division of the Oklahoma Historical Society. (5003)

102. John Gast, *American Progress*, 1872. Reproduced courtesy of Autry Museum of Western Heritage, Los Angeles.

103. Late eighteenth/early nineteenth-century Navajo wall painting, Canyon del Muerto, Arizona. Canyon de Chelly National Monument. School for American Research, Karl Kernberger.

104. James Henry Beard, *Goodbye Ole Virginia*, 1872. Photo courtesy of J.N. Bartfield Galleries, New York.

105. Seth Eastman, *Indian Mode of Traveling*, 1896. Oil on canvas, 78.7 x 111.8 cm. Reproduced courtesy of Sotheby's, New York.

106. Henry F. Farny, *Morning of a New Day*, 1907. Oil on canvas. Reproduced courtesy National Cowboy Hall of Fame, Oklahoma City. (A.037)

107. Anon., 'Theodore Roosevelt in Buckskins', 1885. Reproduced courtesy of the Library of Congress, Washington, DC. (LC-USZ62-23232)

108. Charles M. Russell (?), illustration from *The Virginian*, 1902.

109. Frederic Remington, *Coming through the Rye*, c.1902. Reproduced courtesy of Buffalo Bill Historical Center, Cody, Wyoming, gift of Barbara S. Leggett. (5.66)

110. Theodore Wores, *The Lei-Maker*, 1901. Reproduced courtesy of Honolulu Academy of Arts, gift of Drs Ben and A. Jess Shenson, 1986. (54490.1).

Pages 172–3. detail of Augustus Saint-Gaudens, *Memorial to Robert Gould Shaw and the Massachusetts Fifty-Fourth Regiment*, 1884–96. Patinated plaster, without armature

or pedestal, 36.8 x 52.4 x 8.6 cm; with armature and pedestal 41.9 x 52.4 x 10.9 cm. Photo, Philip A. Charles. Reproduced courtesy of US Department of the Interior, National Park Service, Saint-Gaudens National Historical Site, Cornish, NH, on loan to the National Gallery of Art, Washington, DC.

111. Anon., 'Women Tending Jackson's Grave', after 1863. Photo courtesy of Virginia Military Institute Archive, Lexington, VA.

112. Anon., 'Columbus Day Parade in Baltimore', 1950s. Author's collection.

113. Alexander Gardner and Timothy O'Sullivan, 'A Harvest of Death, Gettysburg', 1863. Reproduced courtesy of the Library of Congress, Washington, DC. (LC-B8184-7964)

114. James Smillie, Plate from *Greenwood Illustrated*, 1847. Reproduced courtesy of Donald E. Simon, New York.

115. Martin Milmore, Civil War Memorial (Standing Soldier), *c*.1867. Photo © 1997 Susan Wilson, All rights reserved. (V-2088)

116. Augustus Saint-Gaudens, *Memorial to Robert Gould Shaw and the Massachusetts Fifty-Fourth Regiment*, 1884–96. Bronze relief, Boston Common, Boston, MA. Photo Jeffrey Nintzel.

117. Thomas Ball, 'Emancipation Group' (Freedman's Memorial Monument to Abraham Lincoln), 1876. Photo Jack Ratlier. Reproduced courtesy of National Park Service Photo Collection, W. Virginia.

118. Richard Westmacott, Charles James Fox monument, 1810–23. Marble, over-life-size figures. © Dean and Chapter of Westminster. Erected by subscription. Reproduced courtesy of Dean and Chapter of Westminster, Westminster Abbey, London. (Box 44a).

119. Winslow Homer, *Prisoners from the Front*, 1866. Oil on canvas, 61 x 96.5 cm. © 1975 the Metropolitan Museum of Art. Reproduced courtesy of the Metropolitan Museum of Art, gift of Mrs Frank B. Porter, 1922. (22.207)

120. Winslow Homer, *The Bright Side*, 1865. Reproduced courtesy of Fine Arts Museums of San Francisco, Gift of Mr and Mrs John D. Rockefeller 3rd. (1979.7.56)

121. Winslow Homer, *Mount Vernon*, 1861. Watercolour, 32.4 x 43.2 cm. Reproduced courtesy of the Mount Vernon Ladies' Association. (CS.1993.8)

122. Emanuel Leutze, *Washington Crossing the Delaware*, 1851. Reproduced courtesy of the Metropolitan Museum of Art, gift of John Stewart Kennedy, 1897. (97.34)

123. Paul Fjeld, Colonel Hans Christian Heg, 1925. Reproduced courtesy of State Historical Society of Wisconsin. (X3 28546 Capitol Album 2)

124. John Vanderlyn, *Landing of Colombus on the Island of Guanahani, West Indies, October 12, 1492*, 1839-47. 365.8 x 548.6 cm. Reproduced courtesy of the Architect of the Capitol, Washington, DC. (70226)

125. Randolph Rogers, Landing of Columbus, lunette of US Capitol doors, 1858–61. Reproduced courtesy of the architect of the Capitol, Washington, DC. (70908)

126. Mary Lawrence Tonetti, statue of Christopher Columbus at east end of Administration Building, World's Columbian Exposition of 1893 (destroyed). Reproduced courtesy of Chicago Historical Society.

127. Gaetano Russo, Christopher Columbus memorial, 1892, Columbus Circle, New York. Carrara marble figure on granite column. Overall height: 23.5 m; statue: 4 m. Author's photo.

128. Five Dollar Bill. US Treasury, series E, 1914. Reproduced courtesy of the Smithsonian Institution, National Numismatic Collection, Douglas Mudd.

The publisher and the author apologize for any errors or omissions in the above list. If contacted they will be pleased to rectify these at the earliest opportunity.

Index